JEFF KOONS
CONVERSATIONS WITH NORMAN ROSENTHAL

Date: 2/6/15

709.2 KOO
Koons, Jeff,
Jeff Koons : conversations
with Norman Rosenthal /

JEFF KOONS

CONVERSATIONS WITH NORMAN ROSENTHAL

Thames & Hudson

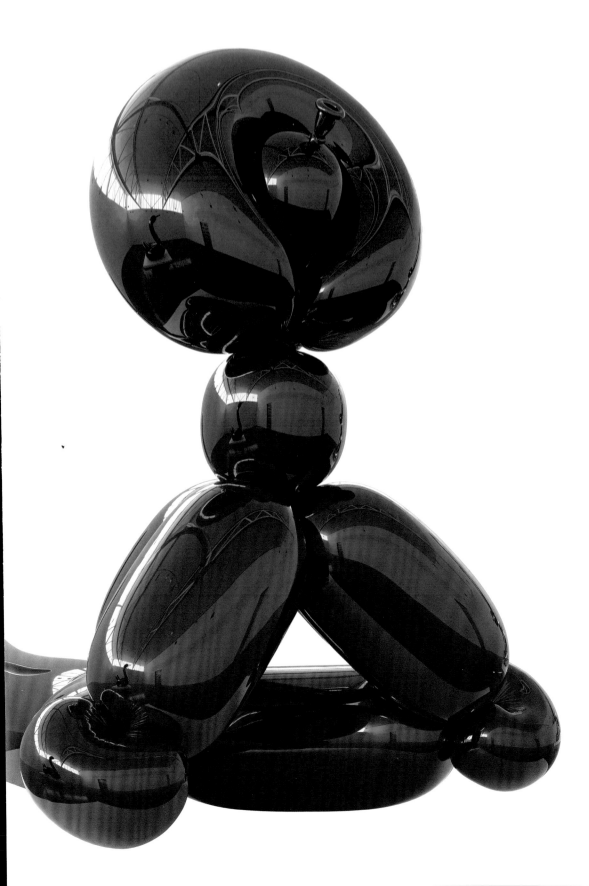

Foreword

NORMAN ROSENTHAL
JEFF KOONS

7

1

Time starts to bend

ART AS CONNECTION TO HUMANITY AND HISTORY

8

2

Everything is already here

FAMILY, THE YOUNG ARTIST, GAZING BALL

42

3

My objects were
just displaying themselves

INFLATABLES, THE NEW AND THE PRE-NEW

74

4

There's just an
acceptance of everything

EQUILIBRIUM, LUXURY AND DEGRADATION,
STATUARY, KIEPENKERL, BANALITY,
MADE IN HEAVEN AND
CELEBRATION

108

5

It's arousal about life

EASYFUN, EASYFUN-ETHEREAL,
POPEYE AND HULK ELVIS TO ANTIQUITY

162

6

I want to make the
grandest gesture that I can

ACTION AND ACHIEVEMENT

208

7

Everybody is hungry for something
that can change their life

COMMUNITY, CONNECTION, COMMERCE
AND CELEBRITY

246

8

Vocabulary is
a profound subject

A KOONS LEXICON

266

CHRONOLOGY: THE JEFF KOONS TIMELINE

288

INDEX

292

PHOTOGRAPHIC CREDITS

295

FOREWORD

As a curator much associated with the so-called 'rebirth of painting' at the beginning of the 1980s, I remember an almost traumatic moment when the legendary art dealer Ileana Sonnabend took me by the hand and said: 'Norman, there is a new Zeitgeist.' She stepped into a car with me and took me from her grand gallery in New York's SoHo to a small gallery in the East Village called International with Monument where I saw the work of Jeff Koons for the first time.

Since then Jeff has imposed his imagination on the world of art in the most generous and open-ended spirit, constantly surprising as he makes connections between humankind's cultural history and contemporaneity. He has shown in many exhibitions I have been involved with, in both London and Berlin especially, and we did our first interview in public at the Basel Art Fair. The success of that occasion has given rise to this series of conversations, in which we both try to locate our sense of the present in the continuum of the past.

We owe much to a number of dedicated individuals who have helped see this project through. They are all friends of many years standing and I owe much to: Daniel Wolf, Gary McCraw, Lauran Rothstein, Inigo Philbrick, Donald Rosenfeld, Jeanne Greenberg Rohatyn, David Breuer, Sam Philips and Dan Fragias.

Above all, it has been a privilege to have these conversations with Jeff. His take on the world through his painting and sculpture is unique, full of love and the total joy of art.

Norman Rosenthal
Jeff Koons

Time starts to bend

ART AS CONNECTION
TO HUMANITY AND HISTORY

NORMAN ROSENTHAL When I look at all these kids working away so intensively in your studio, it is what I imagine the studio of Rubens would have been like, with Rubens walking around directing, making drawings and planning compositions, while around him there would have been a lot of assistants engaged in all kinds of activities in relation to realising his paintings. People would then come from all over the world to see the works in his studio. In this context I really wanted to ask you some big questions. For example, why is it necessary for you to set up this complex machine? And what does art mean for you as an activity?

JEFF KOONS **Those are very big questions.**

NR Yes, and to begin we could start by asking whether 'art' is even a useful word. Until the Renaissance, artists as we know them – people who made the most extraordinary things out of precious materials – thought of themselves as artisans, as workers, just like the local baker. These were the builders of cathedrals, the builders of pyramids, artisans who made things like King Tut's head. And with that in mind, is art a useful word, a useful idea in your head?

JK It has been useful since I was a child. I gained a sense of self from practising art when I was very young, maybe about three years old. I can remember making a drawing and my parents coming up and patting me on the shoulder and saying 'Jeff, that's great'. And that gave me a sense of self: I learned that art was something that I could do, something that I could perform. But then art quite quickly became something that created a sense of anxiety for me. When I tried to create an illusion of the world around me, like drawing a glass that had water in it, there was anxiety because of the set of pictorial rules I thought I had to follow. It took me a really long time to realise that art is actually a process of removing anxiety. Art continues to reveal what it can be, and that changes daily, but for me art is always involved with this removal of anxiety. I think that removing anxiety reveals just how simple the world and the reality of our experience can be.

It's about knowing yourself, as a sense of self-acceptance is so important. The motivation of art is the removal of any kind of guilt or shame, or anything that people have within their history that alienates them from just dealing with themselves. It's very important to try to remove those feelings if you want to function outside the self. If you go inward you can eventually reach the bottom of the self, and art is a great tool to enable that.

The New Jeff Koons, 1980
[THE NEW]

NR Every human being to some degree wants to find themselves, but they won't necessarily do it through art. Do you think this therapeutic effect is true of all professional activities or is it specifically a quality that art can bring? If someone devotes their life to mathematics or to physics, or to being a doctor, or for that matter to being a politician or even a street sweeper, is it the same? Or is art fundamentally different?

JK It's the same. It's absolutely the same. But art makes its therapeutic potential very clear to me because it connects many different disciplines together and it lets you become involved in a dialogue with theology and, at the same time, sociology. It gracefully lets you focus on many particular areas and, in that way, it is a wonderful gift that you give to yourself. Art is about having interest in life, developing a sense of self-respect, respect for others and respect for life energy. You don't have to aim for these things, but what you can become through them – what the essence of life can become – seems to be a higher ideal.

NR You may disagree with me, but I would argue that art is a more complex imperative than, for example, being devoted fanatically to football, whether English or American football.

JK Focusing on something is very important. If somebody really focuses their attention on sport I believe it can take them to a metaphysical state. It could be different from art – I don't really focus on other activities as intensely as I do on art, so I don't know if exactly the same thing can happen.

NR What do you mean by 'metaphysical'? Do you lose yourself in a dream world, an almost surreal world that resembles, say, the world of Surrealists such as Dalí, De Chirico or Magritte?

JK I think it's about a realm of the archetypal, where the vocabulary is profound and communal. If you focus on your interests, you learn to deal in a vocabulary that is very important to other people – you learn to work with it, to articulate it. Eventually you learn to use different aspects of different vocabularies from different people, and that helps you to kind of leapfrog from one stone to another.

NR Different people in history?

JK Yes, and in terms of art, it's people in history who have used different vocabularies of art. Those vocabularies let you go back in time and connect to information that is essential to life, and that has helped

keep people alive. That's how I define an archetype – information that helps sustain life.

NR Yes, such as sustaining culture.

JK But when you do this activity of getting lost – of being open to human energy, to human potential to connect – you realise that time starts to bend. In one moment you are connected to the past and the future, although you are very much in the present moment. All of a sudden you can walk down the street and absolutely everybody will look familiar to you – every face is so familiar and there is a sense of going forward, advancing yourself in time. The mildest example of this is just making connections between things. You can see how everything really does reveal itself through these combinations.

NR Do you want to go both backward in time and forward in time in these moments?

JK The most important thing about these moments is that they affirm participating now. My work enjoys going backward to embrace the resources of the humanities and to make connections that bring about enlightenment. The forward part would be the enlightenment that hopefully the viewer finds in the future within their own being, by making connections with their own life.

NR You are talking as though art has a kind of religious basis? Does it have a theological basis for you? Or, put rather simply, do you feel yourself to be a Christian person, whatever that is, whatever that means?

JK I have always enjoyed philosophy. For me the key thing in life is really a sense of the meaning of life, and having self-respect that allows you to go outside the self, within the family and into the community. I believe in enlightenment and I believe in understanding. I believe that art can help reveal to people how they can open themselves up to their environment, and to the potential of the world around them. Other things can do that also, but art has a way of doing it that is very soothing. It helps you to open up. You deal with external images and objects that require opening yourself up to life energy.

NR It's curious that you use the word 'soothing'. What do you mean by that exactly? And do you want art to be frightening sometimes? To me art can be very frightening sometimes.

JK When I talk about art being soothing, I mean when I feel most comfortable about opening myself up. Everything is free of anxiety and

Moses, 1985
[EQUILIBRIUM]

14

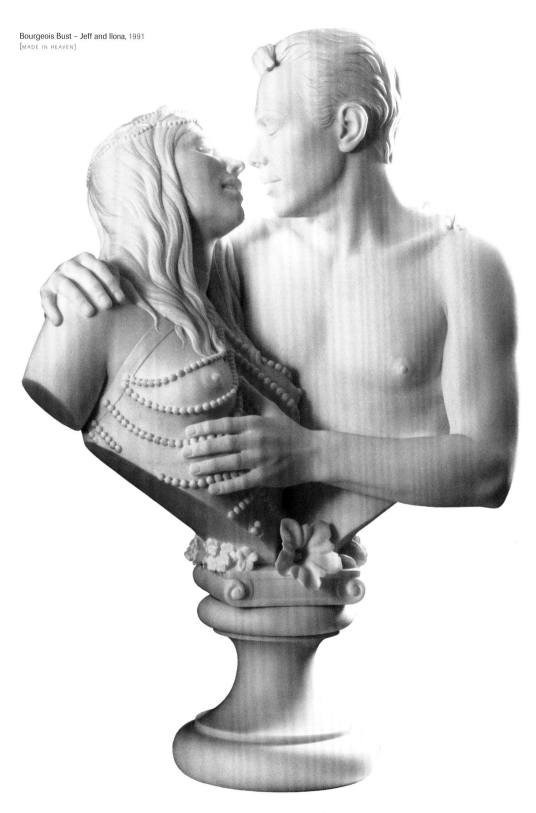

Bourgeois Bust – Jeff and Ilona, 1991
[MADE IN HEAVEN]

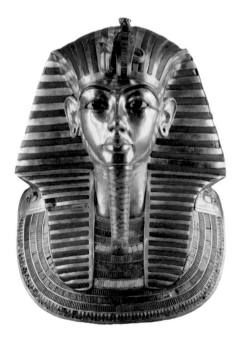

Tutankhamun's funerary mask from Thebes,
c 14th century BC
Egyptian Museum, Cairo

Salvador Dalí,
Lobster Telephone, 1936
Tate Collection

Quentin Massys
Christ, *c* 1500
Koons Collection

The Venus Felix, 2nd century AD
Museo Pio-Clementino, Vatican City, Rome

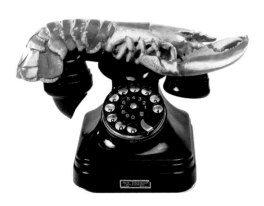

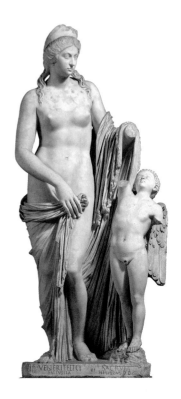

immediately very clear – it's not like things are hidden by different layers or languages. And if the work is getting somewhere, it isn't exposing something that's frightening, but actually the opposite. It exposes something that is quite healthy and positive and constructive for the individual, such as how to face the day, and how to face the future.

NR Do you study subjects like sociology, theology and Classical art in detail when you are making your art, or is how you connect to these areas more of an instinctive thing?

JK I have an interest in reading certain philosophical books, but really I study through life experience. I think that awareness of self is very, very critical as a step of self-acceptance. This sounds incredibly Platonic, but it is really so important to accept yourself – self-acceptance is the key.

NR Are you making things for yourself or are you thinking about your audience? When I curated exhibitions at the Royal Academy of Arts, I made the exhibitions for myself and, with luck, if I pleased myself I might please others. It was really my form of personal expression. You have your activity that is perfected and expanded to an incredible degree, but is it about your self, your personal self, in the first instance?

JK Absolutely. But it is also about the physical self. It involves physiology, as inner understanding of the self involves intellectual activity through chemical responses. When someone jogs, for example, there are chemical releases in the body such as endorphins that make you feel a certain way. There is a similar intensity in truly great artworks: they create physical responses. I am quite dependent on these physical responses to my work. This process of going in this metaphysical direction is a form of addiction.

NR Is there a moral imperative for an individual to become involved with art or is it a luxury?

JK I find my connection to art to be one that is very, very moral. But it is a moral luxury. Luxury is about taking something to a heightened parameter and that is what art lets you do with your life. What I love is that art lets you connect to what it means to be human. I can look at a Rubens painting and I can feel connected to Rubens; I can look at antiquities and get a sense of what it feels like to wake up with a dirty face wearing some fur on your back – just what it felt to be human at that time. At the same time you get a sense that your foot's in the future.

NR So you feel you are reaching out to some kind of eternity beyond yourself through art?

Donkey, 1999
[EASYFUN]

Antiquity 1 (Dots),
2010–12
[ANTIQUITY]

Balloon Venus (Magenta),
2008–12
[ANTIQUITY]

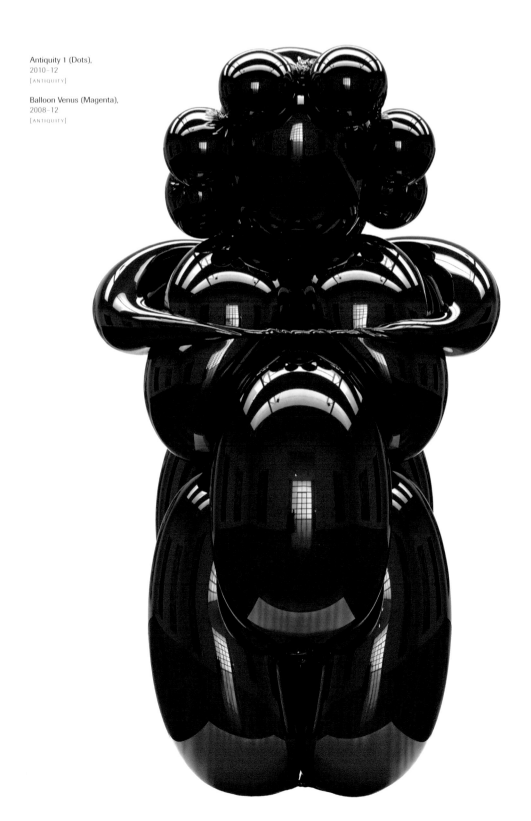

21

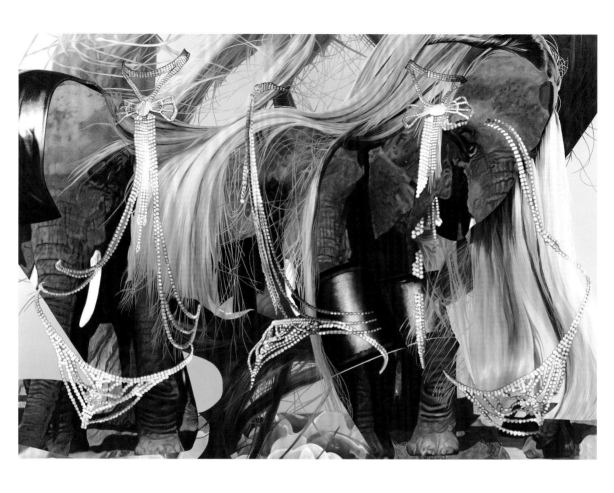

Elephants, 2001
[EASYFUN-ETHEREAL]

Prison (Venus), 2001
[EASYFUN-ETHEREAL]

JK Yes, although I also enjoy showing just what a strong foundation our past is. A lot of the time people like to think that in today's world, in the modern world, we are really refined and developed in a Darwinian way that makes us superior to the past. But the past is bedrock – it's absolutely solid, and everything has been before. The way that we look at the world sometimes forgets that.

NR In art I think this is particularly true. If one looks at predynastic Egyptian art, for example, the amazing refinement those people achieved with unbelievably limited technical means actually boggles the mind, doesn't it?

JK Absolutely. These objects have a sense of soul, a sense of life energy; they contain what it means to be alive.

NR You often speak of individuals, of their anxieties, happiness and energy, but you yourself are an artist. Do you see a big difference between artists and other people?

JK No, absolutely not. The basic aspects and daily functions of being alive, being a human being, are for everyone. I do think artists have the opportunity to function a little bit as philosophers, to think about sociology and contemplate a lot of things. They can actually be a little bit like dilettantes and be involved in a lot of areas at once. That can be beneficial.

NR Yesterday I went to see the Ed Paschke exhibition you curated at the Gagosian Gallery. In his paintings he seems to be concerned with the psychology of the individuals depicted. They are extraordinary tattooed individuals, perhaps heightened by the artist, but still people with strange arms, legs and weird appearances. The pictures are about their selves it seems. They represent what many would regard as freaky or abnormal people, although these subjects are presumably accepting of themselves. Is that the message for you?

JK Yes. I think you as the viewer feel the weirdness of those paintings, and dealing with that sense of strangeness is also about dealing with yourself, accepting yourself. It's about people confronting their own past and things they maybe try to put under the doormat – those paintings bring those things to the surface. And it's really just about bringing new combinations of those things together. I learned a sense of the ready-made and a sense of really looking at my external world from Ed, even more than from Duchamp. Duchamp is very dry and cerebral and learned, whereas from Ed I picked up how to use the world for source material.

'Ed Paschke', curated by
Jeff Koons, Gagosian Gallery,
New York, 2010

Ed Paschke
Red Sweeney, 1975
Rockford Art Museum,
Rockford, Illinois

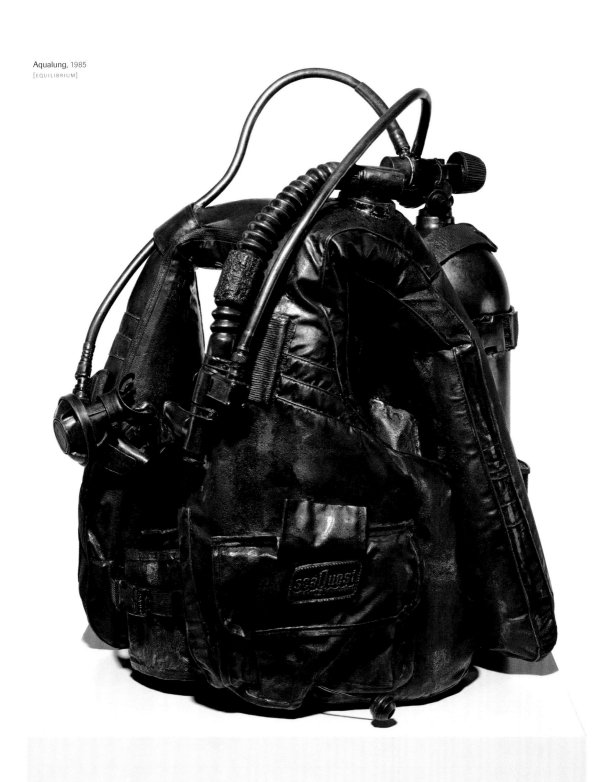

N R Where did he find these people?

J K I don't know. Some of the people in his paintings do exist, some of the people don't exist. The figure portrayed in *Red Sweeney* [1975] has no arms and is very tall and elongated, and you imagine he probably has a phallus of 20-something inches [50 something centimetres]. A lot of his people like this don't exist, but emotionally they connect to an internal life we are familiar with, something that exists within us.

I think the lighting of his paintings is very important. It creates an emotional state in which there's a sense of being on the edge of some excitement, but at the same time a sense of strangeness, and maybe a little fear to put one's foot forward. It's almost stage fright.

N R It is interesting to hear you analysing what makes Ed's work function.

J K Talking like this, I think my main interest is in art history. I remember being an art student and discovering Manet for the first time. In art history class, Manet's work *Olympia* [1863] came up on the screen and my art professor would talk about some of the symbolism, such as how the black cat in the picture has more meaning than just the black cat, because it was a symbol of prostitution, and how that related to other paintings. The effect was to create more energy, which is exactly what people are always trying to accomplish in life. Art manages a fusion that is greater in itself than any two independent things.

N R Yes, we agree completely about that I'm sure. For me art is about connecting to the past while remaining completely in the present. That's why I admire your art so much because it seems to me that the imagery is very much about the present, which soon will become the past in itself. You keep up to date with the times and at the same time connect profoundly to the past.

J K Art has always had a certain magical side. When you start to get in gear and you really work with art as a tool, focus on your interests and get absorbed by them, you realise there's a sense of time travel – time starts to jump a little bit. When you're young and you're involved in contemporary art, before you know it you realise 'My gosh, you know, I was thinking about that six months ago and now everybody's talking about that'. Or if you focus more on your work and your areas of interest, you think 'Two and a half years ago I was dealing with that and now everybody's dealing with it'. This sense of time travel comes from absolute familiarity, from a shared experience and a sense of oneness. Dealing with art history is how you time travel, as it focuses your interests and makes connections. Instead of having this linear view of time, all of a sudden it bends and you can shift it closer to the present moment.

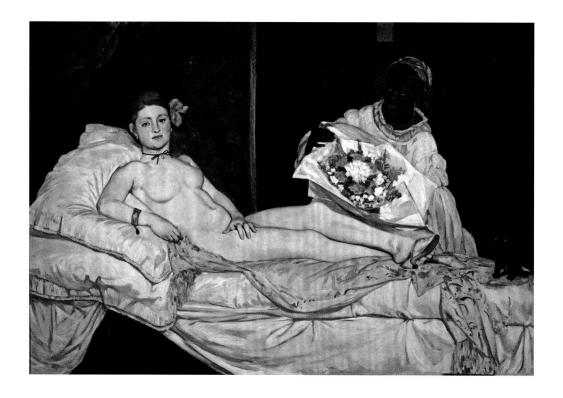

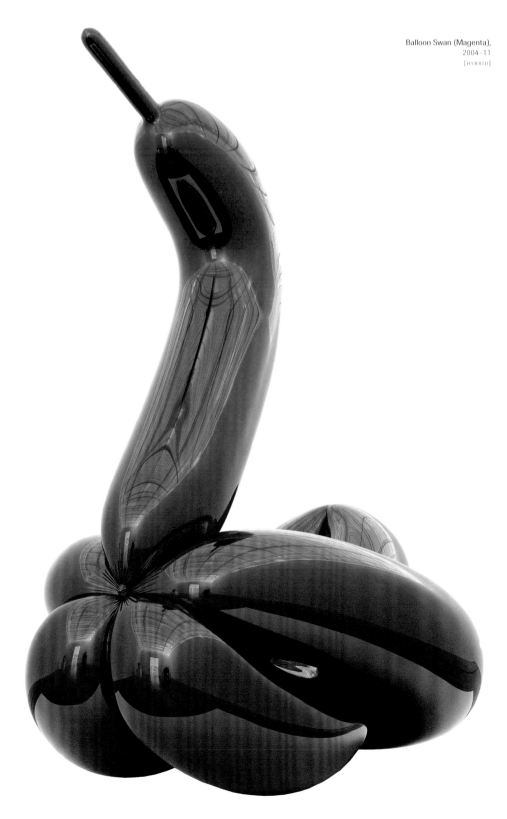

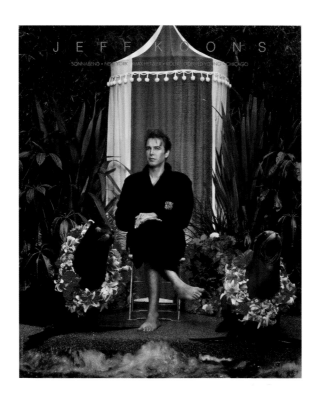

Ad Art (Art), 1988–9
[BANALITY]

Hanging Heart (Red/Gold) [1994–2006],
Palazzo Grassi, Venice, 2006
[CELEBRATION]

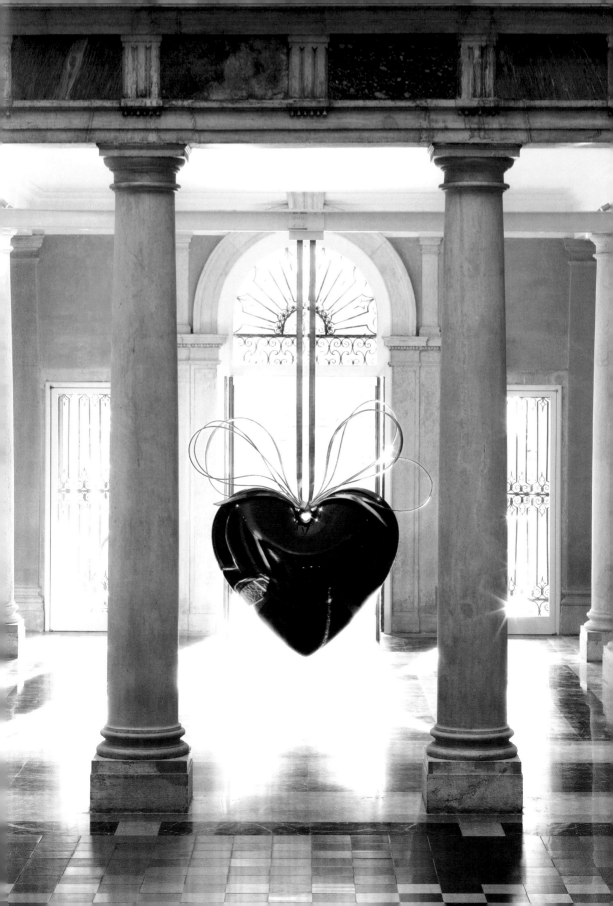

There's a continuation of narrative, of true narrative, and you achieve a much more physical or a biological connection to the narrative and the other people who have participated.

N R Are you talking just about yourself or do you think we can all experience this?

J K I think we can all experience this.

N R Do we all experience this? Not just *can* we, *do* we?

J K I think we do. And I think that's what people enjoy when they enjoy the historical aspects of art. They feel the connections to those moments of being human. Time does bend – it becomes much more circular and we are all included.

N R Do you think the same things happen in music and literature?

J K I'm sure.

N R And in other cultural forms?

J K I'm sure.

N R And in architecture, for example?

J K I'm sure. They are all the arts. People have embedded archetypal information: forms of communication on the most profound level about what this human experience has been and what its potential is. This is what the arts can access.

N R And this is presumably about memory too, isn't it? Do you think that's embedded in our biology in a funny kind of way?

J K Yes. You know Plato stated that all information is already known by the individual and they just have to remember the information. I don't know if I'm completely in line with that, but I think that a condensed amount of information exists within these archetypal images. Biologically everything that's known about life is in the DNA – that's the narrative. Much of our abstract consciousness is in archetypal information.

N R And do you think that as an artist you are somebody engaged in mediating this? Do you think artists are priests in a sense?

J K I don't know about priests, although they have always been performing in the same area.

N R What would you say to the idea of the artist as a kind of god?

J K I think it's more that the artist is conscious that people have potential and they try to live to that potential. I always believed that

I would like to have a certain consciousness, a certain freedom of gesture before I die. I would really like to make the great gesture that I feel inside I have the potential to do. What holds me or others back from that is a form of anxiety. I just feel that everything can be revealed if people can have a sense of acceptance. I'm constantly trying to participate in this acceptance as I feel that the simplicity of everything can be revealed. Then there would be nothing to hold me back from the grandest possible gesture that I could make.

N R But if you are, say, the lawyer or the street sweeper, how can you express yourself? Is it possible?

J K Absolutely – it's possible in the way you live your life, the way you interact within your community, the involvement with your family, any respect that you give to yourself, and the respect that you give to others.

N R But do you think that art is more than entertainment?

J K Art is an area that gives you this ability to participate within these abstractions. It gives you that space to move around within these abstractions, and hopefully to create a reality.

N R Is it a democratic reality?

J K I think so. I think everybody has the space in their mind in which they can participate in that abstraction.

N R What do you mean by 'abstraction' here, exactly? It's quite interesting to me, by the way, how abstract your BMW Art Car [2010] is, but most of your art I would describe as essentially figurative.

J K Well, I mean abstract in a different way, in terms of connections. When we were talking about the different connections that you can make with something, the perception of connection is the type of abstraction I'm speaking about. Abstraction is a connection to the different potentials of things, and that's the metaphysical space I guess.

N R Do you think all art is, somehow, fundamentally abstract?

J K Yes.

N R You do?

J K Yes. Even when you are younger and starting off within the small confines of what you know, you are aware that the potential of art is huge. You try and draw some lips and you feel kind of insecure about capturing a specific thing. You are confined to abstractions.

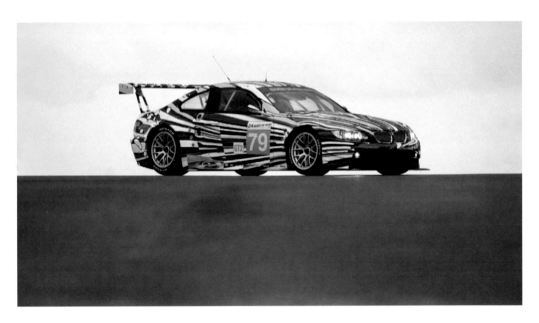

Jeff Koons 17th BMW Art Car,
2010

Auto, 2001
[EASYFUN-ETHEREAL]

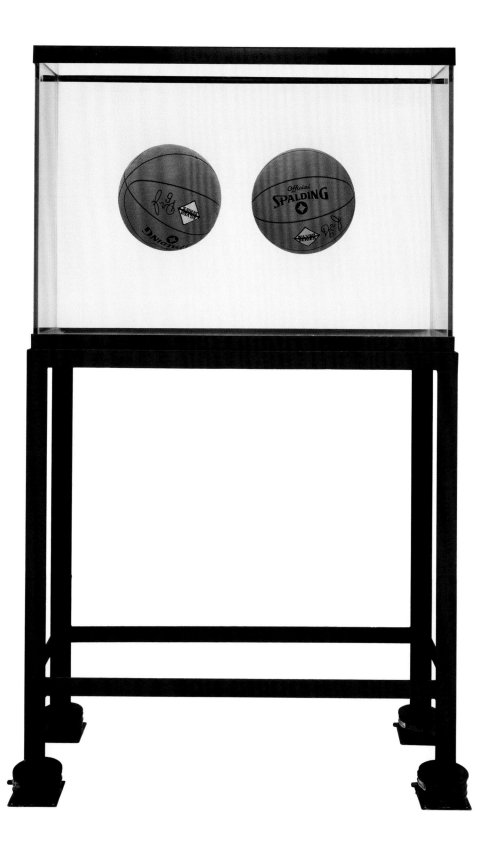

N R But when you are painting lips, are you thinking abstractly or are you thinking about, for example, the sexual power of lips?

J K Well, that is abstract, thinking about the sexual power of lips. It's abstract whenever there's a connection being made with something.

N R Is there a difference between the abstract and the real, for example?

J K Yes, I think that the abstract is more amenable – it's more shifting and you can form it more.

N R Perhaps in terms of forming it into art? And what is real to you, would you say? That's a big question too!

J K Yes, it is a big question. I think reality usually has a sharper edge to it. It's something that tends towards physics. You can try to achieve something, but at the end of the day you have to come to terms with the fact that within the physical world there are certain limitations of what you can do. Reality can be a bit like hitting a brick wall.

N R Can I make a suggestion? My suggestion is that reality is something that you can touch. You know it's there. But if you go into a museum or an art gallery, you are not allowed to touch. An artwork is a slightly mysterious object – it's there, you know it's there, but you are also kept away from it. In your 'Equilibrium' series of tanks [1985], for example, the balls are behind glass and can't actually be grasped. So in that sense they are abstract, they are not real. You can't take them and throw them, you can't use them in a game. Do you think this is a reasonable way of looking at it? You can't touch it, so it's really taking place in the head.

J K But if something creates biological change and if it affects the biological DNA, then it's real, and art can do that.

N R Do you think that is what I call the 'shiver effect'? When I see a great work of art I have that feeling. I remember when Titian's *The Flaying of Marsyas* [*c* 1575] came out of its shipping case at the Royal Academy of Arts for our exhibition of Venetian art in 1984. It changed my life in one second. No one in the Western world had seen that work of art for 400 years because it had been practically exiled in Czechoslovakia in an obscure castle, not even in Prague. It came to London and the whole of London felt changed by this painting – it influenced a lot of artists' work as well as the heads of many individuals who saw that exhibition. Do you think that art has this ability to change people just through looking?

Two Ball Total Equilibrium Tank (Spalding Dr. J Silver Series), 1985
[EQUILIBRIUM]

Titian,
The Flaying of Marsyas, *c* 1575
Archbishop's Gallery, Kromeriz, Czech Republic

JK Absolutely. And it has the ability to do the same for the maker. For Titian to be able to make something like that, to be able to go to that place, to be so open, to be so free, that amazes me.

NR And he was about 90 when he did it.

JK Amazing. Such a gesture.

NR He was 90 years old or in his 80s when he did that painting. It took him a long time. He travelled a long way in order to get to that painting and hopefully you are going to live until you are 90 or 100 or 120 and your art will still be developing. Even now, before my very eyes this morning, I have seen a big breakthrough in what you are doing. Do you have a plan in that way, to push forward as time passes? Do you have a sense of the future or are you just interested in the now?

JK I'm 55 now, so I have a greater sense of my own mortality and I don't want to waste my energies. I have a great platform. I have no excuses. I'm very conscious of that and I don't want to waste the opportunity. I do want to open myself up to the possibility that I have. I would like to make a gesture equal to Titian's. We all have this potential at every moment, but things seem complicated and there are these barriers that keep people from making that gesture. So I really would just like to find the simplicity that you can imagine at your last breath when everything is revealed and it is clear everything could have been so easy. I would just like to wake up and feel that sense of how easy it is and to do it.

Antiquity (Daughters of Leucippus),
2010–12
[ANTIQUITY]

Everything is already here

FAMILY, THE YOUNG ARTIST,
GAZING BALL

NORMAN ROSENTHAL When did your family come to America?
Do you know?

JEFF KOONS I know that both my maternal and paternal grandmothers' sides of the family were here in the 1800s, but I don't know exactly when they came, and I find that really shocking, how little I know about them. In general it's amazing how little we know about our families. These things are so important to us, but how rapidly we just get on with our own lives and how little we know about theirs.

NR Which part of Europe did they come from, do you know?

JK From Germany.

NR So they were a German family?

JK The spelling of the name was probably changed from the German. My maternal grandfather's name was Sitler. My father's name was probably changed to Koons.

NR Probably from Kuhn, a good German name. Do you know what part of Germany they came from?

JK My father came from Leipzig, but I don't know if that's accurate as far as Kuhn goes.

NR It's a fairly common German name.

JK There are Koonses living out in Ohio.

NR Can I ask you something? My mother is dead, but your mother is still alive. How much have you learned from her? Do you still ask her questions? My biggest regret now is how many questions remain unanswered. My parents were quite old when I was born, so they died when I was relatively young. When you are young, you don't really want to talk to your parents about these things, but when you reach a certain age you do, so I can only recommend that you ask your mother as much as possible about where they came from and who they were, because I didn't, and I have terrible regrets in that department.

JK Yes, I have a very good relationship with my mother, and we are close. This weekend she will be coming to visit us.

NR What do you talk about?

JK We talk about family and about the children Justine and I have. I own my grandfather's farm, where my mother grew up, so a lot of the family history is there. That's where we'll be spending time this weekend. The political side of my being comes from my mother's side. My mother's

father was a politician – a city treasurer in York, Pennsylvania, which was where the first meeting of the Continental Congress ever took place. So there's a historical aspect, and through my grandmother I picked up an interest in politics.

NR I always like serendipity, and when we came in this morning, we looked at that photograph of your parents, which is very good. So perhaps we can talk about your parents, your childhood and maybe your first memories. Do you need to bring the photograph?

JK No, I know it very well. It's a photograph of my mother and father, and it was shot in York, Pennsylvania. I was born in York, but we moved to Dover, 7 miles [11 kilometres] outside the centre of York, when I was five. I was probably around 22 when it was taken. When the photographer took the shot, they thought at the time that it would be interesting to make it look like an oil painting, so they stained the photograph.

NR Touching it up.

JK Yes, they stained the photograph and it made it three-dimensional and gave it atmosphere, but over time it changed colour and the faces of my parents became very faded, glowing orange – very distracting.

NR It all went brown?

JK Yes, everything went terrible, shifting in colour. My parents had it rephotographed and somebody tried to correct it. They cut out the background, and they did something else to it. That didn't last very long, and it became very faded. I received an early original photograph of the piece.

NR Taken from the negative?

JK No, we didn't have the negative. We had an early photograph of it, but that had also shifted in colour because of some treatment they did. I had Rob Kahn in Los Angeles work on it to try to remove that. It was somewhat successful. We started working on it probably about eight years ago, and I would work on it a little bit and then put it away because I had my other art work. We've really finished it now, and we're going to frame it up this week and send it back to my mother. But to get back to your question, my parents were always very, very supportive. I miss my father. He passed away in 1994. He was a very open person, very engaged with people. He loved people.

NR Did he like you being an artist, or did he object?

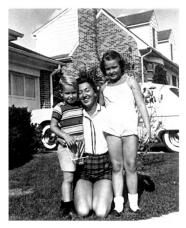

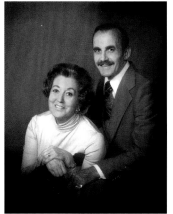

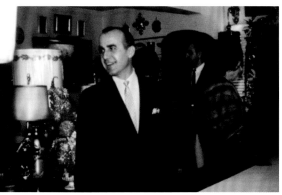

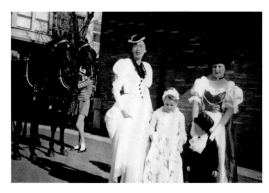

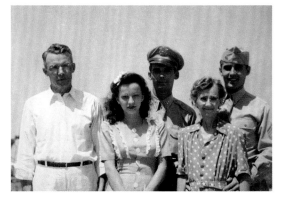

top row, left to right

Jeff Koons with his mother Gloria and sister Karen, 1958

Jeff Koons's parents, Gloria and Henry, photographed in York, Pennsylvania, 1977

Jeff's maternal grandparents, Ralph B and Nell I (Dabler) Sitler in their store in York, Pennsylvania, early 1960s

middle row, left to right

Jeff Koons's father Henry in his store, Henry J Koons Decorators, York, Pennsylvania, 1966

Jeff Koons's paternal grandfather, Clayton Koons, beside Jeff's uncle Gordon (his father's fraternal twin brother) with his wife Lou, and his father Henry with his paternal grandmother Carrie Koons, c 1942

bottom row, left to right

Jeff with his mother Gloria, sister Karen and grandmother Nell during the York Colonial Day Parade, York, Pennsylvania, 1958

The city treasurer election campaign card for Jeff Koons's grandfather, Ralph B Sitler, 1939

JK No, he never objected, and never once said, 'Jeff, you should do something else'.

NR 'You should go and work in a bank.'

JK No, my dad lived an aesthetic life. He was a perfectionist, so I learned from my father about really caring for something with seriousness.

NR Are you doing what your father might have liked to do himself? Would he have wanted to be you, or would he have liked to have been an artist? You knew him well. Did you ask him?

JK I think my dad was very proud of me, and he enjoyed my success so much. I really have very fond memories of my father being at the planting of the *Puppy* [Arolsen Castle, Hesse, Germany, 1992]. You know, my dad was with me through all that time.

NR Then you became a successful world figure – a successful artist. But I want to talk for the moment about when you were a boy.

JK My father was an interior decorator then, and he had a furniture store. I would work with my father on weekends, and if they were hanging drapery or delivering furniture, I would unpack the furniture and go with my father to deliver it.

NR How big was his shop?

JK His shop wasn't that large, probably a maximum of 2,500 square feet [230 square metres]. But within York my father was known as really the best decorator there, somebody who was sensitive and had aesthetics. My father was very aesthetic.

NR What did his father do?

JK My father's father drove the trolley in York, the public transportation, and it turns out, when we moved outside York to Dover, his trolley used to go right past our house.

NR What we in Britain call a tram.

JK My grandfather, my father's father, was known for being a really nice person. People interacted with him every day when he was driving the trolley. He was a very handsome man and people really liked him – my father was very, very sociable. I never heard anyone say anything negative about him; he was just really an optimist.

NR Do you have lots of photograph albums with pictures of your grandparents?

overleaf
Puppy [1992].
Arolsen Castle, Hesse, Germany, 1992

JK Yes, on my father's side. My father's mother, Carrie, died when my father was in the services. She died quite young.

NR In the First World War?

JK In the Second World War. My father was in the military police, stationed in Paris. During the war his mother died, and so we ended up seeing more of my mother's side of the family just because my dad's mother had passed away.

NR And your mother, what did she give you particularly? Did she also encourage your interest in art?

JK I think my mother had a more practical side. Her father was a politician – my grandfather – but I think my mother was trying to direct me more maybe to being an architect or something in that line. She was never really opposed to my being an artist, but there was more of this practical side of her. But my parents were just supportive. I started taking drawing lessons. My father knew of a woman in York, an older woman who gave lessons on Saturday mornings.

NR In drawing?

JK In drawing and pastels. So another young friend of mine took lessons with me on Saturday mornings. We would draw vases of flowers. Then I studied with another woman, a Mrs Amies, who actually painted a mural for my grandfather's house. She was very nice, a very good teacher to young artists and students.

NR Were the Amies a cultured, middle-class family?

JK Yes, in very loose terms, I think. You know, at that time when I was younger my relationship with art was really like a reward system. When I could do something well I would get a pat on the back, especially from my parents when I could do something a little better than my sister. It wasn't until I got into college and studied Manet that I realised that art was much vaster than any type of reward system.

NR Did you go to museums with your family?

JK I grew up about 90 miles [140 kilometres] from Philly, but I had an aunt who lived there. So we would go and visit my aunt maybe three times a year, and sometimes we would all visit the Philadelphia Museum of Art.

NR When did you first go to the Philadelphia Museum?

JK I believe my aunt took me to the museum probably around nine. I'm going to guess it was around that time.

N R What do you remember seeing there?

J K I can't say specifically what I saw, but I felt that she was opening me up to cultural life, and also an idea of openness – this idea of connecting, making connections and getting a sense of a vaster community. That's really what the art represented to me then: a vaster community of people and a dialogue to be involved in, as well as a historical presence.

What I also recall vividly from that trip is going up into the City Hall. On the top of its tower is a sculpture of William Penn by Calder's grandfather, who was also a famous sculptor. I remember experiencing that sculpture and the power of that experience. The observation desk is just below the sculpture and that also had a strong sense of power. It's constructed as fantasy architecture – the way the portholes are constructed makes me think of fantasy adventure films like *Journey to the Center of the Earth* [1959].

N R Did you go and hear the Philadelphia Orchestra or anything like that?

J K No. But I would say that my family – my father – was very generous with what he had, and I always felt we were participating in social mobility.

N R In an upward way?

J K Absolutely. We would take better vacations, and we would always do things together as a family, and there was always a sense of upward mobility, in that there was a better future. It wasn't that the future was getting darker.

N R Did your parents have lots of friends?

J K Absolutely.

N R In York?

J K Yes, and we were always close with the family.

N R How did you spend Christmas, for example? Was it a big affair?

J K We always stayed together as a family with our grandparents, and our aunts and uncles would all come and visit, or we would go and visit them. We always took a lot of vacations together as a family. We would always get in the car and drive to places like Florida.

N R You've said to me how you remember the praise you received as a three-year-old for your drawings. Was there a work in later childhood that you were especially proud of?

JK When I think of my first sculptures, I think back to trying to make a swan in ceramic [overleaf].

NR Beautiful.

JK It would have been fourth or fifth grade. I was probably about nine, and I made sculptures. I made things out of popsicle sticks, but I also remember working on this clay swan and trying to get the neck correct, and I felt that I had failed. I wanted it to be perfect, I wanted the body to have symmetry. I still have that little piece. It's a little funky. But when I made a swan just recently [*Balloon Swan*, 2004–11], I spent probably a year and a half trying to shape the neck of this swan on the computer. I was dealing with the same issues of striving to have something correct – I still wanted to have that neck just right.

NR At the age of nine you cannot have been aware of subjects like Leda and the Swan and the kind of symbolism they possess, but did you already sense the sexuality of the swan?

JK I wouldn't have known consciously about that at that time. But you are informed throughout your life about what these kinds of images mean – these symbols – and even when you are young you do pick up on them. Just looking at a swan there is that sense of grace. This is a picture of my original swan, and here is my new swan.

NR It's good, really good. I would have given you a prize for that if I had been on one of those school art prize panels! It's wonderful, and it's an intimation of what you are going to be, don't you think? We read backwards, of course. I mean, the child is father of the man.

JK For me today I can look at this new swan and say it's about sexual harmony. I really had an epiphany when I looked at it for the first time on a computer and I saw it two-dimensionally. Just how phallic it is, and the testicle shapes become breasts when you come to the side of it, so there is sexual harmony.

NR It's wonderful. Is it being produced in Germany?

JK Yes. They are still welding it.

NR Very Ludwigian. King Ludwig, your famous King Ludwig, loved the idea of the swan. Do you know the story about the swan and Lohengrin?

JK Absolutely. I even was making a swan for the 'Made in Heaven' show [1991]. I had a huge model made of the swan, and then I trashed it. I didn't go there.

NR What is the first work of art that you specifically remember? I can remember the first painting that made an impact on me. I saw it in Kenwood

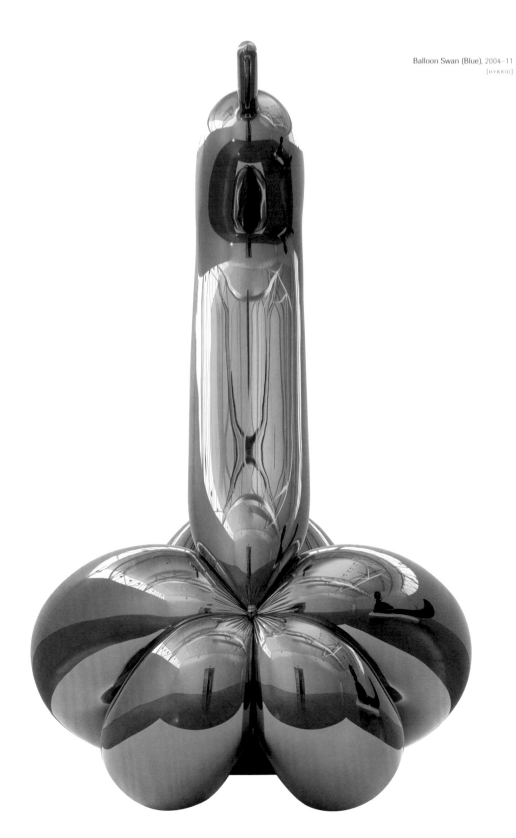

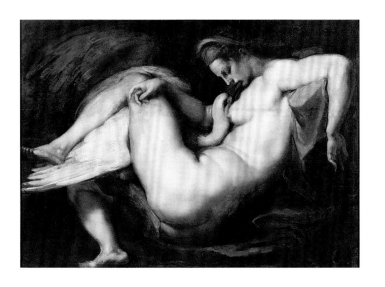

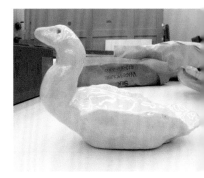

Peter Paul Rubens,
Leda and the Swan, c 17th century
Private collection

Swan, early ceramic work by Jeff Koons, c 1963

Thomas Gainsborough,
Mary Countess Howe, c 1760
Iveagh Bequest, Kenwood House, London

Thomas Lawrence,
The Calmady Children, 1823
Metropolitan Museum of Art, New York

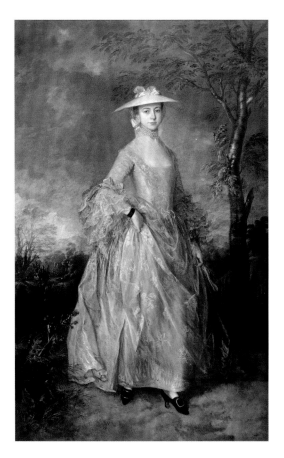

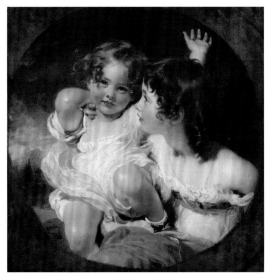

House in London – a Gainsborough, a beautiful painting of the *Countess Howe* [*c* 1760] that I should show you. It's very Koonsian, this beautiful woman in a fantastic pink dress walking through a landscape – I would imagine what was up her skirts. That was the first painting I ever fell in love with and it haunts me to this day. Do you have a first work of art that you can identify?

> JK In the home where I grew up until I was four, above the fireplace mantel was a reproduction of a painting of two young girls. It's *The Calmady Children* [1823] from the collection of the Metropolitan Museum. It's a British painting by Thomas Lawrence. It has these two very, very sweet, rosy-cheeked children wearing lacy dresses, and it's circular.

NR Like a tondo.

> JK I remember there were these two French-looking prints in my parents' bedroom – one of a man looking through a window, another of a woman getting dressed. My mother still has these prints.

NR But were these works significant for you? What was your first important experience of another artist's work?

> JK It would be Dalí, the coffee table book of his work with the gold reflective surface and *The Persistence of Memory* [1931] on the cover. I was given that by my parents one Christmas. We had *Time* magazine and *Life* magazine, and there were one or two articles on art in *Life* magazine.

NR Did you look at Norman Rockwell's works in *Life* magazine? Did you admire those, or did you not take them in as artworks?

> JK It wasn't something that I aspired to. It was interesting. I saw craft and I saw draughtsmanship, but there was something else about Dalí.

NR Did you actually read the Dalí book very carefully, and find out about his life and Surrealism?

> JK Sure. Absolutely.

NR Did you get a sense of what was behind Dalí? Behind Dalí, of course, there is a huge amount of complex apparatus.

> JK I would say that as a young person I would just read these books and take in everything that was written there. But even to this day, some of those images are really amazing. If you look at the Dalí painting of *The Sacrament of the Last Supper* [1955], there's this very beautiful Christ standing there, and you see through to his chest.

N R Not to mention the *Crucifixion* in Glasgow [*Christ of Saint John of the Cross,* 1951].

> J K All these techniques we still do today. Take visual gradations, or how we break down images, how we play with images: it all comes through Dalí and Magritte. And we take those techniques for granted. A lot of people don't know where things come from.

N R You met Dalí, didn't you?

> J K Yes, I met him when I was about 18 years old.

N R You actually went up to him, I think?

> J K My mother knew how much I enjoyed Dalí, and she was looking to get me a print of Dalí. So I guess she contacted the museum in Cleveland, and they informed her that Dalí was staying at the St Regis Hotel in New York. So my mother gave me the number and I called, and they put me through to Dalí, and he said, 'I'm here – come and visit me'. So I arranged to go on a Saturday morning, and he told me he would meet me in the lobby at 12 o'clock. I came to 54th Street and I was in the lobby at the St Regis at 12 o'clock, and sure enough Dalí was standing there, and he came over. Was it Philippe Halsman who photographed Dalí a lot?

N R Yes.

> J K Well, I recently read something that Halsman's daughter said about Dalí, and it was so true. She said that he always dressed as though he was at the most important event. And sure enough, meeting me there in the lobby he was dressed with a tie – he had on a fur coat, and a tie with diamond pins coming through it.

N R And his moustache, of course, absolutely as it should be.

> J K It was so wonderful. It's as though he treated every moment of life as so special.

N R It must have been a very special moment for you. So what did you say to him?

> J K Well, I told him that I was so honoured to meet him and thanked him for meeting me.

N R Were you frightened at that moment?

> J K Of course, I was very scared. I was just a young kid meeting Dalí. Dalí at the time was in his 60s. He was probably about 66, I would think, or about that age.

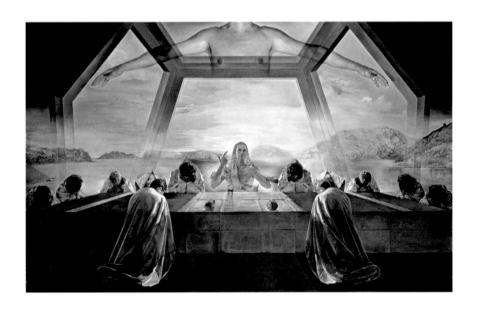

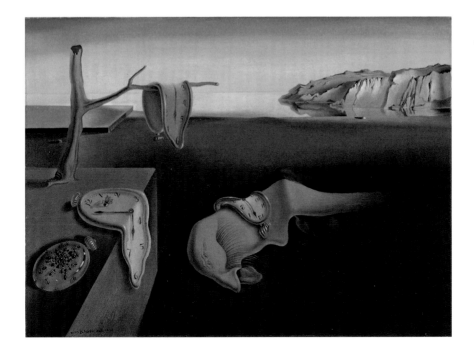

Salvador Dalí
The Sacrament of the Last Supper, 1955
National Gallery of Art, Washington DC

Salvador Dalí
The Persistence of Memory, 1931
Museum of Modern Art, New York

Salvador Dalí
Le Petit Tigre Hallucinogène or 50 peintures abstraites qui, vues de
trois mètres, se transforment en trois félins déguisés en chinois, et
vues de neuf mètres apparaît le tête d'un tigre royal, 1963
Koons Collection

Salvador Dalí poses for a young Jeff Koons,
Knoedler Gallery, New York, 1973

N R Perhaps a little older? Possibly 70?

> J K Possibly. But he was still in very good health. He wasn't
> deteriorating through any type of illness or problems physically. But he
> met me, and he said that he had an exhibition at the Knoedler Gallery,
> and asked if I would like to go up there. I said that I would, and he said
> that he would meet me there. So I went up to the Knoedler Gallery, and
> he was there, and there was a young French woman at the gallery that
> he went around the exhibition with, and they were talking.

N R In French?

> J K In French. And he came up to me and asked me if I wanted to take
> some photographs because I had my camera there, and I said I would
> love to. So we went in front of this painting, which was the head of a tiger
> [*Le Petit Tigre Hallucinogène*, 1963]. So I have my camera, and I'm there
> juggling it around trying to take this photograph, and he's sure that his
> moustache is just perfect for me, and he tells me, 'Come on kid. I can't
> hold this pose forever'. So that was kind of nice. I can show you the
> photograph.

N R Were you photographed together?

> J K Yes. And I just have one or two other photographs of him in
> the Knoedler. But I bought a study of that painting.

N R More recently?

> J K Yes, about five or six years ago. He made about two studies for
> the painting in gouache.

N R What a beautiful day – rather like my meeting with Stravinsky when
I was 14. It's wonderful to touch people from another generation, don't you
think?

> J K Absolutely.

N R I think it's *incredibly* important – I remember the physical touching
of two or three artists when I was young. One was Chagall, another was
Stravinsky, and actually to meet them in person was very transforming.

> J K It's interesting you say that about touch, because that brings
> to mind actually shaking the hand, touching.

N R Yes, you feel you are in touch with a whole world that in a way is more
or less lost.

> J K But also what I am really grateful for, Norman, is his generosity.

N R Of course. He didn't need to see a young boy of 18. He must have been

very flattered at your courage at ringing him up, and he was probably very delighted, because I'm sure, when he was young, he had done that to other people. Because remember, he was also a young kid once, in the days of the 1920s and '30s in Madrid, with the great Lorca and Buñuel and his other friends.

> JK I was at school at that time at the Maryland Institute of Art, just starting out there, and I thought that evening as I went back there that this was really the way of life that I wanted – to participate, to just think about art all the time, to be an artist. That's the only thing I wanted to do with my life.

NR So you had finished school and then you had decided you would go to the Maryland Institute of Art?

> JK I wasn't prepared for anything else. I had spent all my time in art class.

NR You weren't interested in sport, for example?

> JK No. I liked to play basketball a bit, but I was never on the school team or anything. I started to have more curiosity when I was probably in the tenth grade, about 15 years of age, and I started to think about things in a more philosophical way. I had a liberal arts background, but I really wasn't prepared for going to college to be a doctor or a lawyer. I never had ambitions or needs, financial needs. I always knew I could take care of myself and things would automatically just come.

NR You were never a burden on your parents after 18? You were never a financial burden?

> JK I would send money home even when I worked at the Museum of Modern Art, even on a minimal salary. My father had a heart condition, and I would send money just so that somebody could come in and maybe mow the yard. I didn't care. Even when I was making my works like the 'The New' and was absolutely broke and had to leave and go home and live with my parents, my parents were very supportive. My father would help me with the local job that I had then, working to get signatures for somebody's campaign. It was a campaign for property tax relief and I was able to get a quarter for every signature.

NR That was a lot of money in those days.

> JK Yes. I would get paid per signature and my dad would just come out and help me.

NR Tell me about art school. Did you enjoy being surrounded by other art students? Were you social with them?

Hulk Elvis Monkey Train Swish (Blue),
2008
[HULK ELVIS]

JK Yes, I was social. I enjoyed going to parties and events. I enjoyed being social because it was nice being able to interact with people who shared my interests. I wasn't a loner, but I still spent a lot of time making my works, working on my art. I'd be social on the weekends.

NR And were there any other established artists you met at that time? Was Dalí the only one?

JK When I went to Maryland and then the Art Institute of Chicago, different visiting artists would come. Fairfield Porter was one. I remember that I enjoyed his lecture and seeing his work.

NR When you look at that flower up there, do you think there is something of Fairfield Porter buried in a painting such as that? .

JK I would say there are aspects of Fairfield Porter. I'm trying to think of which other artists I met. There was Grace Hartigan, who also taught at the Maryland Institute. Sal Scarpitta was also a teacher of mine. He was an artist who showed with Leo Castelli. He's known more for his works out of pieces of canvas, but he made a race car for Leo Castelli. He ended up in later life being a racer on dirt tracks.

NR What were you doing then as a human being, as a creative person, along with lots of other artists?

JK I was making works that were very personal, from things that I had dreamt about the night before. I was influenced a lot by Jung, and I was making things that were archetypal and I was really trying to go inward.

NR Do you have any of these pieces still?

JK I have images of them.

NR Have you ever published them? Would you publish them, or would you rather not?

JK It's student work, but I've shown some already. I've published some. I don't mind showing some. I'm not embarrassed by them.

NR I don't think you're embarrassed by your life in any way at all.

JK When I was in college I made a pastel drawing of a dolphin. I just want to show you this photograph of it.

NR You made this in college? Wow! Look at that.

JK You see how the dolphin's sliced there.

NR Don't you love the figure, this crazy figure astride the dolphin?

JK It's very subjective art. I mean, in the way of Dada, Surrealism.

Early works by Jeff Koons from his art school days

Untitled, 1974
Untitled, 1974
Woman with Head, 1974

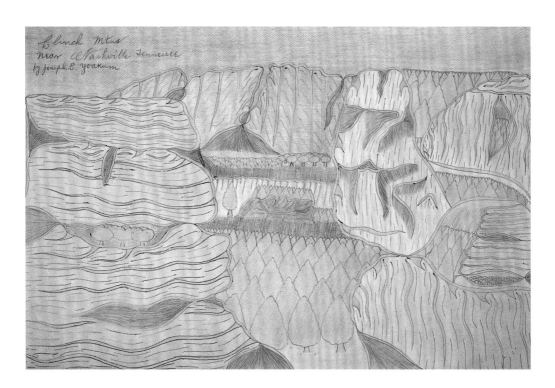

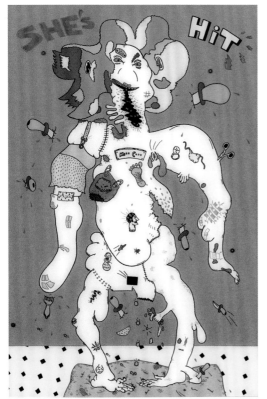

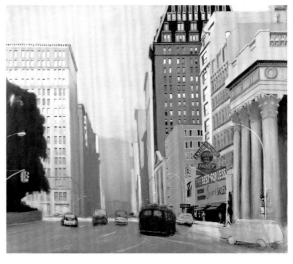

Joseph Yoakum,
Clinch Mtns Near Nashville, Tennessee, undated
Koons Collection

Jim Nutt,
She's Hit, 1967
Whitney Museum of American Art, New York

Fairfield Porter,
Union Square, Looking up Park Avenue, 1975
Metropolitan Museum of Art, New York

NR It may be subjective art, but it has again rather amazing intimations of
what you were to become. And the sense of time is also very much there –
your interest in history.

JK The way the dolphin is sliced like that makes some reference
to castration, but at the same time the dolphin has this sexual quality.

NR How old were you when you made this?

JK I would have been 18 or 19, because I went to art school when
I was 17. That would have been in the second year, maybe the third year.
But I won a prize for it.

NR How big is the pastel?

JK I would say that it was about 8 x 6 feet [3 x 2 metres] or so.

NR It's interesting to know roughly how big a thing is to gauge its impact.
That's a big painting for a student. And that was a painted work?

JK Pastel.

NR It's an incredible composition and full of originality, and I love the woman
on the lower side.

JK I did something similar, a drawing of a woman with a head
in her lap [*Woman with Head,* 1974], in my first year at art school.
It's a similar type of woman and it's like a kind of Cubist head
of St John the Baptist, but I always liked it.

NR Of course, these women sort of reference artists like Picasso and
maybe even Gorky.

JK Yes, but they're still a little cartoony too. These works are more
the subjective work of my past. Since then I've tried to make works with
which I have a dialogue with my audience to a certain degree. You can
create heightened sensations or experiences, and then you start to go
outward. Your vocabularies become more externalised, connecting with
other artists and making references to other artists and art history or
philosophy.

NR I can see that at your age now, Jeff, you read these early works as
somehow subjective. But when you made them, did they feel subjective, or
were they really quite objective in terms of how you were at that time?

JK I felt that they were subjective. There was a self-referential
experience then, feeling certain intensities about things. I was looking
at other art and I was being influenced by other art, but it was still about
self-discovery.

NR Can you withdraw entirely from subjectivity? Can a man or woman
withdraw entirely from subjectivity? I would think it's impossible.

> JK No, it's impossible. It's like trying to remove narrative. If you try
> to remove narrative, you end up with a greater narrative.

NR Why did you decide to go to Chicago?

> JK When I was still at Maryland, I saw [the Chicago Imagist] Jim Nutt's
> work at the Whitney Museum in a retrospective and I was absolutely
> blown away by it. It was very, very powerful Pop, like parallel Pop, with
> very strong imagery. I immediately learned all about the Chicago Imagists
> and that Jim Nutt was also working with people like Ed Paschke, Karl
> Wirsum and Gladys Nilsson.

NR Did you like the Chicago aesthetic of painting with acrylic, slightly
hallucinogenic colours, DayGlo colours? I don't think you've actually used
those yourself have you?

> JK No, their colours are very bright.

NR You can see them in the dark.

> JK That rabbit we looked at [*Balloon Rabbit (Violet)*, 2005–10] – that
> violet colour is pretty bright. I've worked with bright 'Pop-y' imagery and
> I enjoy that in Nutt's work. I'm very moved because somebody like him,
> who is a great artist, was looking at Titian and looking at everybody else,
> and at the same time looking at naïve work. Joseph Yoakum was
> a naïve artist who would draw landscapes that actually look like they're
> composed of figures, and he was a very big influence on Jim Nutt –
> you can see a lot of different references to or images of Yoakum
> within Nutt's work.

NR A Chicago guy?

> JK Yes, a Chicago guy – a black man from the south side of Chicago,
> black and Native American. He was a merchant marine and he would
> make drawings from his travels around the world. Whether the drawings
> really depict anything that he actually saw we don't know. I have a
> Yoakum in my collection [*Clinch Mtns Near Nashville, Tennessee*,
> undated] … here's an image of it. If you look, this is almost like a father
> figure – there are the eyes, you can pick out the nose. Then this would
> be like a young boy – there's the head, the eyes.

NR A strange world.

> JK Yes, Surrealism. The Chicago Imagists had a teacher at the Art
> Institute of Chicago called Whitney Halstead, an art historian who had
> a huge influence on them and introduced them to Outsider Art. So that

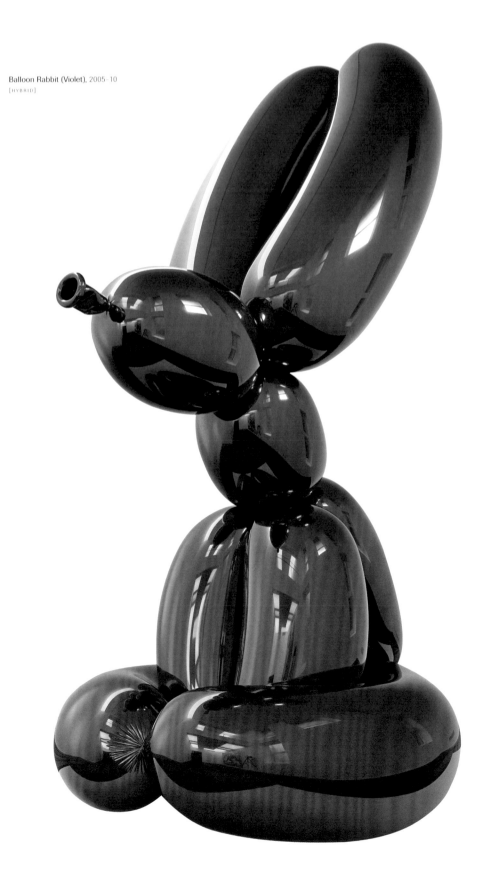

Balloon Rabbit (Violet), 2005–10
[HYBRID]

was one of the reasons I decided to go to the Art Institute – I transferred there for my last year of college. I am happy to say that I was able to study with Whitney Halstead and I think he had a big impact on me.

NR You also studied with Ed Paschke at the Art Institute of Chicago. What was it like with Ed Paschke, communicating with this very serious artist? Maybe he's not the greatest artist who ever lived, but he's certainly a very significant one. I thought that his show you curated recently at Larry's [Gagosian Gallery, New York, 2010] was absolutely wonderful.

JK On the first night in Chicago I went to a bar in the gallery district, in the basement of the building where the city's large galleries were, like the Phyllis Kind Gallery. It was this little bar called The Hourglass, and when I went in there was this guy – a very tall man, very lanky – who looked like everything I had heard about Ed Paschke, and I thought it had to be him. I went up and introduced myself and asked him if he was Ed and he said, 'Sure', and said immediately, 'Sit down, let's have a drink'.

NR How much older was he than you? Twenty years older than you?

JK I was born in 1955 and I think Ed was born in 1939. So he felt like a big brother in a way. Immediately we befriended each other. I told him that I would really love to be in his class. He said that he would try to help out, and he made that happen – I was able to get into that class. Then at one point Ed asked me if I wanted to be an assistant, as he needed somebody to help him stretch some canvases on weekends.

NR The classic thing.

JK So for a dollar an hour or something like that I would go and stretch Ed's canvases and he would talk to me, and it was fantastic. I really learned the politics of being an artist, being a real artist. He had a wife, Nancy, and two children, Marc and Sharon. His studio was above an old movie theatre, but at lunchtime we would go to his home and have lunch with his family, so I felt like a younger brother.

NR Can you remember one phrase he said to you?

JK Yes. Not to shoot myself in the foot.

NR That's a very Ed Paschke thing to say and kind of matches his paintings.

JK The whole thing was to be at the service of your art.

NR That's beautiful.

JK Many people are damaging to their own interests, you know – you have to try and be at the service of your interests. At that time I still had not come into my own. I was definitely ambitious; I was hungry for art. I

wanted to make powerful things, and Ed knew I wanted to make powerful things. Ed really helped to open up the idea of the ready-made and helped me to open myself up to the world.

I learned about Duchamp through Ed, but I also learned about the world around me, that if you're open to things you can find your source material all around you. We would go for walks, we would go out to bars and clubs, but Ed would also show me where to source materials from, or show me the way the light would hit on a certain curtain in a club, or point out the tattoo ads on the shop windows as he drove down a road. Ed showed me that everything is already here and it's just for you to open yourself up to it. Everything is already here. You just need to look at the world around you. You're not going to find something that's not here. Whatever your interests are, if you look for them you'll find them.

NR Let's talk about your first encounter with Duchamp.

JK If I think about how I came to Duchamp, I always think again that I came to his objective art platform of the ready-made through subjective art – enjoying people like Dalí, enjoying this journey inwards and dealing with personal iconography. Personal iconography is really the development of a vocabulary. You start to learn how to make yourself feel a certain way, or how the viewer can start to feel a certain way – you start to learn how to actually put things together so people can have not only an intellectual response, but also a physical one.

But I don't really recollect a consciousness of Duchamp when I was younger. I really learned about him indirectly through the Chicago Imagists and different people working with images from the real world. People would use the external world for their inspiration, and they would start to show me: 'Jeff, you know, for my paintings, I kind of look at this over here, I notice the shop window, I really like those objects.' And so eventually I started to appreciate the external world and would look outwards from this internal place that I had always felt art was, and I started to appreciate that looking outwards.

NR So your work started to change during this year?

JK I wanted to participate, and meeting Dalí while I was studying at Maryland gave me a sense that I could. But when I spent Saturday afternoons in Chicago listening to Ed, he would speak about what it was like to be an artist who balances making and exhibiting work with existing in the world. He had a family and he had to balance that with being ambitious, trying to get his work out there and trying to grow and develop new ideas. Ed helped show me that there was a course, there

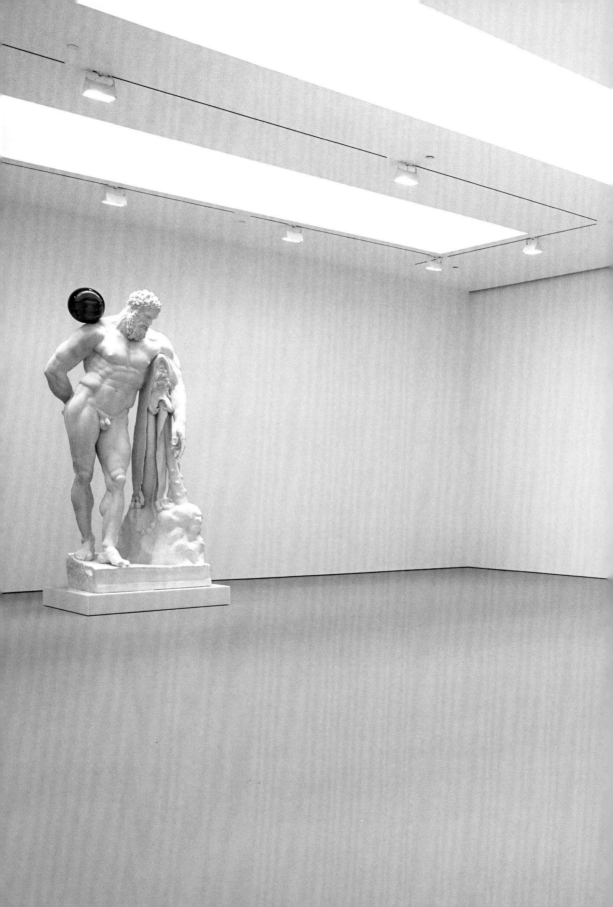

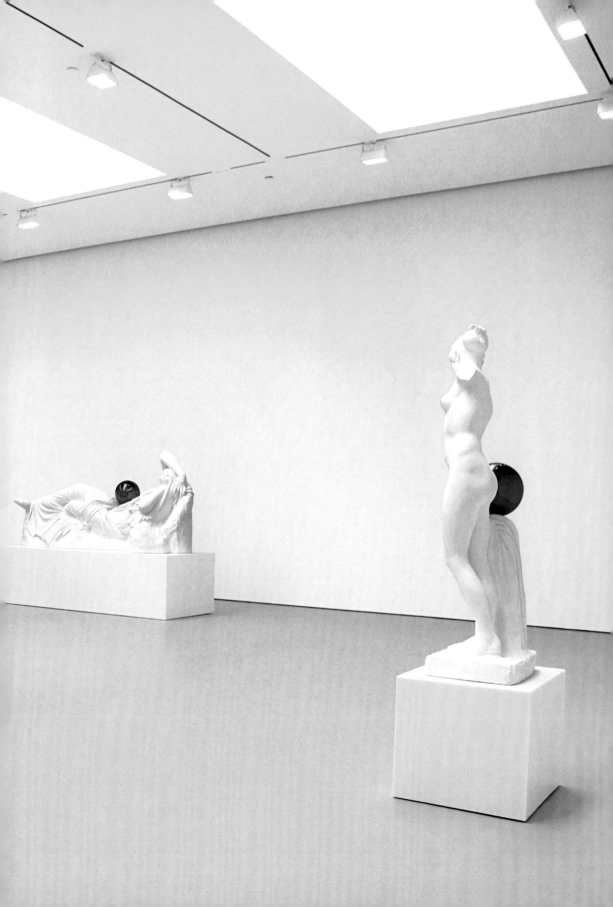

was a way.

N R There's a route.

 J K There's a reality. There's a road and there's a feeling attached to it, an emotional feeling that it's real and it's a way of life. I wanted to participate and Ed wanted to participate, and he helped show me how you do it: you don't say no to things, you try to say yes to things, you always try to keep your interests in play and try to help those interests flourish and have more opportunity.

N R Is there any difference then between art and life in that respect? Is this general wisdom to help everybody participate?

 J K I think it's general wisdom. The art part of it has a basis in feeling, and there's transcendence constantly, as well as a certain awareness or visualisation. In life it just becomes more ephemeral.

N R Does your family life ever give you ideas for art? Do you discuss art with your mother? Does she inspire you in any specific way or provoke you to make anything?

 J K My family has always inspired me through giving me opportunities and their support. When we were children, whatever our means were, we always took the most exciting vacations we could, and our parents always exposed us to things. I've always felt that my parents really tried to give me the best foundation they could. So you end up trying to do that for your own children. My mother has just sent me an incredible birthday gift.

N R What was that?

 J K She actually sent me a little gazing ball on a little stand – it's only about 6 inches [15 centimentres] diameter, and it's absolutely perfect.

N R I'm not sure what a gazing ball is.

 J K It's a reflective ball. There were blue, yellow, red and clear ones – when I say clear, they were silver. When I grew up, if you drove through Pennsylvania, people would put gazing balls in front of their houses. There's a kind of generosity about that. Your neighbour doesn't have to do that, but they do that for you, they do that for whoever drives by. At Easter time people would put inflatable rabbits outside too.

N R Rather like putting out the pumpkin at Halloween, which is a great American tradition.

 J K I think the gazing ball is tied to European history. I can look at it and I can think of Machiavelli, I can think of Dalí, I can think of the whole Christian tradition – all these types of references.

N R I would have said it's the super-American image.

JK Gazing balls are also about the joy of the senses. Their reflection deals with identity, but also excitement, affirmation and the possibility of going into a higher state.

NR So there's a metaphysical aspect?

JK The ball becomes everything. It becomes a universe.

NR A metaphor for a universe that is reflecting.

JK I've wanted to do a series with it for a long time. For years and years I've thought about the idea. I've done drawings for years and years.

NR And you've got the right ball now?

JK My mother just picked it up and sent it to me. It's perfect. I keep it in my bedroom.

NR Did she know she was giving you something that would maybe inspire you to do something?

JK My mother knew, because we just drove to a neighbourhood about four months ago, and I said, 'Mom, do you see this yard? Look, there's a blue gazing ball there and right across the street, a bit further, look there, there's the exact same ball. Do you think they are sisters?' And actually the two were identical, and I just felt somehow that they were family related. She remembered that and sent one to me.

NR So these are like accidents, but beautiful accidents. Do you think there are higher forces controlling our destinies?

JK No. I think there are higher forces, energies and things like that which can control destinies, but I don't believe in any being like ourselves controlling our destinies. I believe in nature, in the forces of nature. I believe in the genes.

NR You believe in the genes?

JK We are all composites of our parents, as everything we feel has been learned from them. Our true existence, everything we feel in this world, will really be distilled in our children and in their experience.

NR But how much of this distillation is nurture rather than nature, learned behaviour rather than genes?

JK It's a combination of both, but a lot is genes. I have also always felt that my grandparents had a huge impact on my life, even though my interaction was limited when it came to my father's parents. Their influence was very strong just through the genes. A lot of times when I think about my 'self' and who I am, I realise that I am not 'me', I am not Jeff. What I am experiencing is my parents – them, not me – and what my children are experiencing will be the closest thing to my experience.

My objects were just displaying themselves

INFLATABLES, THE NEW
AND THE PRE-NEW

NORMAN ROSENTHAL I think it's a good moment to begin to do a little bit of biography or autobiography through your work, because in the end it's not you that is interesting so much as your work. Would you agree with that?

JEFF KOONS Sure.

NR So if we look for example at the 'Inflatables' and the 'Pre-New' sculptures, which is where it begins, can you remember the moment of initial insight? Was there a moment when you were walking down a street and you suddenly saw something? Was there a 'Eureka!' moment? Do you remember that moment, if it existed? That's what I imagine, but maybe I'm wrong and there's a huge long-term philosophical basis behind these things. Maybe there's a whole complex thought process.

JK It's more complex. It's building over a time period. When I was younger I was very influenced by Dada and Surrealism, and I wanted to make work that was considered creative, to feel that I was bringing something to the table. At art school I was making works inspired by my dreams, but Norman, I became really bored with the idea of dealing with myself. I didn't want to deal with myself; I wanted to deal with the world outside. What I was experiencing in Chicago was still very centralised on itself, so I never thought when I was a younger artist that I wanted to be in New York – I wasn't really attracted to what I thought the art dialogue was in New York. But I came here because of the young generation of musicians and poets, like Patti Smith and Talking Heads.

NR Which year was this?

JK The very end of '76, beginning of '77. I got my apartment actually on the 1st of January '77.

NR Where was it?

JK When I first came here I was on Bond Street. I stayed with different people on Bond Street, but I lived all over the city. Coming here I connected with people out of school, people who were ambitious and people who really wanted to participate. And I was really thrilled to experience a city where people specialised in things. If you had an interest in inflatable flowers, there was an area in New York where they sold inflatables, where they had novelties. And if you were interested in Spanish culture and the colours and materials associated with that culture, you could go to a street in New York and find a lot of these objects.

NR And you couldn't in Chicago? Don't tell me that!

JK It's different. There was a sense of not being connected to Europe.

Inflatable Flower and Bunny
(Tall White, Pink Bunny), 1979
[INFLATABLES]

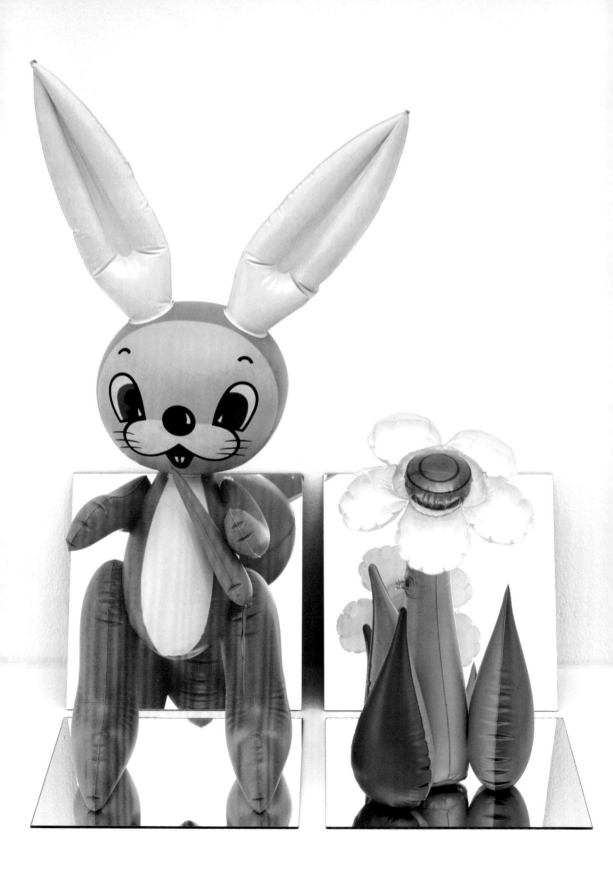

There was a sense of isolationism, of being landlocked. There wasn't this dialogue with European culture.

NR Would you agree that this early inflatable flower [*Inflatable Flower (Tall Yellow)*, 1979] seems like the most non-European object you could possibly have made at that time? Even the flower itself is from the world of American kitsch, which you've now somehow relativised. But that's another question.

JK You know, if I think about it, I really believed that I was dealing with my own cultural history. When I grew up in Pennsylvania, at Easter time people would put inflatable rabbits outside.

NR But then suddenly you have this kind of image, the inflatable flower and the pink bunny [*Inflatable Flower and Bunny (Tall White, Pink Bunny)*, 1979]. These inflatables go right down to the recent series that you were showing at the Serpentine Gallery.

JK The 'Popeye' series.

NR Yes, the 'Popeye' series. There's a relationship between these and the 'Popeye' series, wouldn't you say?

JK Absolutely. And the tanks and the sculptures.

NR The tanks are slightly different because they are a little bit more Minimalist. They seem to have another ethos, but you could put this flower next to the 'Popeye' and the rabbit.

JK When I moved to New York, I got more involved with artists who had really more of a European base and a European understanding of art, and they would speak much more directly about Duchamp and Duchampian ideas of the ready-made. Of course, I knew about Duchamp when I was at art school and knew about the urinal.

NR Of course.

JK But I saw that my activity was different.

NR Did you buy your own ready-mades? Did you pass funny little tchotchkes and buy them?

JK Yes, I would buy them. I would be very moved when I walked down the streets and saw something, and so I would acquire it for my work and make something. I got so excited. It's really hard to calm down from the experience of putting things together. It can be a very intense experience.

NR The business of transforming these objects into your work – how did that take place?

JK I would maybe transform things into different materials, but early on I would acquire things and let them just display themselves.

Chainlink [2003],
Sonnabend Gallery, New York, 2003
[POPEYE]

N R You would let them display themselves?

JK Because my father had a furniture store, I was brought up around objects and brought up to think about how objects make you feel. These objects were just being displayed, and going into my dad's showroom, I would see that things are just what they are. So my objects were just displaying themselves, just on display. At the same time I was dealing with my own sexuality, and if you look at the colours of the inflatables and the reflective aspect of the mirrors, there's a kind of heightened sense of sexuality. But I soon wanted to remove my own subjectivity, remove that type of sexuality.

N R What do you mean by sexuality and the subjective?

JK What is the subjective? The subjective is really about the self, and the most important thing about life is to procreate and believe that you are going to continue. So displaying these things as objects in themselves is a dialogue about removing that self-desire in a way. It is about almost the moral aspect of the self. The sexual aspect is highlighted, but my own self-interest is being removed for a more objective purpose.

N R Do you think making art is a kind of sexual act too?

JK Absolutely.

N R The idea of breathing is an important thing in these pieces, is it not?

JK I think so. They're anthropomorphic, because we are inflatables.

N R You mean human beings?

JK As human beings, we can take a deep breath. That's a symbol of optimism and potential, and if we exhale we deflate ourselves. It's also like our last breath – it's really a symbol of death and by working with an inflatable object, you start to deal with aspects of the eternal, something after life. Art itself always wants to get on top of life's energy, to be life's energy or surpass it.

But there's another phenomenon that happens when you look at an inflatable. In a human being there's density: we have brains, we have blood, we have organs. If you think about the outside world it's very vacuous, there's nothing there, there's empty space. But if you look at an inflatable, all of a sudden its internal space seems empty, even more vacuous than the space around it. Even though it's a mild change in density gradient, it gives the viewer a more secure view that the world – this vacuous space around them – is a little denser. The inside and the outside become more merged, and this gives the viewer a sense of security to feel more open about investigating the external world.

N R What are these pieces made out of?

 J K These were store bought. Everything was store bought.

N R Were they just found objects?

 J K I went to hardware stores. I would buy 12 x 12 inch [30 x 30 centimetres] mirrors.

N R The inflatables were what they were, and you put them on the mirror, gave them the mirror background.

 J K Minimalist art helped me make a transition. I wanted to be dealing with things that were not so subjective, not about the self, but about the world around me and other people. Minimalism was more of an objective-type art. Robert Smithson's works with mirrors had a big impact, because of their use of reflection. I wanted to connect to a more communal type of identity and believe in that identity, and I think aspects of its affirmation came in through reflection. I always loved reflection, from when I grew up with shiny objects such as mirrors and lamps in my father's store.

N R I suppose we are also talking about Carl Andre and Dan Flavin.

 J K I was coming across their work, and work by lots of other people – Donald Judd, Robert Irwin, Robert Morris. It was what Ileana Sonnabend was showing, what Leo Castelli was showing. I remember seeing Robert Morris's work at Leo's gallery. He was making some copper pieces and they were really about fabrication in a lot of ways – very impressive. So I stopped painting. I had always been a painter.

N R That's interesting to me. Up to then you basically painted.

 J K Here's an image of *I Told You Once, I Told You Twice* [*c* 1977], which I created in New York. I was always painting, and then I made this one work and it got so large. You can see all the influences and it was the first time I had worked with inflatables and it's porcelain there – a porcelain woman, a porcelain figure. It's not a very nice painting. It was not a painting to look at, but for me I knew I was going to a different level. Something was shifting in me. Because I got to a point when I would be walking in the hall of the Chicago Art Institute and all of a sudden I felt I was going to fall over and my legs were just going to give out.

N R I know that feeling.

 J K So my works started to incorporate ready-made objects. I bought inflatables and besides those I bought little porcelain figures, and then I started to become more minimal. I started to strip out all the things and

I Told You Once, I Told You Twice,
c 1977

Robert Smithson,
'Mirror/Salt Works' installation view,
The Renaissance Society, University
of Chicago, 1976

ended up just leaving the inflatables there, and then I just have mirrors there, which is affirming to the viewer that when you look at it, depending where you are and as soon as you move, it's informing that it's all inside you. This is an external thing, but the art is happening inside you.

N R Were you ever interested in the world of videos?

J K I was more interested in narrative work, work that Bill Lundberg made, which was really film projection, and the first video film projections of James Carpenter.

N R Did you come across Peter Campus's work?

J K I like Peter's work.

N R Was that never a way forward for you? For example, to the best of my knowledge, you've never made an art film and you've never used video in your work, which is quite surprising actually.

J K I've directed photographs and other things, but I've always felt intimidated by certain aspects of it. I know that when you make a film you hire somebody who's a lighting technician, but I've always felt intimidated by the medium itself. And I've always felt very challenged by the media I am dealing with. If I had a desire to work in film I would be doing that, directing a film, but I never felt comfortable.

N R But you don't seem to be intimidated by technical difficulties. On the contrary, you seem to absolutely persist to the nth degree to get over every possible problem. What I call your 'technical' innovations. This goes back a long way, to your dialogues with scientists for your basketball tanks [1985]. You want to be able to find out how to make things, not only in the most efficient way, but also in the most extraordinary way and in the most up-to-date way.

J K Part of my choice of medium has to do with technical aspects, and the other part has to do with the kind of narrative that I work with, which is a very intuitive narrative. It's not a prolonged narrative; it's a gestalt narrative, which is really dealing more with an archetype. And it's the timing of an idea too.

N R How do you choose your gestalt? How do you choose your archetype? Why the inflatable flower? Why did that become a gestalt? You could have chosen anything. Is this buried in your subconscious, buried in your past?

J K Buried in my being.

N R You know, I am not the analyst to pull it out of you, but maybe I would love to be. I would love to be your analyst. Have you ever actually tried analysis?

JK I think about my work.

NR Do you think about yourself?

JK I think about myself. I am aware of myself, but not in any really analytical way. I am aware that I would like to live to my potential. I would like to try to exercise my opportunity to be an artist. I would like to make the gestures I would like to make, but I'm not sitting down and thinking about what happened to me at this age or that age, or the implications of that. I had my handwriting analysed by the person who dealt with Oswald's writing after the Kennedy assassination. They analysed my signature and basically said that I was somebody who was looking for freedom and expression.

NR Handwriting never changes: it's a bit like your fingerprint. It's always there.

JK There's a biological aspect. When I say a biological aspect, I believe I choose these things because of who I am and probably who my grandparents were, and who their parents were and on and on.

NR Do you remember the moment when you found this inflatable flower?

JK I remember I was working at the Museum of Modern Art.

NR Already?

JK Yes. As soon as I moved to New York, that was my first job. I went there every day asking them for a job, and finally they gave me one.

NR Until they got fed up with you!

JK You know, you don't need a lot of time to actually execute your work. The time is to think about it, to have the ideas. As a young artist, you have very limited time. You have your job, you have your social life, you're interacting with other artists. I remember the intensity of walking down the street on a Saturday morning – having ideas, dealing with my work, putting things together. It was very, very physically intense.

NR These Polaroid photographs show more early works?

JK Yes, I would just make little set-ups of these flowers in my apartment.

NR And in this photograph you have this kind of amazing uniform that you invented for yourself too. This is you at the Museum of Modern Art?

JK No. That's in my apartment. You can see still this remnant of me coming out of a Chicago, out of a very kind of decorative environment.

NR This is positively an Ed Paschke waistcoat, isn't it? It's worthy of Ed Paschke.

Three Polaroids by Jeff Koons with
arrangements of inflatable flowers
and mirrors on his apartment floor, New York, 1979

Jeff Koons in his apartment
in East 4th Street, New York, *c* 1978

JK But can I tell you what I'm wearing there? I have a paper vest on, but I have a bouquet of flowers that I would have bought on 14th Street. And decades later I end up making tulips – you know the tulips, the metal tulips [*Tulips*, 1995–2004].

NR Did you have a girlfriend at the time?

JK Yes.

NR What did she think? Did she think you were completely mad? You look fairly cuckoo there, for want of a better expression. Off the wall.

JK That's how I would go to work.

NR What did they say at the Museum of Modern Art when they saw you? Did they think you were like a walking artwork?

JK I think that they probably saw me as a bit of a performance, but at the time Bill Rubin found me a little bit of an embarrassment.

NR Really? I can imagine that. I knew him quite well. He was very serious about the great tradition, and he really felt that after Frank Stella there was no art. So what did he say to you? What is your memory of Bill Rubin?

JK Well, I didn't really interact with him personally. He would come up to the information desk sometimes and tell us that somebody was coming and to expect them. But I appreciated his exhibitions. His Cézanne exhibition was absolutely incredible.

NR Yes, it was fantastic.

JK So I am very grateful for those exhibitions.

NR Everybody was.

JK But I remember one time when they also brought Kurt Varnedoe in, and they gave him the position of chief curator of painting and sculpture.

NR Who told you about Bill Rubin's quasi disapproval?

JK Dick Oldenburg. Sometimes when very high diplomatic people from Russia or other places were lending a work for an exhibition … I remember one time when Dick, who was the Director of the Modern, called down to the front desk to ask if I could just leave for the next 45 minutes. He said he felt very sad to say that.

NR Because Dick Oldenburg had a sense of humour, because, as you know, he was the brother of Claes Oldenburg. You knew that, didn't you?

JK Absolutely.

NR He had more of a sense of humour, and he would have appreciated you, and he was actually much more in tune with the world of Pop art than Bill Rubin, who didn't really understand it and whose great moment was really Frank Stella.

JK Also I was very engaged with the public. I was interacting with people. That's what I want to do – interact with people.

NR What did people say to you? Do you remember how you talked to people?

JK I would be selling them memberships, so I would wear some of these outfits so that people would have some interest, and I could maintain that interest longer when I was talking to them about membership, or upgrading their membership.

NR It's very Barnum & Bailey, if I may say so.

JK A bit like a barker. So anyway, I see some of these inflatable set-ups as almost like two male figures, although there are feminine aspects to them, and others as male and female together – the sense of abstraction really depends on you. The more that you move around, the greater the levels of abstraction you bring to it.

NR So when did you make these Polaroids of the set-ups? Did you show the works in these arrangements in galleries?

JK No. I didn't have galleries or exhibitions. This is the only way that these works existed at the time. I would set them up in my apartment. I had actually started clearing everything out. You see there's no clutter on the walls. In earlier photos there's clutter, and all of a sudden I thought that I didn't want that stuff, so I started clearing it out.

NR Where was your apartment?

JK It was on East 4th Street.

NR And you made a little gallery there?

JK I kept moving around, but during this time I was on East 4th Street.

NR Did you have a lot of visitors coming to your place?

JK No, just friends, but Holly Solomon was probably the gallerist who visited.

NR Yes, I've heard of her. She was the Pattern and Decoration lady, wasn't she?

JK Yes, she was involved with decorative pattern art.

NR Decorative pattern painting has now sunk without trace, I'm afraid. But it was all the rage at the time. Incidentally, it was the first thing that Charles Saatchi collected. I knew Charles when he was very young, and the first thing he collected – well, he first collected Hyper-Realist art, but then he went for pattern painting. This was in the mid- and late '70s.

JK Holly was always associated in the past with The Factory and she

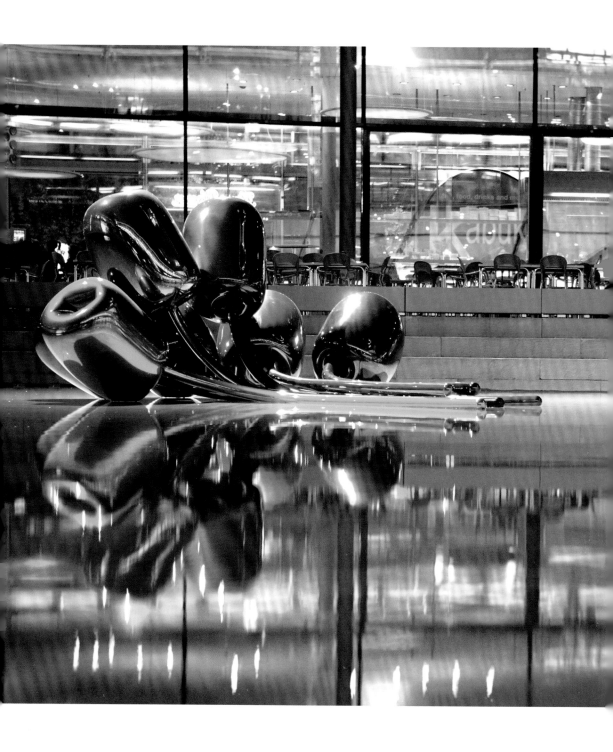

Tulips [1995–2004],
Nord/LB Bank, Hannover, Germany, 2002–13
[CELEBRATION]

had some association with Pop work, and then she got involved with Pattern and Decoration. She was located in SoHo, and right above her was John Gibson. John Gibson was showing narrative works. He was showing Bill Beckley's early work, and James Carpenter, Bill Lundberg and other people like Dennis Oppenheim. That was an important kind of influence in American art for the whole Pictures Generation.

NR Do you feel part of that Pictures Generation?

JK I do, but I'm not known alongside it. The Met did an exhibition, but I wasn't associated with it. I didn't show at Metro Pictures, but I knew the young artists. I didn't hang out exactly with everybody in that group, but I think I touched the edges of it.

NR There was this tension at the time between the older, grand Pop artists and so-called avant-garde Minimalists and Post-Minimalists. Were you interested at that time in Pop artists like Richard Hamilton, or Oldenburg, of course, or James Rosenquist and even Warhol? Were they on your radar in terms of their potential, because they were becoming quite big then at the end of the '70s and early '80s?

JK As a young artist you are always in awe of people like Rauschenberg, Lichtenstein and Warhol. These were American heroes, showing the potential that artists could have – an audience, getting work out there, a way of life and really connecting to the idea of the avant-garde. They were still connected to aspects of avant-garde artists from the early 20th century such as Picasso. But I did not go to The Factory. I never went there.

NR I did.

JK You did?

NR Yes. But you were following the art world closely at that time.

JK I was following everything. I felt I was always trying to wear my own shoes. My teacher Whitney Halstead in Chicago realised I was ambitious and that I was participating in the dialogue, and he said, 'You know Jeff, you have tremendous energy and you just have to learn to wear your own shoes'.

NR Hang in there.

JK Yes, and I always would think about that. I think I was always a bit of an artistic loner – not socially, but artistically. People would say, 'Jeff's over there. We all know about Jeff. His pictures are not really Neo-Expressionism, but always a little …'. That's why, when this younger generation came along in the East Village, my work was able to have

some historical place, but it was a little freed from the dialogue that was going on.

N R So what was your first Hoover piece? Do you remember? This particular one [*Hoover Celebrity III,* 1980]? Again you must have had a moment of insight. Was it an expensive thing to do? Was it a huge effort to do? By this time had you left the Museum of Modern Art, and were you already working in the Stock Exchange?

> J K I was still working at the Modern, and I was very influenced by the architecture and design department. That piece has a very Modernist background; the background is like Mondrian. You can see it's divided there.

N R There's a Flavin-esque aspect to it, of course.

> J K A Flavin-esque display. I mean, it's a Modernist display. Eventually I was able to cut out the Modernist display and have a more commercial display.

N R What's the difference, do you think, between the Modernist and the commercial?

> J K One is a little more brutal. When I say 'brutal', it's a bit more clean. It just is what it is.

N R That's to say, commercial. Do you think the Modernist is too tasteful?

> J K It's layered with a lot of other meanings in a way. I'm making reference to the modern. It's holding on to art in a way. But I'm not contributing anything to this; this dialogue is really about the ready-made.

N R The ready-made is already a big historical concept, as is Mondrian, as is Flavin.

> J K But I didn't bring anything to the table.

N R You think this piece doesn't bring anything to the table?

> J K Maybe in a historical manner, as I look back at my participation.

N R You could argue that, if Picasso had died at the age of the early Blue Period, nobody would have taken any notice of him, and people would have thought he was just a minor follower of somebody like Toulouse-Lautrec or Degas – he doesn't really count. But in the end it's the body of work that stands.

> J K I infringed upon these early pieces. When I made them, I would drill through the back of the vacuum cleaner and put a bolt in through there to hold it, so I was infringing on the object. I was displaying the object,

Hoover Celebrity III, 1980
[PRE-NEW]

Dan Flavin,
'Monument' for V Tatlin 1, 1964
Museum of Modern Art, New York

Teapot, 1979
[PRE-NEW]

New Hoover Deluxe Rug Shampooer,
1979
[THE NEW]

but I was infringing on its integrity. So when I later created 'The New' series, I didn't infringe on the object. I didn't fight gravity, I just used a hole that's in the back of the neck of the vacuum cleaner to mount it.

NR But you still had to display it.

JK I did display it, but I wasn't infringing on it. I wasn't pinning it down. When I was working on these 'Pre-New' pieces, I knew I had a dialogue with a ready-made object and I wanted to contribute to the ready-made tradition, but at the time I felt I really wasn't doing so. I felt that I was just working in some decorative manner. I felt that I wasn't contributing anything new. Then I had the idea of displaying the object for its newness. Newness, which is very kind of ephemeral, actually does have a sense of being about it, a dimensionality.

NR The shop-window effect, in other words?

JK Yes, the object maintaining the integrity of birth had some realness about it.

NR When you look at 'The New' Hoovers today, for example, do they look dated? Do they look a little bit shabby, or do they still look as fresh as the day they were born?

JK I always knew that the objects would age and that designs age, new technologies change.

NR Nobody uses Bakelite any more, for example.

JK I think those aspects of design changed, but the concept of them has persisted. Their integrity of birth, I think, is still there, somehow maintained.

NR Were you aware of all these kinds of quasi-philosophical, existential issues that you are now projecting onto the piece? You are not telling me that you were aware of those at that time, are you?

JK That's why I was doing those things.

NR But this idea that you were violating the object? You knew you were doing that? You felt that already?

JK Absolutely. And everything that we've been talking about is related to the aspect of removing anxiety and being able to live more clearly. It's the same kind of dialogue about this type of violation, this kind of taking away the openness, taking away the purity and the originality of that object's presence.

NR Your recent work so consciously has all these layers of history. These 'Pre-New' pieces have their own layers of history, wouldn't you say?

JK This one [*Teapot*, 1979] to me was always like a Frank Stella stripe painting, but again this teapot was glued on top of the plastic tubes.

NR Was it? Was there anything wrong with that, fundamentally? It's almost as though you feel pejoratively about these pieces. Do you reject them?

JK I like these pieces.

NR Do you possess any of them still?

JK No. My mother has two very, very early decorative ones. But these works – I wouldn't be where I am today without creating these works. So I'm very proud of them. I was just more or less pushing myself to try to go further and make a breakthrough where I could start to contribute to the idea of the ready-made. I don't think that I was really contributing at this point, but this shows my desire to contribute and the direction I'm going in.

NR Did you ever have a dialogue personally with someone like Dan Flavin? Would he have hated what you did, do you think, this kind of Minimalist artist par excellence who dealt with light? Or were you poking fun at him as well?

JK No. I wasn't poking fun; I was being open to that work and I was being open to the beauty of that work.

NR Yes.

JK Again I'm going from a very heavily layered, subjective background and opening up to this more objective, Minimalist-based work. Norman, when I mentioned about removing my own sexuality while we looked at the rabbit …

NR Removing your own sexuality?

JK I really start to focus on that more. Those inflatables I knew were very heightened, and I liked that. They were becoming more minimal, but with a very heightened sexuality. So I thought that the next step was to remove my sexuality more, my own presence more, and that's when I started to do this 'Pre-New'. Now I think that in bodies of work like 'Banality' I do bring my sexuality back, and I resurface it a lot of times in other work.

NR By removing your own sexuality, is it almost as though you are trying to say, 'I'm neither a man nor a woman'? Is that what you are trying to do? Is sexuality to do with the male and the female? Of course it is.

JK I think it had to do with the subjective, and I still felt that earlier work was subjective. I loved the intensity to it.

NR Subjectivity and sexuality are not synonymous, are they?

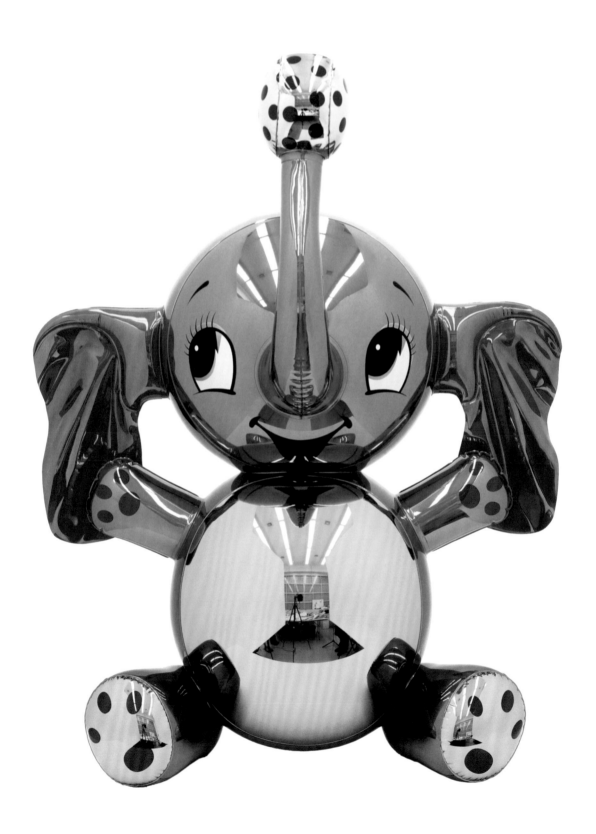

Snorkel Vest, 1985
[EQUILIBRIUM]

JK But it has to do with learning a dialogue of objects and working with objects, and how to communicate with both sexes.

NR So it's about communicating with the male viewer and the female viewer? Do you think the male viewer is somehow different from the female viewer?

JK Absolutely.

NR What do you think a feminist would say about that, for example?

JK About the male viewer being different?

NR Yes.

JK I don't really know what they would say, but I wouldn't care.

NR You wouldn't care?

JK No. Because the reality of it … well, I would care to hear somebody's opinion, but my own belief is that in the male experience, in the basis of the male, there are some things that are different. It could be they are 99.9999 per cent the same, but that millionth per cent …

NR For that tiny little bit …

JK That tiny little bit they are different.

NR I would agree with that.

JK And the things they respond to for the shape and continuation of life are probably different from the things that a female responds to. We know that vision is different, that the male has different perceptions to the female. There are a lot of differences.

NR What do you think about the homosexual male or female? Do you think that's a natural thing or an unnatural thing?

JK It's natural in that it happens in nature, that it's in the world, that it's in nature. So it's natural.

NR Do you know what we saw on the street? We saw a male dog fucking another male dog. Have you ever seen that?

JK I've seen that. Different animals hump each other. There was an article in the *New York Times* about same-sex behaviour and gayness in the animal world.

NR I think you told me about it.

JK Let's get back to this. The reason the lobster [*Lobster*, 2003] is on the cover of the Taschen book [*Jeff Koons,* Taschen, 2009] is because I'm very, very proud about how it deals with this issue of the male/female and this communication. It has to do with wanting to communicate – not just

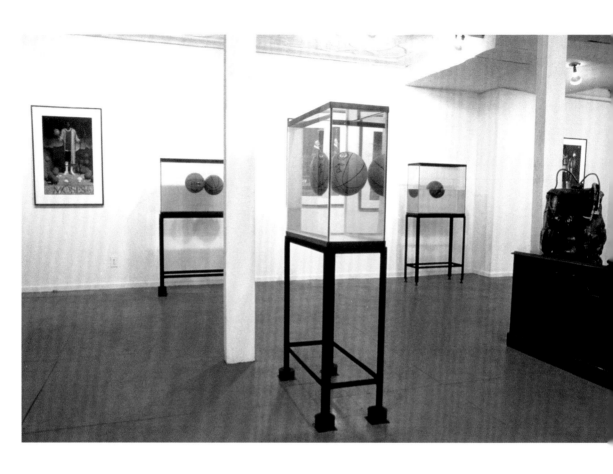

'Equilibrium', International With
Monument Gallery, New York, 1985
[EQUILIBRIUM]

Jusepe de Ribera,
The Bearded Woman, 1631
Hospital de Tavera, Toledo

with a male audience and not just with a female audience, but wanting to be able to have true communication with both audiences. So it has aspects that are feminine and aspects that are masculine, and it's very, very balanced in that arena. The arms tend to be masculine; the tentacles could be like a moustache. The tail is very feminine, like a Botticelli *Venus* shell. But at the same time its body could be a phallic shape.

N R Do you know that painting by Ribera called *The Bearded Woman* [1631]?

J K I may have seen it.

N R If not, it's an image you should call up one day. It's basically a mother suckling a child at her breast, but she has a full masculine beard and looks like a man.

J K One of the things I was proud of in my early exhibitions was works like the tanks that showed a masculine side of consumerism – that was the analytical quality of the tank. But the tank was also a womb.

N R Is the ball itself a masculine element, and the tank the womb, the feminine? Is that one way of reading this thing?

J K I think of the nature of this ball as being masculine, even though women play basketball. Coming after my vacuum cleaner pieces, I wanted the work to have a more masculine side. I didn't want people to think of all my work as like a '50s housewife, but for it to have a more masculine presence. And the reflections that are happening in this tank – the mirrors that are created when you fill it with liquid – is the same thing that's happening with those mirrors with the inflatable flowers, and the new sculptures that I'm making with the polished steel. But I don't look at that basketball as being the male foetus – I think of the foetus as being both male/female.

N R In your work is it true to say that you've tried to get away, through this concept of objectivity, from your own sense of being a male person rather than a female person?

J K I don't strive for it, but it's something that has become very natural for me. I realised early on that when I made my *Aqualung* [1985] [page 26], it was like a masculine Venus of Willendorf [page 132], and when I made *Snorkel Vest* [1985] it was more feminine – I realised the different attributes.

N R But are you conscious of your own femininity as well as your masculinity? Do you feel you have some kind of femininity within yourself?

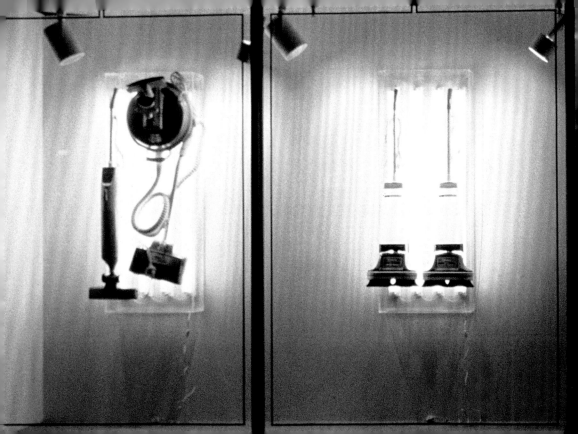

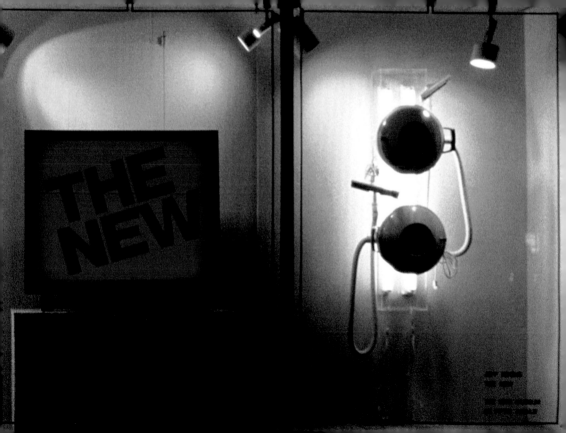

JK Yes, I think everybody does.

NR And are you trying to explore that, consciously?

JK I have two daughters, and I feel like I exist in this world in a feminine manner to my children.

NR Perhaps we can return now to 'The New'. I wondered, did you call the 'Pre-New' objects 'Pre-New' at that time, or was that a retrospective action once you had come to the concept of 'The New'?

JK 'The New' was when I did the window for the New Museum and I showed these works in transition where I was not infringing on the objects. I eventually called the earlier objects 'Pre-New', but that was over a period of time. I didn't call them 'Pre-New' at that moment, but after I started doing 'The New' I kind of differentiated.

NR Would you like to reassemble these as an exhibition? Could you imagine someone reassembling them?

JK I could do that in a retrospective. It would be great to do that.

NR But even if you look, for example, at 'The New' sculptures – the Hoovers – when you selected the colours and the placing of the colours, was it an arbitrary thing or was it very careful? Do you think the colour is an intrinsic part of these things?

JK I think it's an intrinsic part. And I chose Hoover because Hoover was the door-to-door salesman in America, the person knocking on your door saying, 'Hello, can I sell you a Hoover?' So working with the Hoover was a very conscious thing.

NR Even as late as the '70s they were doing that right through America – the Hoover salesman?

JK Yes, and working with the Hoover, working with this recognisable thing, it had to do with this door-to-door idea. I did door-to-door sales as a child.

NR Really?

JK Yes, I would sell wrapping paper and sweets. I enjoyed that experience, because I felt it was really meeting folks' needs and I enjoyed the acceptance of it.

NR The door-to-door salesman must have been very happy when you bought something like fifty Hoovers? It must have been quite expensive for you at the time to buy all these Hoovers? I mean, these are not cheap objects to make for a young artist, I wouldn't have thought.

New Hoover Deluxe Shampoo Polishers, 1980–6
[THE NEW]

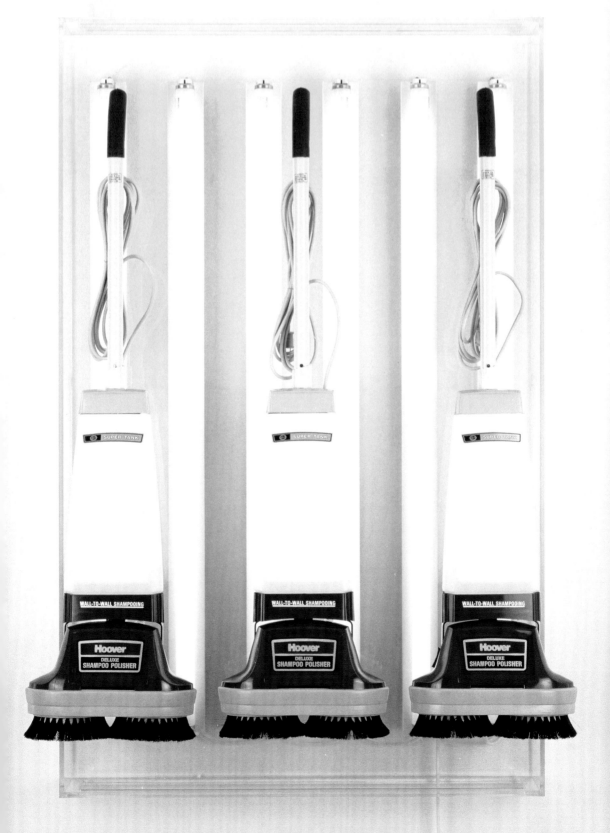

New Hoover Convertible, New Shelton Wet/Dry 10 Gallon
Doubledecker, 1981
[THE NEW]

New Shelton Wet/Dry Tripledecker, 1981
[THE NEW]

JK The acrylic ended up being the most expensive thing.

NR Sorry to interrupt, but did you have somebody supporting you?

JK At the beginning I was making these on my own, but then I had a gallerist. I was going to show with Mary Boone, and Mary put a wall piece in her office, but then Neo-Expressionism came, and I realised that I probably wasn't going to have the show that I was told I was going to have, so I ended up working with other people.

NR She started concentrating on Basquiat.

JK Different shifts took place, so I ended up having to really produce the work then on my own, and that's why I ended up going broke and had to go home in 1982. There was also this aspect of depleting stocks. I would work with one vacuum cleaner and then I tried to get others and they said they didn't make that one any more, so I was dealing with the aspect that these Hoovers were being discontinued, because, of course, everything becomes discontinued. Then I would travel the whole country buying up all those old vacuum cleaners.

NR It's almost like a nostalgic act – an act about something that's about to disappear.

JK So it's also very poetic. I would just get a bus right across the country to every store on the printout that the dealers gave me of places that handled their products. I would go there and buy up their stock. I went to Pittsburgh, I went to Kansas City; I went to all these places buying up all their last stock.

NR Then you schlepped them back to New York? You went by car by yourself? You drove yourself?

JK When I was making this piece, Daniel Weinberg was somebody who gave me the opportunity to make some of the works I designed.

NR Who is he? Is he still around?

JK He lives in Los Angeles. He's not as active as he was. He had Gagosian's old place on Richmond Avenue or one of those. But I remember he gave me an opportunity to build some of these works, and I remember I stayed up day and night to get these works completed. I also drove across the country in a van to deliver them. I got absolutely no sleep, and I felt I had failed because somebody was backing me and I didn't get all five finished for the opening. I only got three finished. And I just remember thinking that I had this opportunity and I had failed. I was so upset, but of course it was a big success, and when the works

were greeted, people enjoyed them, and I stayed on in Los Angeles for a week and I finished the other pieces.

NR How many did you make altogether? There seemed to be quite a lot of them altogether.

JK The whole series altogether of 'The New' is 24.

NR 24?

JK Eventually. In the beginning there were three, then I showed Dan the designs and we did the next five.

NR Then you stacked them.

JK Yes. There were doubledeckers, tripledeckers.

NR In fact, they are technically quite complex, aren't they, in terms of manufacture? Did you actually make them with your own hands?

JK I made the early ones myself.

NR You ordered the Plexiglas boxes presumably?

JK The acrylic people that I ended up working with were the best. They followed my designs, they knew the precision we had to work with.

NR You also connected them to an electrical source and so on?

JK Yes, wiring them. I did all the wiring myself.

NR Was it easy for you to stay positive in the '80s when you had those difficulties with the costs of making your work?

JK I had youth.

NR You had youth.

JK I had youth and I just wanted to participate, and if you are participating it's a joy.

NR Did you ever have doubts?

JK I would say I always have doubts because I really want to experience this revelation. You know, I want to walk out of Plato's cave.

NR You want to get out.

JK I want to experience that revelation and absolute comprehension of opportunity, of what human potential can be, and then to be able exercise that freedom. That's the best way I can describe it: to be able to exercise that freedom. To not exercise it is a life of confinement, instead of a life of the realisation of opportunity. I think we already sense that freedom in everyday life.

New Hoover Deluxe Shampoo Polishers,
New Hoover Quik-Broom, New Shelton Wet/Dry 5 Gallon,
New Shelton Wet/Dry 10 Gallon Tripledecker,
1981–7
[THE NEW]

There's just an acceptance of everything

EQUILIBRIUM,
LUXURY AND DEGRADATION,
STATUARY, KIEPENKERL,
BANALITY, MADE IN HEAVEN
AND CELEBRATION

NORMAN ROSENTHAL: What was your first lucky break? Do you think everyone needs a certain amount of luck at the beginning of their career? I did. I always feel that my career was made out of two or three instances of good fortune. Of course, I didn't even know that they were going to happen to me. Did you have one lucky break that you can remember, in terms of getting through and communicating your ambition?

JEFF KOONS: When it comes to the politics of the art world, I think there is so much luck involved, and certainly coming across certain individuals in my life has been very fortunate. I think about certain friends that I had who would talk to me about aspects of European art, or a certain artist, and I am very grateful for those friendships, having been able to sit and talk to people who have passion and expertise.

NR I remember the first person who took me to see your art was Ileana Sonnabend. I had just done an exhibition called 'Zeitgeist' in Berlin with my friend Christos, and it was a very magic moment. She took me to the East Village to show me your art, and she said, 'Norman', pointing at your work, 'this is the new "Zeitgeist"'. How did she come to respond to your work? She was, of course, a very European woman in so many ways. Did she open your eyes to many, many things as well? What kind of dialogue did you have with her, beyond what you might call the commercial relationship that you obviously developed with her at a certain point?

JK Ileana was very, very wonderful. She opened up my work to a whole new audience. I think she came to my studio to look at the 'Equilibrium' tanks in 1985, but I was downtown then. She was very supportive once I began working with the gallery, which would have been in 1986, I think [with 'Statuary']. Ileana was very supportive: she would introduce my work to people who were involved in helping connect European art and American art. I started to show in Europe through Ileana.

NR She was very European – even more than Leo [Castelli] in a way, even though they were both European. Like some grande dame of some lost world.

JK Yes. I remember Ileana would just speak about clocks, and how informative they are, if you look at them.

NR As far as history is concerned.

JK Yes, as far as history is concerned – the types of dialogue, maybe even narratives or allegories, that are taking place with them, which are very important. She was always very informative. I always think of Ileana and [her son] Antonio, because Antonio was very much a mouthpiece for Ileana, to an artist like me.

NR Yes, and he is incredibly cultured too.

Jeff Koons with Ileana Sonnabend
in her gallery, New York, 1998

Andy Warhol,
Ileana Sonnabend, 1973
Sonnabend Collection, New York

JK So if I talked to him about the *Farnese Bull* [AD 222–35], he would go on and on about the *Farnese Bull*.

NR Then there was her husband, Michael Sonnabend, who was also a very big character.

JK I always enjoyed it when Ileana brought Michael to see an exhibition, because Michael would have more than just a philosophical perspective. But Ileana was always more quiet. She would always let me know that she understood.

NR She had this extraordinary look to her face, this inner look.

JK There was no one else ever who supported my life, who just gave me absolute …

NR Confidence?

JK Yes, confidence.

NR She did this with many artists.

JK My parents were supportive, but I mean, economically, she took that economic pressure off me. I could just make work, and I felt that she believed in me and in her mind placed me in a historical context along with a lot of cultural heroes of mine. You could see, coming after Rauschenberg, Warhol, Liechtenstein, that I was somebody who was comparable.

NR Do you think she represented a world which is largely lost now, that doesn't exist in the same way in terms of support. I'm not talking about commercial support; I'm talking about cultural support.

JK I don't think people really discuss art so much, really. The economic aspect has become very highlighted. The dialogue always seems to be about the economic aspect of it.

NR Do you think that's a pity?

JK Yes, absolutely, because the power of art doesn't lie there. Automatically when something has power, economics and everything else come along with that power. But people want to be supported. People want somebody who really has a desire to be active in their community, and they clearly get the sense that their interests are being looked out for by this individual.

NR Did you talk with her about the content of your art? In what way did she, an archetypal grand dealer, understand what was happening?

JK Ileana expanded the possibilities. I know she funded my work and suddenly whatever idea I had, I could just go and produce. Even then, I took responsibility for thinking about my work before I made it, because

the energy that I had to give to it for the next nine months or year or even two years …

NR Or even longer in some cases.

JK When you are younger, the time period is sometimes even shorter, but it's usually about two years from finishing one group, letting a new body of work resonate, going into production and having a new exhibition. So there was a lot of time and therefore energy that would build up, as I would really think about things.

Ileana trusted me very much, and she realised that I gave my work 100 per cent. We didn't really talk about the content so much. Maybe I would say certain things to her, but really Ileana was just supportive. I remember Ileana being very, very shy, and so my memory is of her just being shy and supportive. I felt her confidence in me. She responded to the things that she liked, and I think she enjoyed the content of my work. I remember one time – and I'm talking of Antonio here too – when I had interest in creating 'Banality', I wanted to work with porcelain factories. They recommended a certain part of northern Italy and southern Germany to look into and said there were good production people there, as I was having difficulty with production in northern Germany, where it was hard to find people who were flexible and willing to do the work.

NR Are there dealers who have dialogues with you about the content of your work? I mean, your dealers in Germany, your dealers in London, your dealers in New York?

JK More with friends.

NR With other artists who are friends?

JK Artists, writers. I have a friend called Alan Jones, who was in New York.

NR Not the English artist?

JK Not the painter, but the poet, the writer, who was very involved with Fluxus artists in Europe. I would always talk to Alan a lot. He enjoyed Conceptual art. So we would talk about Duchamp, and he was very connected to what was going on in New York with mid-20th-century art.

NR Modernity. Is Alan Jones still alive?

JK Yes.

NR What does he do today?

JK He's still a writer. So what I found, Norman, is that a lot of my friends, a lot of young artists, would go out and do things. We would show in different group exhibitions together. So when you ask, 'Do you

feel really lucky?', I feel really lucky that I was able to keep in contact with these friends. But when it comes to performing in the political structure

…

NR Here we're talking about the art world?

JK Yes, in the art world you find that many people really don't want to go on the front line. I always wanted to be there. I want to participate; I want to have a dialogue on a grand scale. There's an aspect of risk, of going to what my limitations would be, but all these things I've always wanted to do. I have always wanted to participate in a dialogue with people like Dalí or Manet or Michelangelo – and I believe that if you really want to participate, you can. The ball is going to be thrown to you.

NR What about your contemporaries? Did you want to participate with your contemporaries as well, or were you more interested – even at an early age – as it were, in 'talking of Michelangelo', as TS Eliot said. Or of Dalí or of Courbet or of Fragonard, or whoever might catch your eye?

JK When you start out, you don't really know what art is. Today I don't know what art is, but I have developed a respect for different vocabularies or different areas that art can touch or go into. When you're younger you realise that different artists, different civilisations, spent their lives articulating certain vocabularies, and there's a certain beauty in continuing to use them and to articulate them in a new sense, to keep them activated.

NR What vocabulary did you expand upon in the 'Equilibrium' sculptures? What associations did those cast inflatables such as *Aqualung* [1985] [page 26] have for you, and also the basketball tanks?

JK I should place that series in context. I had just finished 'The New', which was about displaying objects as an ultimate state of being: being new. Those objects are just displaying their integrity of birth. Even though I would always try to have both a masculine and feminine aspect to the choices of my vacuum cleaners, people thought of 'The New' as being feminine – the idea of the housewife vacuuming the home, and the more feminine side of consumerism.

But with 'Equilibrium' I wanted to present more of a masculine side, and more of an analytical approach. There would be glass aquarium tanks with black trim, black steel stands, anti-vibration mounts and a basketball, which is more associated with male sport, even if the colour is the orange.

NR Are those basketball tanks about keeping afloat, like *Lifeboat* [1985], your cast-bronze boat from the same series?

Lifeboat, 1985
[EQUILIBRIUM]

JK Yes, the tank keeps the ball in total equilibrium, so it just hovers in the centre of the aquarium when it's filled with water. It's just hovering there in equilibrium in 50/50, with exactly half the ball submerged below the water and exactly half above. I was really trying to have a dialogue with philosophy – with Kierkegaard, with Sartre and Existentialism. It's about being human. It's more biological: the basketball is like the womb. It's another ultimate state of being, but unlike 'The New', where this aspect is after birth, here it is pre-birth. This is timeless, the before and after.

NR Were they technically difficult to do? How did you find the technical help to do the science, to realise the vision?

JK Well, I really wanted permanent equilibrium – I really wanted one of these balls to just hover there forever. I went to all different libraries reading about equilibrium, density gradients and so on, but the physics said it could not be done in such a small tank. But then I read an article in *Time* magazine about the Nobel Prize winner for quantum electrodynamics, Dr Richard P Feynman. He was teaching at the California Institute of Technology at the time, but he appreciated the arts and he thought of himself as a kind of artist. He was a really brilliant guy. He was the one who found out why the space shuttle blew up in 1986. He was the scientist they had investigate that.

NR So he was a famous man and you were relatively unknown.

JK So I called him up and he would tell me that I could do it.

NR He took you seriously? He didn't think, 'There's this nutter ringing me up'? He wasn't patronising?

JK No, no. He was great, and people in the scientific community are like that. It's when you get into companies that they want to own information, when people aren't so helpful. I also worked with Dr Green at DuPont and he was very helpful. He said that I could do it, but that it was impossible to keep it in permanent equilibrium. So the tanks I made are in equilibrium for about three months, although it depends – maybe if you can remove all vibrations they could go for six months.

NR Can you recalibrate them?

JK You just redo the tank. You take the water out and you put really pure water in the bottom and then you mix in salt – very, very pure salt, a sodium chloride agent. Then you just lay water on top that doesn't have any salt. Within a day of doing that it's really hard to see any difference between the two layers.

NR Do you think they could be permanent now? Could you redo them and with advanced science make them more permanent?

JK I could have redone it then to be more permanent, but it wouldn't have been as pure in its organics. You know, I wanted to use just pure water – I wanted it to be a like a virgin experience. I could have put different oils in there that are not homogenous. You would have a separation line, and it just wouldn't have been as pure.

NR Were you interested in the idea of sport and sportsmen, in the tanks and in your Nike posters in 'Equilibrium'?

JK I would be walking down the street and I would see a Nike poster and I would think, 'There are the sirens, there are the sirens'. The basketball players were the sirens, the great deceivers, telling people 'Come, come, you can achieve equilibrium'. They were like weak middle-class artists today who say, 'I'm an art star' and puff themselves up, but actually are they really doing anything at all? Are they really achieving anything?

NR So were the basketball players role models or anti-role models?

JK Kind of a mixture of both. You have to become your own role model. You have to pull yourself through – clarify your desires and pull yourself through. These people can't do it for you.

NR Do the adverts for alcohol in 'Luxury and Degradation' similarly transcend being merely Cognac or brandy ads?

JK I was making reference to levels of political abstraction that were embedded in them.

NR What do you mean by that exactly? Is it about advertising and the subliminal aspects of advertising, or was it a social critique? Is there an element of social critique in your work?

JK I think there probably is, but it's not in a negative way. I would say that 'Luxury and Degradation' was one of the more direct social critiques, which was just saying that white middle-class art is reducing art to social mobility for certain ethnic groups. 'Luxury and Degradation' was a critique showing how art can be used, that there are different levels of abstraction in the world of art. You need to be aware, because art can be used against you, forcing you to give up your economic and political power. I did the same thing again with the lobster from my 'Popeye' series [*Acrobat*, 2003–9]. If you look, you can see an acrobat being burned at the stake; the lobster's carapace is in the flames. He's a performer and eventually gets done in. And 'Luxury and Degradation' is about not wanting to make art against people. Art's not about desirable objects in the world; it's not about fulfilling a kind of self-aggrandisement. Making art is not for the pursuit of luxury.

The Dynasty on 34th Street,
1985
[EQUILIBRIUM]

Board Room,
1985
[EQUILIBRIUM]

Stormin' Norman,
1985
[EQUILIBRIUM]

Aqui Bacardi,
1986
[LUXURY AND DEGRADATION]

Hennessy, The Civilized Way
to Lay Down the Law,
1986
[LUXURY AND DEGRADATION]

The Empire State of Scotch,
Dewar's,
1986
[LUXURY AND DEGRADATION]

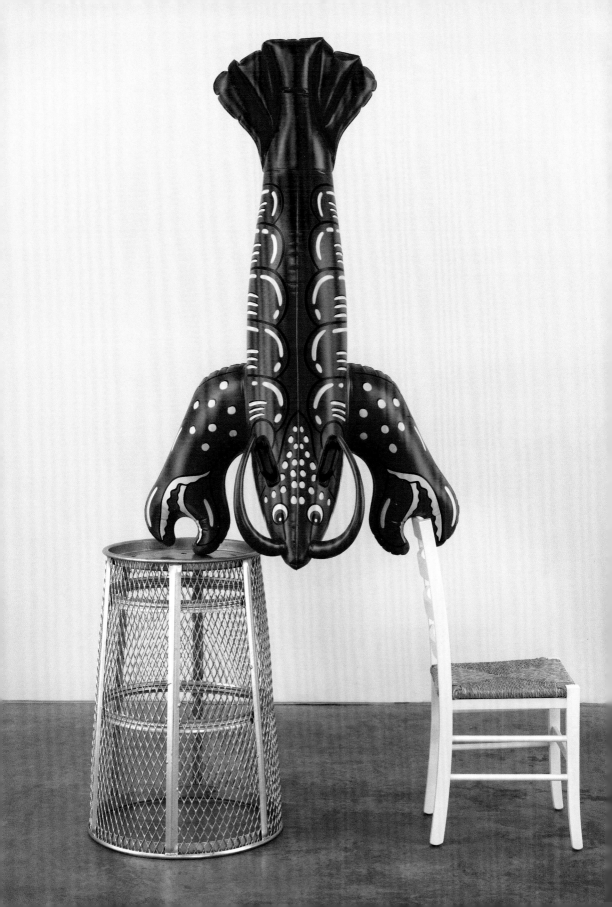

N R Do you lead a simple life, or do you lead a life of luxury?

J K I actually believe I lead a simple life, although I know that I have a framework underneath me to do the things that I have interest in, and it gives me support to develop those interests. I am sitting here wearing jeans and sneakers, and yet I'm able to work at a certain scale.

N R Was 'Luxury and Degradation' your most political series?

J K I believe that all my work has a kind of political basis, but it's a political basis in the self-value of the viewer, a platform for trying to communicate to them that their own history is perfect. It's about the expansion of their own parameters and to me that is political, even if it's not about one particular issue.

N R 'Luxury and Degradation' includes sculpture as well, like your copy of your father's travel bar.

J K Yes.

N R Is it an object of affection, or is it an object of a little bit of ambivalence?

J K Affection. My parents would travel with their friends in the '60s – maybe they would go to the Virgin Islands or some place – and they would carry a travel bar with them. That was a symbol of mobility, of social mobility, that they were middle class and that they were moving. My parents always gave me that sense of movement: we had transcendence, we had an aspect of growth and we had increasing parameters. We experienced life, and my parents created for us, for me, the idea that we could do interesting things in the future.

But those sculptures aren't always direct appropriations in that way. I have a sculpture of a *Fisherman Golfer* [1986] there, but I don't know really what he symbolises. *The Jim Beam – J.B. Turner Train* [1986] is kind of phallic – it's more abstract, not in a normal kind of figurative narrative.

N R Recently there was a show in London and they showed what I call your 'Brancusi' – namely the rabbit, the beautiful silver sculpture [1986] – and there was a little film about when you took part with a blown-up version of the rabbit in the Macy's Thanksgiving Day Parade [in 2007]. Did that make you particularly happy?

J K I was happy.

N R Or did you feel overwhelmed by it?

J K No. I was happy to see my children smile. They enjoyed it, and that was really my main motivation. I thought my kids would get a kick out of seeing the rabbit in a parade, and I am really very happy and pleased that I decided to participate and to have the rabbit blown up to that scale.

Acrobat, 2003–9
[POPEYE]

overleaf
Rabbit – Macy's Thanksgiving Day
Balloon, New York, 2007

NR And art being a very fragile thing, the parade somehow seemed to overwhelm the perfection, if I can put it like that. I know you don't like this word 'perfection' to describe your art, this idea of perfection, but the chaos of the parade seemed to overwhelm the perfection of the sculpture, whereas if it had been alone in a room, one would have been more overwhelmed by it. Do you see what I'm saying? Context is everything. Would you agree with that?

> JK Well, I have to say, I don't really think of the balloon as a work of art. I think that it makes reference to a work of art and that it is an interesting object, but I don't think of it as a work of art. It's just making reference to the rabbit.

NR Did you like that reference being placed next to the rabbit itself? I felt that what I call the 'fragility' of the rabbit – and by 'fragility' I mean its integrity – was compromised a bit by having this film of the parade in the room. But that's just my opinion, of course.

> JK I think the rabbit is strong in its own sense of itself. It can withstand commingling with different things, whether they are comprehended as a work of art or not. But something like that rabbit came from a very intuitive process also. If you would ask me, 'Where did the rabbit come from exactly?' I know I was looking at inflatables, and it was part of a 'Statuary' show, in which I wanted to have a panoramic view of society. I had *Louis XIV* [1986] at one end of this panoramic view and *Bob Hope* [1986] at the other end.

NR Did you feel that *Bob Hope* and *Louis XIV* were of 'equal value' as symbols – cultural symbols?

> JK They were ready-mades. After making the 'Luxury and Degradation' show I was invited to be in an exhibition at Ileana Sonnabend's, an exhibition as one of 'The Fab Four' – this group of four artists she chose, including me, Peter Halley, Ashley Bickerton and Meyer Vaisman. So in a very short period of time I had to have another body of work put together, so I made 'Statuary' within about a six- or nine-month time period, a very quick time period. I remember walking down Canal Street and seeing a fibreglass bust of Louis XIV in this place called Canal Plastics, where I would get a lot of my plastic sheets. I thought it was fantastic. I carried that with me in my head and then when I was walking around somewhere, probably somewhere around Times Square, I saw a little plaster cast of Bob Hope. Then this narrative started to develop. I realised they were really symbols of what happens when you put art in the hands of either the mass, with Bob Hope, or an individual, in Louis' case of a monarch.

Fisherman Golfer, 1986
[LUXURY AND DEGRADATION]

Travel Bar, 1986
[LUXURY AND DEGRADATION]

overleaf
Jim Beam – J.B. Turner Train, 1986
[LUXURY AND DEGRADATION]

If you put art in the hands of the mass – Bob Hope – he would tell a joke. He would choose the joke not because he subjectively really liked it, but because he told it the night before and it got the largest response. It would be reflective of the mass ego. But if you put art in the hands of a monarch like Louis it would eventually only be reflective of his own ego.

NR The Sun King.

JK So the underlying context here, too, is if you put art in the hands of Jeff Koons, eventually it's just going to become reflective of my own ego.

NR Does that worry you?

JK Yes. You want art to keep moving. You always want art to be taking you somewhere, not showing you where you are.

NR No complacency.

JK That's right

NR Do you think that Bob Hope and Louis XIV were complacent au fond in a certain way? Are they the symbols of complacency? Grand complacency?

JK It's hard to say, Norman. But within this panoramic view in 'Statuary' [1986], I had works about other ways in which art has been used. In the *Two Kids,* the spoon that comes out of one child's hand is about how you can actually end up with an object to eat off, if the worst comes to the worst. There's also an allegory taking place in that piece where one child is spilling the other child's porridge, which feels to me that it's about morality. *Doctor's Delight* is about sexuality.

And then you have the rabbit. The rabbit was really art as fantasy, but it's very iconic because of how chameleon it can really be. I think it deals a lot with archetypes. It's an image that could be read as so many other different things; you could look at it and think of the *Playboy* bunny, or you could look at it and think of Easter.

NR You could look at it and think of Brancusi too.

JK You could look at the carrot coming to the mouth – it's a kind of masturbation – or you could think about Brancusi …

NR Or Nefertiti in a certain kind of way.

JK The Venus of Willendorf, because the tiny little hands that the rabbit had feel almost like her little arms – or what they thought were arms. I also realised that the *Kiepenkerl* [1987] was a Priapus for me, a male fertility figure. The *Kiepenkerl* was my next piece and really important for me Norman. I guess it was 1987 when I was invited by Kasper König to be in a very important international show in Münster that is held every decade.

Louis XIV, 1986
[STATUARY]

Bob Hope, 1986
[STATUARY]

Two Kids, 1986
[STATUARY]

Doctor's Delight, 1986
[STATUARY]

N R Yes, Münster on the Dutch-German border.

> J K So, when I was invited I immediately said I would love to and I went to Münster – the whole idea was to make a site-specific work in the city. I immediately came to this particular town square where I saw this bronze cast of a figure called the *Kiepenkerl*. It's the image of a man coming to market with a *Kiep* – a basket on his back, which holds pigeons and other things.

N R Basically, it's a German folk tale.

> J K It's a symbol of self-reliance. The man had tobacco, he had a pipe, he had pigeons, he had potatoes, he had eggs, he had hares. This figure was actually a reproduction of the original because the original *Kiepenkerl* bronze was used by the American troops as target practice when they came to Münster after the Second World War. I thought that this image of self-sufficiency really was very pertinent to today's world. I was working with stainless steel at the time and I decided to transform it from the original by giving it a reflective surface.

N R Is self-sufficiency an American idea particularly? It has good sides and bad sides, but everybody has to invent themselves and exist on their own in the American culture. It's now gone right across the world, but in those days, even in the mid- to late '80s, the socialist ideal – the state – was still quite important in people's heads. Do you know what I am saying?

> J K I don't know really. I believe in self-reliance. I was always brought up to be self-reliant.

N R I would say it's a very American thing.

> J K It could be.

N R It is, if you like, the American matrix, and this cultural matrix has now, I would say for better largely and to some degree for worse, has become incredibly prominent in the world from Russia to China, and in Europe. Do you remember in 1968 when it was all about being socialist, waving Mao's *Little Red Book?*

> J K I remember 1968. I was born in 1955 so I remember.

N R Perhaps not quite as well as I do. You were 13 then and I was in my late 20s.

> J K As for the idea of self-reliance, it's great that people want to be responsible for themselves, to do what they can do, to exercise the energy that they have to do something to affect their own lives directly.

N R Do you think every human being has within himself or herself the ability to do that, to pull themselves out of whatever misery they may have been born into?

Venus of Willendorf, 24,000–22,000 BC
Natural History Museum, Vienna

Rabbit, 1986
[STATUARY]

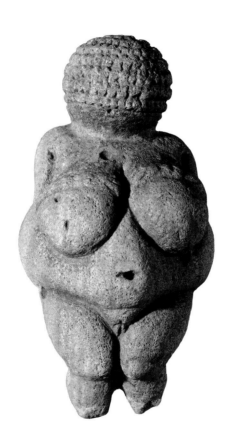

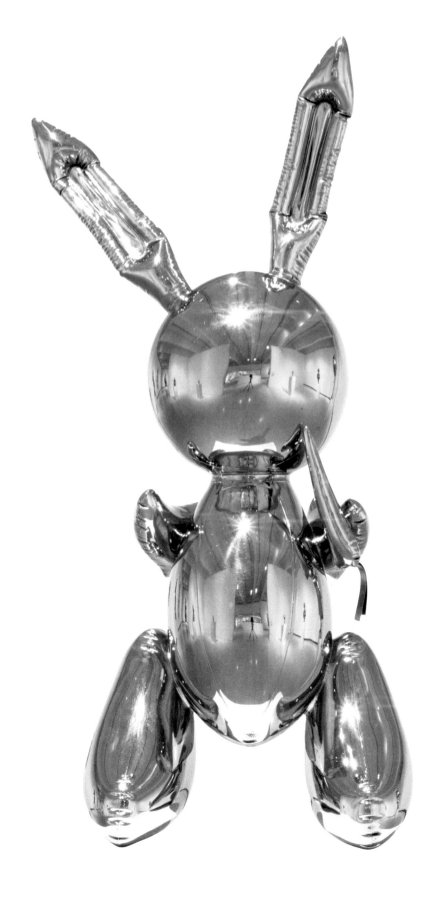

Kiepenkerl, 1987

Jeff Koons after the unveiling of his
Kiepenkerl in Münster, 14 June 1987

Priapus, Fresco from the Casa dei Vettii
(House of the Vettii), Pompeii, *c* AD 50–79
Naples National Archaeological Museum, Naples

JK In some situations, some political situations, you cannot do anything. You are in a situation and it's pretty hopeless and I understand that people cannot.

NR If you were born in Syria today, for example, or some godforsaken part of the world, and there are many, too many such places of course – even parts of America.

JK In the reality of some situations nothing can happen, but it's still good in those situations to try to have impact in your own life and even to pull yourself out of those situations as much as you can.

NR You and I, in our different ways, have managed to make it and get to the top of our lives and pull ourselves through. To return to my earlier question, what role do you think luck plays, what I call 'Cagian' luck? Or chance rather than luck? I am not bad at what I do, but nevertheless I consider I have had one or two incredibly lucky moments – unpredictable, lucky moments that happened to me, such as meeting certain people – that somehow enabled me to get to this seat here now, where I'm sitting and having this beautiful conversation with you.

JK I've had those moments, Norman, and they affect your life greatly, but I think also at the same time you have to be open to those moments.

NR Nietzsche says somewhere that good fortune resembles the person to whom the good fortune comes. Would you agree with that somehow?

JK Yes. That's perfect. You have to be open to the opportunity. You are having impact and giving yourself greater opportunities by being aware. I always think about letting things resonate and just trying to be very open to things, especially things that continue to present themselves that have some relevance to me. I think, 'OK, I have my camera and I should photograph that', or 'That's kind of interesting and I should do that'. Then I do it. I don't just think about doing it – I'll do it and follow that interest. I go on and see where I'm pulled to and let it resonate.

But I don't feel like I have to act on something immediately, if I can let the things important to me present themselves over a period of time. When I made my stainless-steel rabbit, I really couldn't decide whether to make an inflatable rabbit or an inflatable pig. I would stay up at night. I have drawings from around that time where I have written down, 'Shall I do the rabbit or the pig?' I would inflate the originals and look at them, and I couldn't decide. 'Shall I make the inflatable rabbit, or shall I make the inflatable pig? I like both.' Economically, I could only make one of them at a time, and I chose the rabbit. But my next body of work was the 'Banality' series.

NR And there was the pig: he didn't disappear.

JK The main symbol was the pig. I let it resonate over a period of time, and that process still goes on. I will make a doodle, and then wait until I feel as though it's time to act. You feel the gesture, you want to make the gesture and you realise that to hold back the gesture then is inappropriate. Then you act – you just want to see it realised in the world.

We were talking about the *Kiepenkerl*, Norman, which was important for 'Banality'. I found this bronze sculpture in Münster and decided to cast it in stainless steel, and then to polish it to a mirror surface. But the foundry that cast it, instead of letting it cool for a certain amount of time, banged it up against the wall to knock off its ceramic shell before it was cool, so it became deformed. The arms were bent, the legs were bent, things were shortened and other things went wrong.

NR A fiasco.

JK This was my first big international show and it was becoming apparent that I might not participate in it. Because at this moment in my life every object I had worked with was always about preserving every perfection and every imperfection – it was about the object's integrity. So when I looked at the piece I had to decide whether to pull out of the exhibition or to give it radical plastic surgery, which was basically to bring somebody in to help stretch a leg back and try to elongate the arm. That would be against everything that my work was about up to that moment.

But I decided to give it the plastic surgery. We just pulled it and stretched it and it was such a liberating event, because I realised that the integrity that I always cared about was not about the integrity of the object, but the beauty of the viewer. I cared about every perfection and imperfection that *they* had, not the object. So it freed me to go on, and in 'Banality' there is no replica of a ready-made there. Everything is just from a montage of different images and different things pulled together and made by hand. The viewer is the ready-made, what's happening inside them.

NR Why did you choose the central image of a pig in 'Banality', and images like Michael Jackson or, indeed, St John the Baptist. Do you see a kind of equality between these pieces – between the funny animals standing on top of each other and Michael Jackson, and the bear embracing the policeman and St John the Baptist, a religious subject? Are you seeing an equality of imagery?

JK I have to say, Norman, you have said that very well about equality. In 'Banality' this aspect of removing judgement is very, very clear. I know at the time I was looking at ads, I was looking at postcards, I was looking at the things around us in the world and what people respond to. They will respond to an ad of somebody balancing a watermelon on their head

Ushering in Banality, 1988
[BANALITY]

and wearing big sunglasses, maybe playing a jazz trombone at the same time.

But although they will respond to that, somewhere there's a sense of guilt about it. People use art to disempower people. They use it as a mechanism to empower themselves – they are the holder of the rules, they are the holder of the significance of culture, and art is something that you have to come pre-prepared for. I wanted to make a body of work that was all about empowerment and to let people know that everything in their past, in their cultural past, is perfect.

NR What do you mean exactly by the word 'banality'? It's a really important thing for me to try and understand. Saying something is banal is quite pejorative. It's almost the worst thing you can say to an artist – it's almost the worst word you can use – and here you are making art which you are calling 'Banality', in which you include things like the tower of pigs, Michael Jackson and, of all people, St John the Baptist. Why do you think the banal is capable of being elevated into art? How did you arrive at that kind of intuition? It's clearly an aspect of your art that is incredibly important.

JK On the chalkboard in one of my ads for the 'Banality' exhibition, I wrote 'Banality as saviour'.

NR Banality as saviour?

JK As an art format. I was using banality to communicate that the things we have in our history are perfect. No matter what they are they're perfect. They can't be anything else but perfect. It's our past and it's our being, the things that we respond to, and they're perfect. And I used it to remove judgement and to remove the type of hierarchy that exists. I don't like to use the word 'kitsch', because kitsch is automatically making a judgement about something. I always saw banality as a little freer than that.

NR Yes, I understand. Do you see Duchamp's urinal as banality?

JK I think it's in the dialogue of banality. There are aspects of banality. It's just something from this world.

NR But is there anything that's not perfect? Is there anything that's either unacceptable or not perfect in the world, or that is just merely *fine* in terms of its visuality? I'm not talking about morals; I'm talking purely about the visual.

JK Morals are very important – you cannot separate the moral from the visual. I really believe that to have transcendence into the highest realms you have to have acceptance of others. You have to leave the self. You get so bored with the self. You don't want to deal with the self. And this

Michael Jackson and Bubbles, 1988
[BANALITY]

Michelangelo,
Pietà, 1498–9
St Peter's Basilica, Vatican City, Rome

Sleeping Ariadne, 2nd century BC
Museo Pio-Clementino, Vatican City, Rome

overleaf
Split Rocker [2000],
Château de Versailles, France, 2008–9

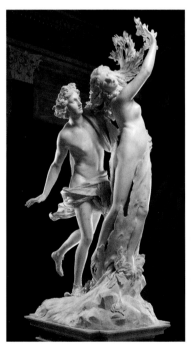

Gustave Courbet
L'origine du monde, 1866
Musée d'Orsay, Paris

Gian Lorenzo Bernini
Ecstasy of Saint Teresa, 1647–52
Santa Maria della Vittoria, Rome

Masaccio
The Expulsion from the Garden of Eden, *c* 1425
Santa Maria del Carmine, Florence

Gian Lorenzo Bernini
Apollo and Daphne, 1622–5
Galleria Borghese, Rome

transcends into the acceptance of others. A lot of metaphors are in there, but it really comes to the acceptance of others.

NR But is there anything that's bad – bad in the pejorative sense?

JK I think violence to the self, violence to others. I know that death is a part of life and the whole continuum, and you have to have decay and you have to have disease and you have to have all these things, but for the equilibrium of the moment I think a respect for others equal to the respect for yourself is necessary. Not to have a sense of communal respect, I think, is the beginning towards disequilibrium.

NR What's the difference between *Michael Jackson and Bubbles* [1988] and a sculpture like the *Sleeping Ariadne* [in the Vatican, 2nd century BC]? If you were to put the two in a single room do you think they would speak to each other?

JK I think they would speak to each other, but when I made *Michael Jackson and Bubbles* I was thinking of Renaissance sculpture instead of antiquity. *Michael Jackson and Bubbles* has a triangular-shape structure that is the same as Michelangelo's *Pietà* [1498–9]. It does also make reference to Egyptian sculpture – it's a little bit like King Tut, and the way the leg comes up makes a pyramid, and the body makes another pyramid. So you have the three Pyramids of Giza there. But it is more of a reference to Renaissance sculpture.

NR Another work of Renaissance art, Masaccio's fresco *The Expulsion from the Garden of Eden* [c 1425], was a catalyst for your next series, the 'Made in Heaven' pieces. This was a wonderful and extraordinary yet difficult period in your life.

JK With 'Banality' I had started communicating for the first time that people should embrace who they are; embrace their own history, their own cultural history. 'Made in Heaven' was about one of the things that distances people from embracing who they are, embracing their own being: their sexuality. So I wanted to use sexuality as a metaphor, as a kind of continuation of 'Banality', but to go a little more direct psychologically into what keeps people from embracing who they are. After I saw the Masaccio painting *The Expulsion from the Garden of Eden* I wanted to make a body of work about sexuality that would help remove that guilt and shame. My ex-wife, Ilona, always embraced her body without any guilt or shame, so she had that really tremendous energy.

NR Energy?

JK Yes, energy and the grace of just revealing herself without any sense of guilt or shame. That body of work is actually one of the first

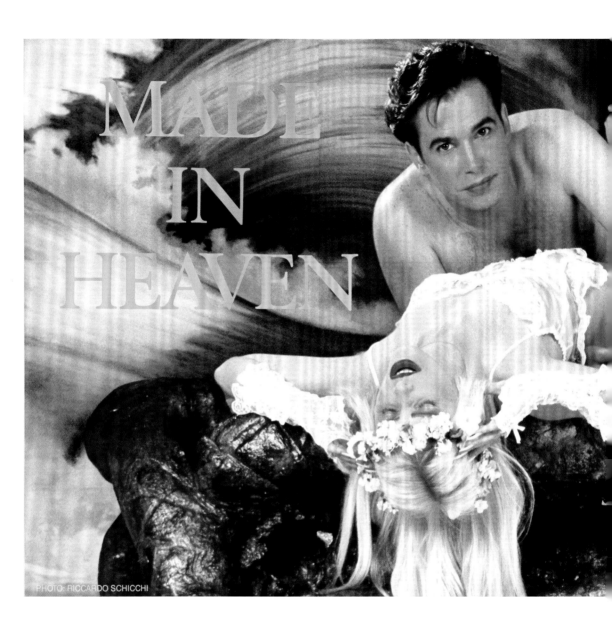

MADE
IN
HEAVEN

PHOTO: RICCARDO SCHICCHI

Made in Heaven, 1989
[MADE IN HEAVEN]

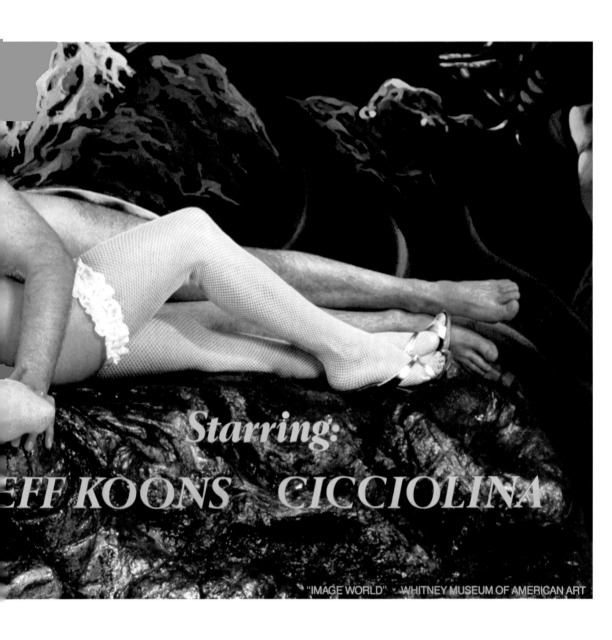

Starring:

EFF KOONS CICCIOLINA

"IMAGE WORLD" - WHITNEY MUSEUM OF AMERICAN ART

bodies of work where I start to make more direct interactions with other artists, with Masaccio, with Manet. One painting is called *Manet* [1991].

N R Courbet. Fragonard.

J K Courbet's *Origin of the World* [1866]. Fragonard. All these different connections.

N R Even Picasso? Because Picasso is a fantastically sexy artist, as you know better than I do.

J K Picasso would be there, although you can feel the external world more in the 'Made in Heaven' work – with Picasso you don't quite feel the same aspect of the external. I am very, very proud of a lot of the work in the series. Everything has its plan.

N R No regrets in that sense from a cultural, an artistic point of view?

J K No, absolutely not. Everything has its place and when I show those works I try to have a conscious awareness of that. For certain audiences it's wonderful to be able to experience that series.

N R Do you find it connects with Bernini's expressions of ecstasy in, say, the *Saint Teresa* [1647–52], or in his *Metamorphoses* sculptures?

J K Sure. *Apollo and Daphne* [1622–5].

N R Apollo and Daphne. Did you really feel that when you were with Ilona? Did you feel like an Apollo with a Daphne?

J K I would say that there was more this sense of trying to represent every man and every woman – it wasn't about the image of us as two people. It was really very objective. I wanted to have a dialogue with these other artists, and I wanted this sense of acceptance, acceptance of our bodies, accepting biology.

N R Is this when you were beginning to get involved for the first time in the history of art, the great Western art history? Masaccio is a big name, Bernini is a big name, as are Fragonard, Boucher, Courbet, Manet. You don't really see them in the early work, in the Hoovers or in the basketballs, do you?

J K No, and in this body of work I also wanted to show the dialogue with the Baroque, with the Rococo, in my experience. I had spent a lot of time in Europe. But this series is about the eternal, just like 'The New' and 'Equilibrium' are about the eternal – it's the biological eternal, it's the preservation of life, the continuation of life.

N R Were you beginning to collect works of art then?

J K Yes, I started. I acquired a Roy Lichtenstein, *Surrealist Head II* [1986]. I acquired it from Leo Castelli.

Suzuki Harunobu
Storm and the Lovers, 1760s
Koons Collection

John Wesley
First Kiss: Blondie Bumstead and Ynez Sanchez, 1991
Koons Collection

Geisha, 2007
[HULK ELVIS]

NR Buying old masters is a whole different ball game. That came later?

JK That came later. I would say the first old master wasn't that long ago, maybe a decade ago.

NR Do you collect contemporary art? You collect, it would seem, historic things – everything from an ancient, undetermined phallic object, which seems to be archaeological, to old masters paintings.

JK I have some contemporary work. I've just bought some John Wesley paintings. I think he's great.

NR Where do you put them? Do you have them so that you can look at them every day?

JK I have two paintings at home. I just wanted to get what I felt was the best John Wesley.

NR Do the Wesleys feed into your work in some way? Do they give you the same kind of stimulus that old art clearly now gives you?

JK Absolutely. There is a sculpture that I am doing right now of two ballerinas [page 195] and I have been looking at Wesley's painting that has two women in a shower [*First Kiss: Blondie Bumstead and Ynez Sanchez*, 1991].

NR It seems to be a combination of Disney and Ukiyo-e. Have you ever been into that world of Ukiyo-e, the world of Japanese prints, which have been so influential on artists certainly since the 19th century?

JK I've used a reference of a geisha in some of the 'Hulk Elvis' paintings and I own two Japanese prints. But I wish I was more informed, I really do. I've seen some exhibitions and I know the importance of it and I try to incorporate it – that Eastern type of work is very beautiful. It also reminds me of Roy Lichtenstein's last body of work, that kind of style of painting.

NR Let's talk about 'Celebration'. There were pieces in that series that were so difficult and expensive to realise, and then there were tensions that you had later on with certain art dealers as well. Did you get angry? I'm capable of getting incredibly angry – my anger is quite famous, if things are not perfect. My image of you in the world is of somebody who is unbelievably, beautifully and perfectly benign. But when it came to the 'Celebration' series did you actually get angry and how did you express your anger? Or did you just smile?

JK I think that I just forge ahead. When I come across problems I try to deal with the problems, if I feel I can have some kind of influence on the outcome. I reflect on whether it's really worth it to go through it all, and if I feel that it is I will just push forward, push ahead. You know, a lot of

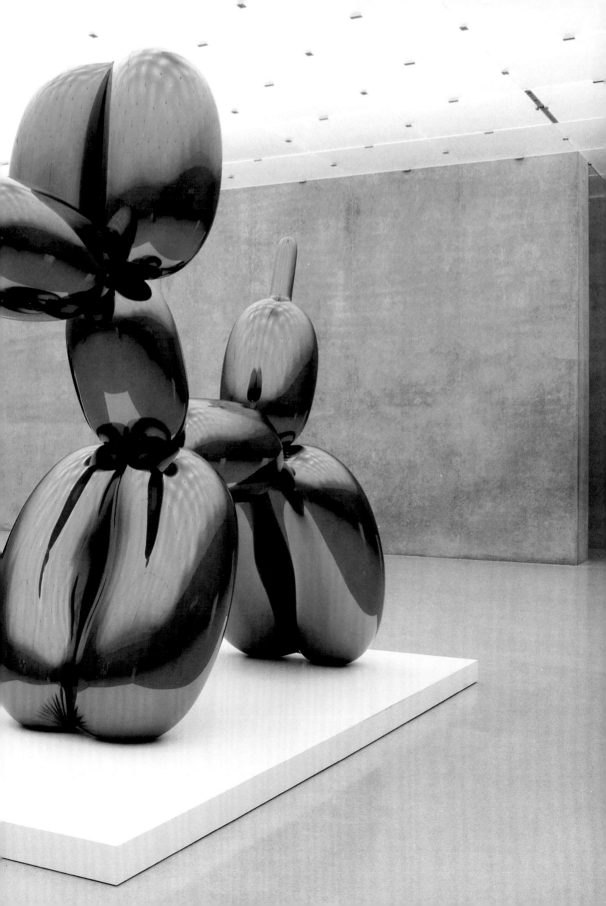

times, my works are very, very difficult to make and they take technologies to the edge.

NR And they are expensive. There are financial implications too.

JK That comes about, but it's never my intention to make something complicated or difficult. It's just that I follow my interests and a lot of times that will automatically take me into these areas of production that are complicated.

NR How do you say 'no' to things that are not going right? Are you very calm or do you get angry?

JK I don't think I get angry. Maybe I feel frustration at a certain point. If I start to realise there are problems and that I should stop or change gear, then I will do that, but usually that doesn't happen very often because there's a lot of pre-thought that's already gone into things, because of the advanced engineering that has to go into the works. If I commit to make something I know the parameters of its production.

NR Even if that production takes years?

JK Even if it takes years. I don't want it to take years, as it's very important to have a kind of immediacy, but sometimes it does take years.

NR But when there were difficult moments for yourself and your collaborators with 'Celebration', did that stress you out a lot or not?

JK Well, there's almost a mythical aspect of that surrounding the 'Celebration' series.

NR That's what I mean.

JK Before the 'Celebration' series I had made several bodies of work that were very successful. And after having had a lot of success, different dealers would come to me and ask me if I wanted to make a body of work with them. I am always open to working with different people, so I was working with three different galleries on 'Celebration' and they would all contribute a certain amount.

So I went off and pulled my ideas together and I came back and said, 'This is was what I would like to do, but it's probably going to cost a little more'. Everybody looked at the work and said, 'Wow, great'. So we talked about how we were going to deal with the price, because it was going to cost more. There were different ideas discussed and we moved forward. But then we also had problems with the production with the people we were working with, and were told that it would cost even more. I was a little novice then and I have learned a lot since that time.

NR I've been there too.

JK We would go into things and we maybe didn't have the right contracts from the very beginning, so things kept becoming more and

more expensive. So these things happened, but it wasn't really so catastrophic.

N R We've all gone through it.

J K The costs went up and that wasn't good, as there wasn't as much profit in things and in some cases there was actually a loss on individual pieces. We had multiple dealers working together and there was conflict there because nobody really wanted to assume more responsibility. With more responsibility would have come more reward, because it ended up that 'Celebration' was an extremely profitable body of work.

N R It's a most wonderful series, wonderful work.

J K Even though certain works made a tremendous loss – a loss on maybe this piece or that piece – in the long run it was a successful body of work.

N R We've all gone through that. I had that with my big exhibitions at the Royal Academy. Believe me, I've been in exactly the same situation, so I know exactly what you are talking about.

J K You know, on 'Made in Heaven' I was also working with multiple dealers. You have the politics in between the dealers.

N R How have you navigated that psychologically? How have you dealt with the so-called art world, or whatever you want to call it?

J K At the beginning part of 'Celebration', of course, I had my custody situation with my son – the divorce custody. I was preoccupied by that, and at the same time I was making these archetypal childhood images in 'Celebration', which were a driving force in trying to communicate with him from a distance.

N R I remember you at that time. I remember meeting you in all sorts of different circumstances.

J K So I had an economic drain, not through 'Celebration', but through the costs of lawyers to defend the custody case. So, basically, everything I had was lost to my legal expenses. Then the 'Celebration' work kind of got bogged down and production was slowed down, because we thought one thing would cost $600,000 and it ended up costing $1.6 million at the end. That was the greatest extreme that we had. It just slowed everything down.

N R Were you accepting of this? Did you lose sleep? Were you angry?

J K I wasn't angry. First of all I was upset with the production companies for not being more direct or having a greater understanding of what the costs would be. But it was also new to them. And it was the first time I was taking things to this level, just to produce objects that people could sustain as much belief in for as long as possible, to be lost

in the abstraction of viewing these pieces. I believed in the work.
I believed in the value of the work.

N R It is the overriding thing always, the value of the work.

 J K I remember Jeffrey Deitch telling me at one time that all the pieces
 of 'Celebration' wouldn't be finished for a decade. And I thought, 'What
 are you talking about, a decade? I am going to have to have a show.' The
 Guggenheim offered me a show and they needed it all within a year's
 time. They needed big pieces to fill a large space. I thought a decade was
 long, but some of those pieces are still unfinished – we are finishing that
 series right as we are speaking.

N R I think it's all rather beautiful, actually. What is a decade in human
history?

 J K This is two decades. We're finishing a sculpture called *Play-Doh*
 right now. But I realised that I had to work in parallel with this series –
 to work on other things, to be making other things at the same time.

N R 'Celebration' has a lot to do with a child's self-acceptance. One could
go even further with another question. Do you think that the child is the
archetypal free artist? Do you think of yourself as still being, in the best sense
of the word, a child, even today? Is that something that you want to preserve?

 J K It's beautiful that a child doesn't feel a sense of judgement.
 They don't make judgements about things. They just enjoy green for
 being green, a shape for being a shape. So I enjoy that openness from
 childhood, but I have to say I love the consciousness of mature life, the
 consciousness of how to try to have a vaster possibility. With a child
 it's just energy.

N R Is it chaotic, the child?

 J K People feel that time goes slower when you are a child. But it's
 just that you don't have anything to judge it by. I actually enjoy mature life
 as I have something to judge things by. It gives me a much greater sense
 of possibility for expansion, not just feeling that I wasn't here before.

N R At the moment you seem to be full of incredibly fertile ideas. But has
there ever been a moment when you didn't know what to do next? That's what
I would imagine life as an artist could lead to, as it were: not optimism, but
depression and pessimism. Have you ever been pessimistic about the world or
about yourself and your future?

 J K Well, there have been moments when I wished I had my work
 flowing more rapidly. You know, it's very important as an artist to make

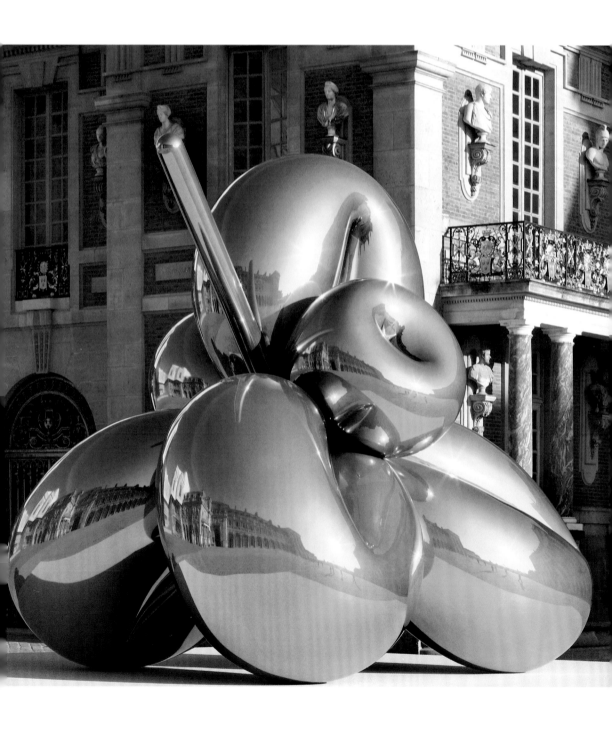

Balloon Flower (Yellow) [1995–2000],
Château de Versailles, France, 2008–9
[CELEBRATION]

things as rapidly as possible because it's a dialogue with time, with mortality. You want things to have reference, to have importance past your time, but it's very much of the moment. And so, when things become delayed, all of a sudden you are working on something and you realise five years have gone by or a decade has gone by. I don't want that. I want what I am thinking about today to be in this world at this moment. I want to have sculptures for these new paintings here now. I don't want to have to wait a year and a half or two years. But I'm closing that gap. Things are becoming more oriented in time.

My 'Celebration' series was where my time kind of went out of sync. I had to do it going through a divorce settlement when I was very distracted, but the delay also had to do with the development of the techniques to be able to make those works and then the economic ability to create them – we thought it would cost one amount, and it cost more. So that kind of spread the time out for my work, which is now getting condensed again. Then I would say going into a later body of work – something like the 'Popeye' – once I had things flowing again, it was just more or less a case of keeping building to create them at hand.

N R Are the 'Celebration' paintings and the 'Celebration' sculptures, if you like, objects for children? Have you had any response from children to these things already?

J K You know, when children come to the studio or to exhibitions, they usually enjoy the experience and respond well to things. There's just an acceptance of everything. There isn't a segregation; there's nobody in any way circling around, informing or creating segregation, creating a hierarchy, creating some form of rules of what can be in play, what cannot be in play and, really, disempowering.

N R Do you hate the idea of an elite? Do you think that art is an elitist thing or not? Or do you think it's an elite that's infinitely expandable, so that ultimately the whole world can participate?

J K In a perfect world the whole world could, but I think in the long run it's about an educated public, and an educated public that enjoys educating. Art is something that has educated me. But without education, there's still this openness with art, where green is green and blue is blue and a material – like porcelain – can be very, very exotic.

Building Blocks,
1996–2009
[CELEBRATION]

overleaf
Shelter
1996–8
[CELEBRATION]

Play-Doh, 1994 – work in progress
Production photo, San Fernando, California, 2006
[CELEBRATION]

It's arousal about life

EASYFUN, EASYFUN-ETHEREAL,
POPEYE AND HULK ELVIS
TO ANTIQUITY

NORMAN ROSENTHAL Your new paintings – and in fact your paintings since 'Easyfun' – are all very complex compositions. They are not easy things to view. How do you plan them? How do you make them, both technically and also philosophically, so that they project the answer – if you like, this sense of transformation and participation – that you wish them to?

JEFF KOONS I follow my instincts. The girl riding the dolphin [in *Antiquity 2,* 2009–11] is Gretchen Mol. I was asked to photograph her for the *New York Times Magazine* in 2006, because she starred in this film *The Notorious Bettie Page*, and in getting prepared for the shoot I looked at Bettie Page's old photographs. She was the great American symbol of free sexuality, our first pin-up. This was in the '50s, and she was one of the first liberated models … sexually. She *enjoyed* modelling.

NR Was she a real person called Bettie Page, or is that an invented name? Bettie on the Page?

JK I believe it's her real name. But she really represented women not having guilt or shame about their own bodies and having acceptance of themselves as sexual creatures, in American culture in the '50s.

NR Do you think they didn't before?

JK They wouldn't reveal that acceptance so much.

NR And you photographed her personally, this particular actress who was playing Bettie Page?

JK Yes. She's a great actress. I really thought she would be nominated for an Academy Award for her role here. She was great in that film. So this is her in the Bettie Page role. In an original photo that I found, Bettie Page was in a situation like this on the floor with the same type of '50s furniture, but this monkey was more of a Raggedy Ann type of doll – a kind of strange, clown-type figure. And so I just put the dolphin underneath her and changed the doll to a monkey. But the monkey gives it a sense of Darwinism, and it gives this sense of child, the Eros type of thing. I felt that it had a sense of mythology. It felt a little bit like Oedipus, this relationship with the monkey. And so I became interested in that, and that really led me to the antiquity period. When I started to investigate it, I had these feelings, but I didn't know exactly why. And then I found this, an image of Aphrodite and Eros and a dolphin, the same as Aphrodite and Eros featured in the 'Antiquity' paintings.

NR And you saw that after you had actually done this restaging?

JK Absolutely. Yes.

NR That's wonderful.

Hair, 1999
[EASYFUN]

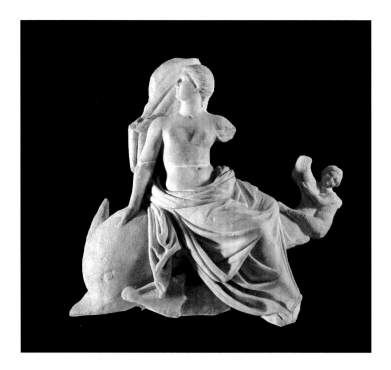

Girl with Dolphin and Monkey,
The Whitney Museum of American Art 75th Anniversary
Photograph Portfoilio, 2006

Statue of Aphrodite with a dolphin and Eros,
3rd century BC
Archaeological Museum of Thasos, Thasos, Greece

Antiquity 2, 2009–11
[ANTIQUITY]

Dutch Couple, 2007
[HULK ELVIS]

JK I realised that Eros is the child of Aphrodite, so it was all there in antiquity – the idea of Eros and the Oedipus thing of sex with the mother.

NR All riding the dolphin. Except that she was riding an inflatable dolphin – an American inflatable dolphin. As they say in French, *'Plus ça change, plus c'est la même chose'* – the more things change, the more they stay the same. You agree with that as well, presumably?

JK I think these are very core things.

NR Core images. It's a story, I think, that shows precisely what you are talking about, which is connecting and, certainly in this particular case, connecting to the past in a very important and a very significant way, while still using modern language.

JK When I have talked about metaphysics, or a form of connecting and bending time, for me this is an example.

NR Where did you find this dolphin object?

JK I just found it on the Internet. From a collection in Greece.

NR In Greece – I would have guessed. It's miraculous in a way. So do you, for example, feel like making a painting based on this as well?

JK I've been working with the dolphin for quite some time. When I was an art student, I remember making a drawing with a dolphin, and I've been making these dolphin sculptures in 'Popeye'.

NR What I call the 'pool toys', creating steel objects that look almost like balloons. It's the illusion that you could take a pin and prick one and it would just explode. It's the most amazing piece of … trompe l'oeil, if you like. Are you interested in the trompe l'oeil?

JK Not really. I don't really like the faux. What I'm trying to get with the pool toys isn't an illusion, but something that's dealing with the real – something existential, about inside and out. I would work with a ready-made pool toy, but it would eventually become soft. It would break down because of heat.

NR Like Damien Hirst's shark that began to collapse.

JK The plastic material it's made out of wouldn't hold up and when you looked at it you would have a different emotional response because of that, so I have had to make mine of a stronger material. Another aspect of those pool toys is that most of them are interacting with a ready-made in some manner, like *Caterpillar Ladder* [2003], where the caterpillar toy is going through the ladder. It's about being able to maintain one's course in life – these objects go through things, but do not lose their course.

NR Has this Bettie Page photograph appeared in other artworks, or is this the only one?

JK Well, I've made maybe one or two other dolphin paintings with Gretchen in them. I made a print edition of her on this dolphin. And this is a triple 'Popeye', Norman, with three 'Popeyes' in the background and a girl on top of the dolphin and a monkey [*Girl with Dolphin and Monkey Triple Popeye (Seascape)*, 2010].

NR I can see that.

JK It has a feeling a little bit of an edifice – connecting to antiquities, Greek tragedy.

NR Why Popeye here?

JK There's a little bit of a paternal, parental aspect to it – a little bit of my father's generation. But the monkey gives the sense of some youthful figure.

NR The monkey, as you say, is like a child. And this kind of Aphrodite girl riding the dolphin? She reminds me a little bit, in a certain way, of the famous Europa by Titian – I saw it the other week when I was in Boston. Do you know that wonderful painting *The Rape of Europa* [1562]?

JK Oh yes, absolutely.

NR So can we say perhaps that it is a kind of modern version? But who is Popeye? Why Popeye? You know, we can make these little jokes about 'Pop' and 'eye', and we can talk about what Popeye meant in America in the 1920s or '30s, I think. Was he not an invention of what you might call the Depression?

JK Yes, absolutely. It's this sense of 'I am what I am'. This sense of …

NR Acceptance.

JK Yes, acceptance. But look at Popeye's face. Look at his nose, and look at his chin. It's a symbol of male energy.

NR You mean the balls in the chin?

JK Yes, it's a bit like genitals.

NR I suppose I can see that!

JK The background is from a painting, a seascape. I found it on the street about 20 years ago, and I thought I would like to use it in some way in a work. I could never really find anything in which it functioned well, and finally for this painting it did. So we have Popeye, we have these swishes. This kind of arabesque type of swirl, as if Cy Twombly were to draw origins of the world.

N R Yes. I know those swirls of Cy's.

 J K It's like Courbet's *Origin of the World* [1866] [page 144]. That could
 be pubic hair up top. The movement just up and down.

N R And there's the spinach, of course, the legendary spinach that
I remember from my childhood.

 J K In this case the spinach would be the symbol of how art can give
 you that transformation, that type of change.

N R And the tank, that rather phallic-looking tank on his arm? Is there a kind
of phallic aspect to the tank?

 J K That energy makes me think of Roy Lichtenstein's paintings. It's a
 sense of having a communication with Roy, absolutely – it's male energy,
 this very visceral quality.

N R Well, I am looking at this painting, and I can see those three Popeyes
and the beautiful girl riding a dolphin, and the Popeyes begin to remind me a
little bit of Picasso's *Les Demoiselles d'Avignon* [1907] – that
semi-pornographic painting. It isn't pornographic, of course, but it is about a
bordello somewhere in Avignon, with four women and another woman
crouching to the side, and I don't think there is even a male figure in it, but
while it's kind of inviting, it's a kind of shocking painting. And that's what I see
in this picture. But I'm not sure that Picasso is really a painter about community.
He is a painter about private dreams and private communication. There is this
difference between privacy – the private communication that a work of art can
engender – and the public piece. And you have obviously done both.

 J K But there is a definite sense in his work of the community in Paris at
 the turn of the century.

N R The art community, yes. Even though in the case of *Les Demoiselles
d'Avignon* Picasso kept it back from his community. He was so shocked that he
had done it that he kept it away from people for many years before he showed
it to the world. He just couldn't bring himself to show it to people – it was so
shocking, even to the artist. He became this medium that executed the
painting, which now looks as though it belongs to the grand tradition of Titian
if you like, this grand history, because of its scale and its *noblesse* at one level,
its *poesía*. Yet the subject was so shocking that he didn't present it for a very
long time. He turned the canvas round instead.

 J K I have a painting called *The Kiss* [1969] by Picasso that makes
 reference, I think, to his accomplishment of painting *Les Demoiselles
 d'Avignon*. The woman in *The Kiss,* the way he painted her, and where her
 elbow is on a pillow in the painting, probably makes reference back to
 his sense of conquest in painting *Les Demoiselles.*

Titian
The Rape of Europa, 1562
Stewart Gardner Museum, Boston, Massachusetts

Pablo Picasso
Les Demoiselles d'Avignon, 1907
Museum of Modern Art, New York,

Pablo Picasso
Le Baiser, 1969
Koons Collection

Willem de Kooning
Woman I, 1950–2
Museum of Modern Art, New York

NR And the dolphin in your painting here seems to be laughing. Popeye seems to be laughing. Do you want us to laugh when we look at the painting? Do you want us to enjoy it, in the sense of smiling? Should it bring a smile to your face when you look at the picture?

JK You know, Norman, I wouldn't necessarily like a smile. I would want the viewer physically to feel engaged in a very positive manner – you know, upbeat – but I don't know about humour necessarily. Maybe a smile, but not a laugh.

NR A gentle smile?

JK Maybe a gentle smile because it's about a positive kind of energy.

NR Once again, what I find so remarkable about these recent paintings is that you actually feel the satin, that you feel the plastic, and they have – I hate to use this word once again, but I'm going to come back to it and I'm not going to let it go – this idea of perfection. Your assistants who help paint your pictures, doing a lot of the manual work, are unbelievably skilled in achieving this sense of absolute reproduction, so that when you look at that monkey it really does look plastic, and when you look at that girl's gloves they really do look like satin. When you look at those stockings, my God, they're unbelievably sheer, they are perfectly sheer. I've never met a woman with such sheer stockings.

JK You know, their gestures are fake gestures. We paint these with little brushes so they are transparent, but it's all done with little brush strokes so we never come with a flourish or a swoosh.

NR When De Kooning paints, it is literally 'whoosh, whoosh, whoosh', but when you do it every moment is a kind of … a simulacrum of expression.

JK The whole thing is a gesture. It gives even more impact, I think, that the whole painting is a gesture.

NR And she is eternally riding. There is the sense of eternity too, that she's forever on this beautiful ride. It's a magic moment, which is, again, the beauty of paintings. You know the reason I like paintings rather than film is because they have this sense of forever-ness. Do you understand? A film is like life. You're here now, then you'll be there, then later on you'll be there, and you will never be here again. You are only here now and in this particular position. But the thing about painting – and all great paintings, including yours – is that it has this incredible sense of eternity. Do you agree with me about that? You know, this painting we are talking about has remarkable movement. It's like some crazy Futurist picture – movement and dynamism and all that – but at the same time it's not moving, it's there.

JK I think there's a sense of humanity in paintings, there's a warmth to them.

N R The complexity of your pictures, that is interesting to me. Let's talk about this word 'layering'. You say you don't like things to be confusing or different or difficult, yet your paintings now seem to exist in an infinite number of layers, both historically and also technically. I mean the technical layering of your paintings is highly interesting and complex. Is this meant to make the reading of them more difficult or less difficult? Do you feel that you want your things to be direct and simple?

> J K I would hope that a viewer could come in and just get excited, as they would start to be visually stimulated from images. I would hope that it's very intuitive. It's not about using history or technique against the viewer; it's not that it's somehow saying that this is on a level that you must know, that you can't understand or appreciate this unless you have more knowledge. I'm not just trying to put layers of history in there so that somebody could only understand them if they opened up a Janson book on history and looked at the timeline of civilisation.

N R It doesn't feel at all like that to me.

> J K It's not inhibited. It doesn't inhibit the viewer. The viewer doesn't look at this 'Antiquity' series and say, 'Oh, my gosh, do I have to go to this museum and that museum to understand what Jeff's talking about?' Because they don't need any of that. It's about what happens to them internally through these layerings.

N R Why did this world of antiquity become so important to you relatively recently?

> J K I would say it's due to a sense of my own mortality. A sense of time and the appreciation of human history, with a desire to contribute, automatically make you want to look back at significant contributions of others and to learn from them.

N R Could you imagine getting involved with Asian antiquities for example, which can be just as old and ancient as Greek objects?

> J K I could imagine getting involved with anything, looking at any image, any object, any period. But for me it just seemed intuitively that Greek antiquity was the most direct for me to use. I've always enjoyed philosophy, with a basis in Greek philosophy.

N R Are you making connections with the makers or the viewers from the past, or both?

> J K I would have to say it's more the makers. But, Norman, connecting shows in a way how little things change. The motivations don't really change, the desires don't change, the freedom that the individual has – the opportunity that they have to take advantage of – doesn't change.

Sometimes when you look back at history you understand the parameter of that freedom better than you do in the present tense. I find a little reassurance in that. I guess there's a sense of understanding because you view it at a distance.

NR But if a person looks at your *Farnese Bull [Antiquity (Farnese Bull), 2009–12]*, who perhaps doesn't know the *Farnese Bull* in the way that you and I know the *Farnese Bull* [AD 222–35], what do you think they get out of the *Farnese Bull* or the satyr as an image? What would they get?

JK Only what they need at that moment to get from it. I think they are going to look at it and they will notice the shapes. I think they will probably notice in the tree that there's a knot that's a very vaginal shape. They will realise that this is a bull, a very masculine object, a very sexualised object that's being harnessed in some manner. They'll pick up that there's a woman there, and automatically as soon as you have a woman – a beautiful and attractive type of woman – you start to get ideas about sexual interaction. I think it's about external culture, about human desires.

NR Do you want people literally to be sexually aroused by your pictures, or do you want them to be intellectually engaged, or both simultaneously?

JK Intellectually engaged. The definition of 'porno' would be to be sexually aroused, and it's not about sexual arousal – it's arousal about life. I'm an optimist. I'm pro-existence. I think it's more interesting to see where we can go than just see how soon we can stop. And it's just very open. It's very generous; it's completely not demanding anything from the viewer other than just to …

NR To enjoy the picture.

JK Yes, that's right, to enjoy their own physical and intellectual response.

NR Do you think everybody should form their own intellectual response, or do you think there's a kind of programmatic intent? In the 19th century these might almost have been called history paintings. They seem to embody a kind of history that relates both to particularly old European culture – talking about your current paintings – and to contemporary American optimism. So it's almost like a combination of melancholy, on the one hand, and optimism, on the other, which you embody so beautifully. Do you feel them to be optimistic paintings purely, or do you think there is also this melancholy as well – a kind of lost world that you might like to recover?

JK I would like the body of work to be three-dimensional and to be able to show as many sides in as many situations as possible, so that

Antiquity (Farnese Bull), 2009–12
[ANTIQUITY]

Francis Picabia,
Mi, 1929
Koons Collection

The Farnese Bull,
Roman copy of a Greek original by
Apollonius of Tralles, AD 222–35
Naples National Archaeological Museum,
Naples

Capitoline Venus
from an original by Praxiteles,
4th century BC
Musei Capitolini, Rome

The Farnese Hercules,
Roman copy of the original by
Lysippos, 3rd century AD
Naples National Archaeological Museum,
Naples

even in individual works it's not just one-dimensional. You do not have to have just the one side.

NR I wonder, do you have a kind of programme how these things are read?

JK I think in general with work there is a certain aspect where you do have to give up control. You know you are not even going to be around in however many years and that whatever is read, whatever is listened to, whatever moves contemporary audiences, whatever their cultural history may be, whatever the political situation at that time, is constantly changing and will be in flux. Only key central parts of the work are probably going to stay relevant, and those things are more profound and not so surface-orientated around individual lives. I would say that those are the things that I'm trying to direct and formulate control around, so that the viewer comes into contact with those areas. I leave a lot of freedom on the outside, and that freedom is actually exciting. It has a certain texture to it in itself.

NR In relation to what you were saying about generational change, and about dimensions, I think your sense of time and going back in time in your paintings is so fascinating at the moment, because you seem to be going back not only to Classical times, but even to a geological time through the way you are layering the paintings. Your paintings now are very much about sculpture, and they are very much about what I can only describe as dimensionality, almost in an Einsteinian sense, in that it's not about three dimensions, it's about four dimensions and possibly more. The way you layer your paintings now allows you to achieve sculptural things that you can barely achieve in sculpture itself. Do you agree?

JK I enjoy layering, and there are some artists who have worked through placing images on top of each other with montage.

NR Since Picasso, for instance.

JK Picabia opened up a lot with his layers of transparency; Magritte and Dalí opened up ways of being able to have images on top of images or having more images there than just a single one, and I enjoy that because it helps to add more dimensions, to speak about multiple dimensions. I'm always interested to make a painting bigger than its parts, something that doesn't just seem to be composed by sticking things together. I want the connections to enrich the work and to hide the formal construction of the piece. The works always want to be sure that they are total gestures.

NR How do you accomplish that cohesiveness? How do you control the drawing, which in the end is the foundation as far as the paintings are concerned? The colour is incredibly important – the precise colour and the gradations – but the drawing, in whatever form it takes, has to be the beginning.

JK I'll start looking at images, at night, online perhaps – things that I have interest in – and then I'll come in the morning and we'll download them. For instance, recently I'm looking at kayaks because I'm thinking of this vaginal kind of shape, and I'm also looking at different pieces from antiquity.

NR There is a private library. It's a repertory of images that make sense to you, whether it's the vaginal kayak or the *Farnese Hercules* [3rd century AD]. Do you want people to know this about these images, or would you rather that they didn't know? Do you want people to know your sources, which are the result of a kind of study, or would you rather that they remain secret?

JK I think it doesn't matter if they know or not. I mean, if they do pick up on these things, that's great.

NR For me it's fascinating.

JK To know is an enrichment, but you don't have to; it's back to art not being an intimidating thing. You don't have to bring anything to it other than your own life experience, because it's really about you and your interactions. I have my interactions and my enjoyment and what helps me continue to expand my parameters, but the viewer doesn't have to participate specifically in the dialogue I find interesting. For instance, take the new rabbit [*Balloon Rabbit,* 2005–10]. When the nose was added on, it became very cute, and it is 14 feet [4 metres] tall, but still, it has a 7-foot [2-metre] vaginal area. That is beyond a cultural recognition, it is biological. And yet I know I've told you before that, when I made it, I thought it reminded me very much of an Egyptian sun god. I know that there's a kind of a masculine aspect to it, but if you look at this – there's Nefertiti.

NR Yes, Nefertiti, the whole angle of the thing.

JK Yes, keep going and you see the wrapping around here – the nose, the angle of the hat, the proportion of the hat – and there's still a masculine aspect. That's Nefertiti – very feminine, but there's a masculine aspect to its power. I thought that was an interesting coincidence.

NR I completely see what you mean, and I don't think it's making it banal. I think it's making it modern. And what is interesting is that in the last 10 years there has been this ability to call up imagery on the World Wide Web; for

Bagel, 2002
[EASYFUN-ETHEREAL]

Bust of Queen Nefertiti from Amarna,
Thutmosis's workshop, Egypt, *c* 1350 BC
Ägyptisches Museum, Staatliche Museen zu Berlin

Balloon Rabbit (Yellow), 2005–10
[HYBRID]

example, when I came in this morning we suddenly decided to call up a painting by Titian. Well, unless you had a big volume on Titian here you wouldn't be able to look it up that easily, and maybe it wouldn't even be in that book. But we were able just to press a button and in one second have the picture. So there's this bottomless wealth of imagery now that is available to everybody – academic to pornographic – and one can just get it up with the switch of a button. Has that changed the world incredibly, do you think? For you?

JK Absolutely.

NR And you are using that all the time?

JK Yes, because I love to look at things. When I was younger, or in a prior time before the Internet, I would walk around on the streets, and I'd look in showroom windows, look in galleries, an activity of physical movement around a city looking at objects, and now it can be more just

…

NR Cruising the Internet – what I call cruising the Internet, as it were, which everybody now does. But are we losing something? Are we losing reality, or are we more in touch with it? Or is it just another form?

JK I think just another form. But you still have to stay motivated. You have to continue to expand your interests; you have to always let something leave you somewhere else. It's the same if you are physically walking around and investigating something, and then you are confronted by something else and then you follow that direction. But I think when people surf they have to continue to keep expanding their interests.

NR To follow choices through. It's about following choice, isn't it?

JK Yes, they have to continue to expand and use their choice, because I think people end up not using it. At first there's a novelty to surfing, but I think you have to continue to choose, because otherwise it's overwhelming, actually.

NR You are, of course, beginning to develop this new series of works that perhaps you are going to call the 'Antiquity' series. I am loving that you are becoming a man of the past and the present and, maybe through that, the future. Do you think the future is embedded in the past?

JK I think everything is connected. We discussed the first time I saw Manet's work and how, when my art history teacher started to talk about it, then all of a sudden the possibilities of art started coming to me. Prior to that I had no idea what the breadth of art could be. It had been something about making things that looked good; I had absolutely no

idea. From that time I have always appreciated other artists' work, how art can really connect you to the different disciplines. So, in working on something like the 'Antiquity' series, it's being able to have a dialogue, taking you back to Praxiteles and these artists where we are not sure their work even exists. There are different copies, or maybe there is a vase of Praxiteles that still exists, but even with the greatest artists of antiquity, we really don't have anything left, and that aspect – having a dialogue with mortality – is really important. It enters into this archetypal information that we carry, narratives that are truly important to us.

N R Would you like to see your new sculptures situated in rooms with Classical sculpture? Or would you rather have them completely isolated and by themselves?

J K I would say first they would want to be in rooms with my paintings. First, for this new series, they would want to have their dialogue together as a group.

N R With themselves as a series, in other words?

J K With themselves. So that they can be experienced to whatever level the world sees their dialogue and what my intentions were. Once that intention is felt, then they can each go off on their own.

N R Would you like to do a painting or a sculpture specifically to sit somewhere forever? On a staircase or on a ceiling in the Louvre? Would you enjoy that?

J K That would be great.

N R The Louvre is only an example where other artists have done this recently.

J K I would enjoy that, but the only thing I wouldn't enjoy is giving the idea that 'You have to see this forever'. That's the only thing that I wouldn't like about it. I would enjoy the concept of it. It's great, it's wonderful, but the only negative thing is setting something up like that where it has to be there forever. Hopefully it would be there forever, that people would want it to be there forever, but by force of excitement, not some agreement.

N R I understand that relationship with permanence, not wanting to be old. You have this sense of time, where different periods exist simultaneously within every sculpture and every painting. Maybe I'm wrong, but that's the way I read what you are doing at the moment in the 'Antiquity' series.

J K When a very controlled vocabulary, a very precisely articulated vocabulary in two dimensions or in three dimensions, is brought together,

Antonio Canova
Fountain Nymph, 1817
The Royal Collection

Édouard Manet
Le dejeuner sur l'herbe,
1863
Musée d'Orsay, Paris

Gian Lorenzo Bernini
The Rape of Proserpina,
1621–2
Galleria Borghese, Rome

William Adolphe Bouguereau
Le Jour, 1884
Koons Collection

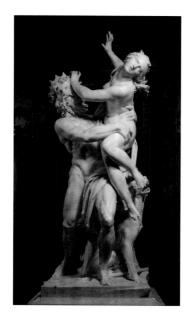

it emulates our kind of human experience in the way we see the world both in the form of body and idea. That's what I feel is very special about having these objects.

NR Do you want people to recognise your sources or just instinctively feel them?

JK I love Manet and I'm trying to share how coming into contact with Manet, or Dalí or Rubens, perhaps helps provoke a sense of enlightenment, an expansion, a sense of feeling connected and of possibility. I would like them to rejoice in the sources and the connections.

NR You talk about Praxiteles, and perhaps we can talk about the sculptors of the past that interest you. For example, do you love Canova or not?

JK The Hermaphrodite? Not so much. Not so much.

NR Why don't you like Canova? Because at one level one could say that I could imagine you giving me the opposite answer. Canova is certainly an artist who tried to achieve this kind of Neoclassical perfection.

JK I feel that perfection, and I think that my work is a lot simpler. I don't want my work ever to feel that confined, that its performance is confined. For me the performance happens outside the object. It's a freer performance. If I look at Canova, I feel that everything is so controlled and that it has to be just a certain way. If I look at Bernini, it's so powerful, it's so rich, so involved …

NR So sexy too.

JK And so perfect. But you look at the chest of the dog in *The Rape of Proserpina* [1621–2]; it's so lightly honed as far as the chisel marks go. Even though the dog's hair flows in a pattern in one direction, the dog's hair is going in different directions in a way that wouldn't actually happen on a dog, but still it just works. It's perfect, and that sense of freedom is also necessary. Norman, I know you always enjoy *Puppy* [1992].

NR That kind of sculpture – *Puppy*, for example – has a different manner to the quasi-perfections of the 'Celebration' sculptures.

JK The element that I think is so successful in *Puppy* is this dialogue between control and giving up control, and that's what you feel in Bernini – absolutely controlled elements meeting other aspects that are completely uncontrolled. The passions are uncontrolled, and the action, the movement, what's going to happen next is more open.

NR And in Bernini's *Saint Teresa* [1647–52] [page 144], for example.

JK Yes, if you look at the ability to control the material and at the same time the joy you could feel of him giving up controlling it, like on the chest of the dog.

NR What do you feel about Michelangelo's sculptures – say, of the slaves? What do you feel about those?

JK It's the same aspect, same effect.

NR So you think Neoclassical sculpture, as it were, is not that? I mean, you are very interested in antique sculpture – as you say, Praxiteles, but Praxiteles is more of an idea, as we don't quite know what he did. When you go to a great museum, whether it's the Metropolitan Museum, the archaeological museum in Naples or the British Museum, you see these white, perfect sculptures that, as you know, were probably once painted. If you look at the label sometimes it says 'slight traces of colour', as though you could even possibly know what they really looked like. The sculptures are not coloured in your Neoclassical paintings that you are doing at the moment.

JK There's just a kind of patina they've developed over time.

NR Over years and years.

JK But my sculptures, I patina some of them – and some of the new stone pieces will just be the natural colour of their stone.

NR Have you ever thought of painting the stone?

JK I am going to, in some. I am making one, a ballerina couple, which I will call *Ballet Couple*. I'm thinking about using a Greek stone – you don't have that pure white stone coming out from there any more – or using a stone from northern Italy, and I will patina it on top. But I've always loved working with ready-made objects; I always just loved the colour of the object itself coming from the object itself and not imposing any type of polychrome on top.

NR Will the couple be like our friend over there [Pink Ballerina, work in progress], in this kind of manner in what you might call the 'Dresden effect'? Like a little Dresden porcelain ballerina.

JK When she's completed, this little Dresden ballerina will be 8½ feet [2.5 metres] tall, so a little larger than life, and she will be in her ballerina dress, but her hands pull her dress up together in the front with this lace on the outside, which is very decorative, almost like coral, as if Aphrodite is born from the sea. But underneath, the ruffles of her dress are smooth like the porcelain. So it's very vaginal and it's like the rites of spring, and it's really celebrating her biology. It's celebrating a true narrative, a biological narrative. There will be flowers that are embedded in the lace of her dress, which again ties it to a belief in life and a true life energy.

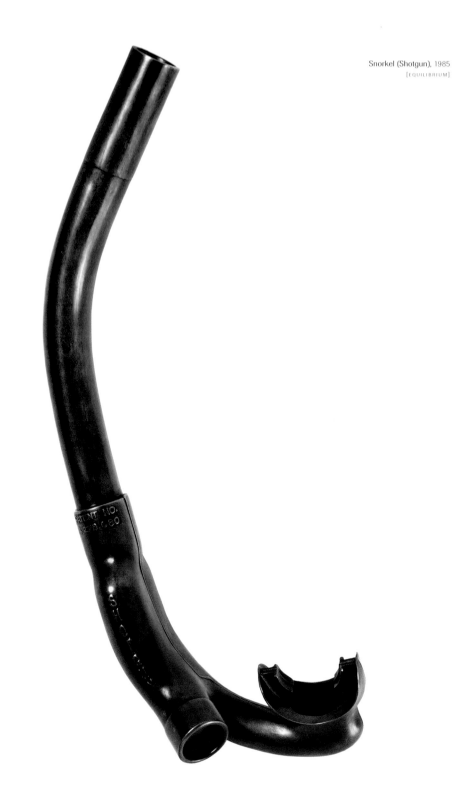

Auguste Rodin
Triton and Nereid, *c* 1886–93
Metropolitan Museum of Art, New York

Auguste Rodin
Monument to Balzac, 1898 (cast 1954)
Museum of Modern Art, New York

N R Is she going to empower a man in a different way to the way she might empower, hopefully, a woman?

 J K I hope that the experience is similar, but I'm also working on some images that are more male, as well as some fertility-type images. But I think something like this touches everyone because of the life energy.

N R Can I ask you about Rodin? How do you regard Rodin as a sculptor?

 J K You know, I like Rodin.

N R Is he useful to you in any way?

 J K Absolutely. I think about someone like Bernini more, but I love some of Rodin's figures. Here's an image of a little statue at the Met where the leg is removed [*Triton and Nereid, c* 1886–93]. It's cast in bronze but it's from a terracotta. The leg is removed and you look all the way through her. When I was making my *Balloon Venus* [2008–12] [page 21], I was so excited about looking inside these different areas. The Rodin is like that, where through her leg you look right up into her. Isn't it great? It's so sexy, her legs are open, spread, and then her leg itself is open so that the hole penetrates in the core of her leg. That's great. I also want to show you another Rodin [*Jules Bastien-Lepage*, 1887–9]. This is in the Philadelphia Museum. He was a friend of Rodin's, another artist, and if you look here, there's a woman's vaginal area in the base.

N R That's exactly what it is. Do you find these things expressionistic, or do they actually correspond to your concept of objectivity, these works – particularly Rodin?

 J K I would say objectivity is vast. It's making many references to different aspects of human life: involvement in the world, with each other, interests.

N R Could you imagine yourself making a modern version of *The Gates of Hell* [1880–1917]?

 J K I could imagine making a modern version of *Balzac* [1898]. I think I am already trying to make something similar. There are references to a person in *Balzac*, but I see it as just a very phallic structure. That became so evident to me when I saw it in the Modern's new glassed atrium and I realised that the coat was just like a foreskin.

N R I wanted to ask you again about religion. You are a very spiritual person clearly. What in your work or your life relates directly to Christianity?

 J K I was brought up basically in the Protestant religion. We were Lutheran, but my family wasn't really practising. I would go to church

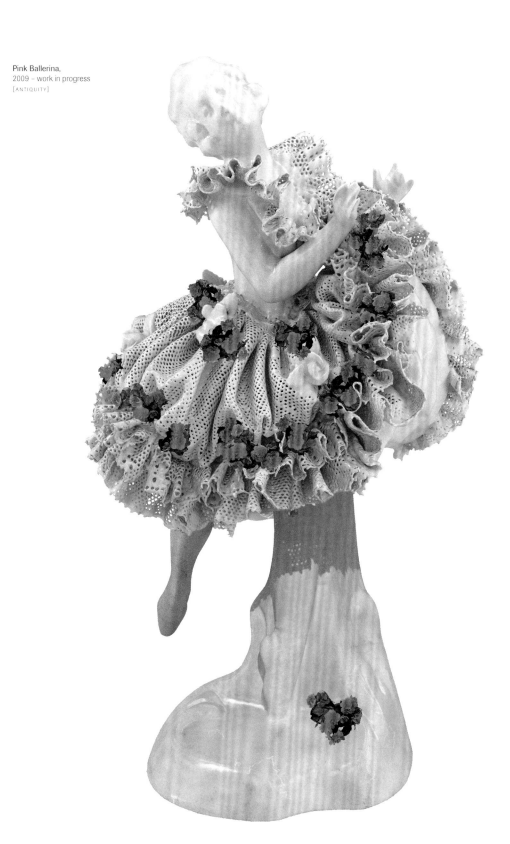

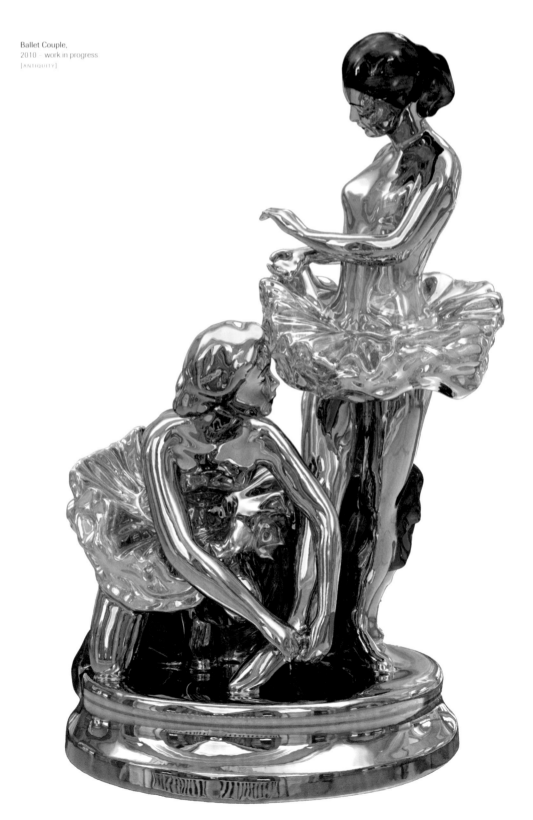

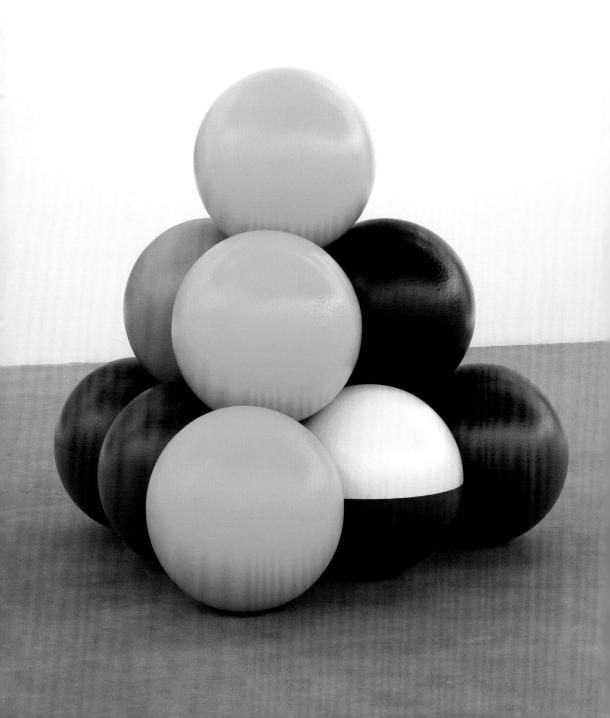

sometimes with my family and I enjoyed looking at the images, and feeling a kind of positive sense of being gathered together within a community – people showing that they care about each other. There's a sense of something a little different there, maybe a sense of transcendence in some manner.

I never got involved in organised religion and I would have to say that I feel more scientifically based. But I believe in caring about other human beings, I believe in the community, I believe in a connective quality, and I think it's a responsibility that we have to connect.

NR Do you believe in God?

JK No, no. I believe in something larger, vaster, a much greater perspective on everything. But I don't believe in God in its form in organised religion.

NR Will your works exist far into the future, do you think?

JK They exist now because I would like them to exist, and also because I have a platform at this time to a certain degree that also supports their existence. As long as that platform exists they continue to exist. If a platform is removed – and all platforms, it seems, eventually in history get removed – things then go into non-existence.

NR And then they become maybe archaeology?

JK They become archaeology.

NR And then they get resurrected.

JK Eventually they become dust.

NR No, they become resurrected, because you are resurrecting a lot of thoughts coming from the past.

JK There is no Praxiteles, for sure. There may be one that they think is, but nobody knows for sure.

NR But he is a kind of idea. He's like a philosopher of art and, as it were, he made models that you are still remaking. So you are re-manifesting the idea of Praxiteles.

JK But the way that things disappear, it's through, at some level, a lack of appreciation for what they are. And some things happen because of economics, which change in time, so that economic value is placed above a cultural or artistic value, and things get melted down. If something is more expensive to move than to destroy, then sometimes people just destroy. Even a young artist, if you have a lot of work and you are changing studios … I mean, artists have destroyed a lot of their own work for economic reasons.

Cannonballs (Hulk),
2006–10
[HULK ELVIS]

overleaf
Dictator [2006–9],
Park Avenue Armory, New York, 2009
[HULK ELVIS]

NR Economically they cannot hold on to them. Tell me, by the way, about
these two works that you've made recently. To me it's quite surprising looking
at those balls there, a piece called *Cannonballs* [*Cannonballs (Hulk)*, 2006–10],
and you made a piece called *Dictator* [2006–9]. They are in a sense slightly
uncharacteristic – certainly the titles and the subjects.

> JK When we discussed 'Statuary' [1986] before, I mentioned *Bob Hope,*
> which was on one end of a panoramic view of society. I had *Bob Hope* on
> one side and on the other *Louis XIV*, and *Bob Hope* was supposed to be
> the masses.

NR The people.

> JK The people. And then Louis XIV was, of course, somebody who was
> just in control, total individual control.

NR He was the archetypal king. Is *Dictator* connected to Louis XIV. It's like a
kind of cannon?

> JK It is. It's a water cannon. It is based on the cannon that they say
> really terrorised the people in the Civil War.

NR So it was in control of the masses, like Louis. It's very uncharacteristic in
many respects, and it's quite difficult even to recognise it as one of your works.

> JK I think if you see it eventually within the context of the 'Hulk Elvis'
> sculptures and paintings it would sit well. This is a moral exercise of
> recreating something. You can't recreate The Dictator cannon
> authentically. You can't cast it with the same original chemicals, but
> morally I tried to make as authentic a recreation as possible.

NR An equivalent.

> JK An equivalent. But it's as authentic as I could make it.

NR You researched it and everything?

> JK Oh, yes, absolutely. We can say there's nothing in this world that is
> as authentic to The Dictator cannon as this *Dictator* sculpture.

NR Is there a particular thing in a museum that it is 'copying'?

> JK We used every museum curator we could find for drawings and
> references. The straps in the back are very sexual. They're very much
> containing, but through a sense of castration to a certain degree. And
> because it's very thick, it maybe shows the imperfection of war, or the
> concept of war. You have war constantly throughout history, but it is
> imperfect. What goes on the other side of this is, of course, the *Liberty
> Bell* which is like the *Bob Hope* to the *Dictator*.

Liberty Bell
2006 – work in progress
[HULK ELVIS]

NR So the *Liberty Bell* is part of 'Hulk Elvis' too?

JK Yes, it's the other panoramic side. So you have the *Dictator* and then you have the *Liberty Bell*. Both have sexual references. The *Liberty Bell* is like a skirt – it always reminded me of Dalí's little Alice running around.

NR Would an American person recognise that cannon for what it is?

JK No.

NR But they would recognise the Liberty Bell. Even I recognise the Liberty Bell.

JK I think they will feel the power of what that is. They will feel the power of what it could do. They will feel the sexual references to it – that one is masculine and one is feminine. This bell is cracked. It's like a loss of virginity. The spider is up inside it. The spider is very, very similar to, again, looking inside the woman. It has all the Duchampian references, and a lot of people have worked with the Liberty Bell. But again this is an exact moral exercise, and it fails.

I think *Cannonballs* looks very nice with this painting, which is called *Couple (Dots) Landscape* [2009], which is paying homage to Pop art, to machine-made art, to Dalí, to Polke, and in contemporary times to Damien Hirst's spots. It's constructed differently from those examples, but it functions like an avant-garde painting and that's what it's making reference to, going from Courbet to the concept of the avant-garde to today. Even though we don't think so much about the avant-garde today.

These paintings and the other sculptures that are a body of work called 'Hulk Elvis'; I've never yet had the pleasure of showing them as a complete body of work. But it includes high-testosterone, male paintings of the hulks, posed as triple Elvises – like Andy Warhol's *Elvis* works [1963], the images he made of Elvis with the gun. As well as Warhol, the Hulk inflatable reminds me of the guardian gods from Eastern cultures. And then I have these more feminine-aspect paintings that are couples in landscapes [such as *Landscape (Waterfall) II*, 2007]. The *Cannonballs (Hulk)* sculpture [2006–10] is a Hulk that's broken down by colours proportionally into a pyramid of cannonballs. One cannonball is divided in half.

NR Could you describe the huge train you are planning, because I've seen the image. Does it move at any point, or is it just a thing that is suspended from a crane? It is a still thing, if you like?

JK Yes. The only things that move are its wheels, and it has different valves that move and different gears that move.

Landscape (Waterfall) II, 2007

NR So, like a clock, like a kind of magic clock?

JK It does everything that a real train does, but it's suspended and it does it at a different speed. Even the noise situation is there.

NR What kind of metaphysics, as it were, impels the train to be suspended from a crane? Did you have a dream about it?

JK I saw a crane out in a field in Sweden, and I thought it was a wonderful ready-made. It's like a ladder, and I've always wanted to do pieces with a ladder – I've done works with a ladder. It's a great ready-made, and it's a symbol that something has happened.

NR Something has happened?

JK Yes, something's happened when you use a crane – when you are building or dismantling, that's when you use a crane. And I was taking my children riding on steam trains and I don't know if that was part of the impact of it, as I am always open to my environment and always looking for information. I don't know if 9/11 was also part of the impact of it; 9/11 affected everybody somehow.

NR Is there a disaster aspect to this thing? Is there danger? Are you supposed to feel that this thing is going to come crashing down?

JK You walk right underneath it and it will not come crashing down, but it's the intensity of its power that you are playing with. And I really want to excite children. I really want to give children an experience that they want to be part of, so it isn't them complaining, 'I don't want to go there, not again'.

NR Yes, I have that with my children too.

JK You say, 'Let's go and look at these paintings', and they say, 'Oh, no, not again'.

NR There's the great *Puppy*, which had immense power to reach an extraordinary number of people. It has become a great image of our time. Thinking about your train project, it could be on either coast, it could be an amazing project for Ground Zero. It would be an amazing symbol for the *new* New York. It could be built as high as the Statue of Liberty. It would be much better to have that than another boring office building, to build an incredible train as a kind of symbol of something – I'm not quite sure what. Is it a symbol of America, by the way, the train? Or a lost world, which is after all what the great railroads of the 19th century have become? Is the train your great gesture at the moment? Or at least one of them?

Train, model for public sculpture,
2003 – work in progress

JK I conceived of the train, I guess, probably about 2003. I would like to see it built, and I'm very confident that it will be built. If it doesn't happen at LACMA it may end up going somewhere else. It could go to another place in the world.

NR How tall is it supposed to be?

JK The top of the crane is 161 feet [49 metres] tall. I think the train does have an aspect of mortality about it. There are references to an industrial age, or at least to power, different kinds of power, as the steam engine is very powerful. When you think about power, one of the things that comes to mind is nuclear power, which has surpassed steam, but the steam engine is one of the great images that we keep going back to. It has an iconic quality.

NR The steam engine is an image of the past almost as much as the *Farnese Bull* [AD 222–35], which is also an object of power.

JK It would be great to have the *Farnese Bull* in a square somewhere. Just because it's older doesn't mean it shouldn't be there. The train is making reference to a past, but I don't know if it's necessarily just American; it's trying to have a dialogue with mortality. If the viewer can have a sense of a dialogue with mortality, then it works. It can keep people in contact with this kind of sense of time – still enjoying a moment, but having a sense of perspective on one's place in history. There's also a sexual situation taking place: the whole starting of the train and going up to maximum power, then having a pause there and then a 'woo woo' – an orgasm – and then coming back down.

NR Do you like the idea of the monument?

JK I like the idea of the monument.

NR Presumably your train is a kind of monument, because it's so public? It's a public sculpture, if it ever gets realised, and I hope it does.

JK I hope it gets realised too. I've also designed a huge airship called *Lips*.

NR Lips. Like Mae West's lips, or Dalí?

JK Lee Miller's lips actually. Man Ray's model, the photographer Lee Miller.

NR I knew her very well by the way, although she was an old lady by the time I met her. She must have been incredibly beautiful.

JK Here's an image. It comes from realising that Man Ray's *Airship* – his *Lips* – probably came from seeing an airship in a park in Paris; they

used to lift up the airship. The Hindenburg was three-quarters of the length of the single *Lips*, so *The Kiss* is four times the size in volume.

NR Do you imagine this as a sculpture that would move around the world?

JK Yes, and we've engineered the first phase. I worked with the company Zeppelin.

NR So it would move around the world as a *thing* to delight people.

JK It is completely covered with silver panel.

NR It's incredibly beautiful. That's another dream that *could* – if there was energy – be realised.

JK Yes, it could be. And with the train, I hope that they do proceed at LACMA. If they don't, then I would have to take it to another part of the world.

NR For example, would you like to see it in Beijing? Would you be happy for it to be in Beijing or Shanghai?

JK I think it just wants to exist.

NR It just wants to exist.

JK And I guess it believes that its situation would be a public space, but it would be happy anywhere. It just wants to be around people and let people enjoy it. When I say that 'it wants', of course, these are objects; they don't have feelings as such.

NR So that it becomes almost like an object that becomes a symbol of a town. Would you like it to be like a symbol of a place?

JK Maybe not.

NR Like the *Little Mermaid*. I'm sure you know the *Little Mermaid* in Copenhagen has become a symbol of a place, even of a nation. And in Paris there's the wonderful monument – the Eiffel Tower – which was thought to be rather horrendous when it was built, but which in fact has become a great symbol. Do you feel that is a grand gesture? Do you think, in fact, that your train is a kind of equivalent to that, for a city, for a place, for the world?

JK I don't feel that the scale has to be the same. To make something grand it doesn't necessarily have to be big in scale. But it has to be profound. Duchamp's ready-mades are small in scale, but were a very, very large gesture.

I want to make the grandest gesture that I can

ACTION AND ACHIEVEMENT

NORMAN ROSENTHAL We have spoken somewhat about the concept of art, and we have spoken at length about individual works you have made, but I would like to consider the manner in which you have very carefully organised your works over the course of your career – your many series. Perhaps the best way to get towards this is to ask another sort of tricky question. Do you see yourself as an Apollonian artist or a Dionysian? By that I mean, do you want to create order and beauty and have clear boundaries and beautiful lines like Apollo, or are you more like Dionysus, celebrating nature and intoxication? Are you instinctive, are you intuitive, are you wild? Or do you think you are perhaps both?

JEFF KOONS Both. That's what I was thinking as you were describing everything. I have trust in nature, but also I appreciate a sense of order and a sense that there is a positive path. I don't really like chaos.

NR You don't like chaos?

JK No. I believe that if I had a choice between order and chaos, I would choose order.

NR Yes, I can see that completely. But often there is a sense of excess in your work, isn't there?

JK Well, you know, I enjoy new things, so it's not that I want to have a sheltered existence or not to have experimentation, not to push boundaries or experience different things. But in general I would have to say that, if I go out to certain edges, I like always to be able to come back. I think it's like alcohol: I prefer to drink beer because if I have a few beers – you can have one beer, two beers, three beers – I know what the effect is going to be, but if I pick up rum I don't know what the effect would be. Maybe four rums are past the point of being drunk.

NR Have you ever been drunk? What do you do when you are drunk?

JK Sure, I've been drunk. That's what young artists do.

NR Where do you go in your head? I'm not talking about what you do, but what happens inside your head? Is it creative or is it counter-creative?

JK I think getting drunk is in a way counter-creative, because the next day you don't function very well. I like *weissbier* – you know, it's a wheat beer – and I find the taste intoxicating and there is a feeling of oneness with nature. I find it very moving, I find it inspirational – I find it a great inspiration. So there are aspects of intoxication where you can relax and think about what you would like to do to challenge yourself, but actual outright intoxication …

NR Is art intoxicating?

JK I think so. Sure. It's moving. It takes control. You know, that's another aspect of of art – enjoying control and also giving up control. That kind of dialogue came into my sense of being as an artist in the early '90s.

NR A kind of push and pull.

JK Understanding the importance of exercising control, but also the importance and beauty of giving it up. My sculpture *Puppy*, I think, deals with that.

NR The more that one looks at your work, the more one sees connections between the early work and the new work. At the same time, because of your ability to work in these series – the way you have managed to construct a series of chapters in your life – your work is a little bit like reading a book. One chapter follows another chapter, and there's a rather beautiful logic, I think, in the way that things seem to evolve. So your life, your biography, as embedded in your art, is like a rather beautiful novel, which is not complete yet and won't be complete until you presumably – like us all, but I hope it won't be too soon – pass somewhere else.

JK Yes.

NR Mozart died young, but somehow he managed to complete a huge body of work, a fantastic body of work, and one cannot imagine what he might have done had he lived longer. And it's as though he couldn't live longer. His late work, which he completed by the time he was 33 or 34, has all the qualities of a late artist's, an old man's, art.

JK I enjoy looking at Picasso's late work, which serves to show that an artist can remain very, very strong.

NR He's another artist whose work falls into a huge number of chapters, and these chapters sometimes overlap, particularly in the '20s and '30s, when he has three separate chapters overlapping, just like your work at the moment. You seem to have so much energy to have these three chapters on the go, which impressed me so much on this particular visit – seeing the 'Antiquity' series, seeing the flowers and seeing the Baroque sculptures. I just hope you have the means and the energy to complete these things relatively soon so that you can go on to the next thing.

JK I know I will complete the 'Antiquity' series soon, for sure, and the sculptures that go along with them, but the flowers I don't know.

NR Your series often seem to be grouped together and then end in a kind of climax: for example, the dogs and the flowers of 'Made in Heaven' seemed to culminate in the *Puppy*, and 'Statuary', if you go a little further back, seemed to culminate in *Kiepenkerl*. Do you think that's something conscious? Do you feel that each series needs to have a kind of climactic moment like, almost, if

Antiquity 4, 2010–13
[ANTIQUITY]

Antiquity (Satyr), 2010–13
[ANTIQUITY]

you like, an ejaculation, and then you have to start something new? Or is it not quite like that any more?

> JK It's always great if you can do a well-rounded body of work where the whole thing has an intensity about it; that's wonderful. But there are certain times in my life, such as in my 'Celebration' work, when I've never really had that complete moment because of production time. I also enjoy periods not having to be under the pressure of creating within fine parameters. I want to reject parameters and not have a work within a defined body. And I think that this work that I am doing now doesn't have defined parameters.

NR Of course, there are also connections between different series.

> JK There are certain symbols that you have in your life as an artist.

NR They don't go away.

> JK They are kind of embedded from your interests – things that you respond to in life, and if you look back you can see them very clearly sometimes. Right now I am working with plants again. I just showed you a plant piece. A lot of these sculptures are embedded in plants.

NR Even grass.

> JK It's about giving it up to nature. It's about giving up control. There's so much control involved in creating these things, but there are certain aspects when they give up control and trust in nature's narrative.

NR When you talk about trusting a narrative or about recurring symbols, I think your early work, your early series, were very embedded in an American experience, yet your more recent work is more embedded in a European cultural experience. Do you think you would go beyond that, towards a new universal experience? Are you interested, for example, in Indian art or in Chinese art, or in ancient Egypt? The world is so big and culture is so bottomless, if you like.

> JK Absolutely. I would say that from the time of doing my 'Banality' show I wanted to make my work very global. I made a piece – *String of Puppies* [1988] – which I thought I painted in a kind of Indian way, with the blue of the puppies.

NR Yes, I can see that.

> JK The figures, the colours, with the orange, the flowers – I thought that had a kind of Indian aspect – and I felt my work *Stacked* [1988] [page 138] was very much about Eastern philosophy, and even looked at power, the practical aspects and the impractical, the rational and irrational aspects of power. So I think I have always been looking at art and what it means to be human past a nationalistic framework and

String of Puppies, 1988
[BANALITY]

overleaf
Donkey, 1996–9
[CELEBRATION]

instead in a global way. In the 'Antiquity' series I feel that I am very much working in an Eastern way, especially through the guardian gods. You can think of the Hulk as an action figure, a comic book figure, but at the same time you can look at it and see the connection to Eastern guardian gods.

NR There's a lot of talk now about what they call the universal museum. Would you like to aspire to be, in all humility, a kind of universal artist?

JK I would like to think of myself as an international artist, but at the same time I am very aware of my own cultural history and I'm not running away from my cultural history; I embrace my cultural history.

NR Of course you do.

JK But it is not what I want to reflect. I want to reflect my growth and development as a human being throughout my life, not just reactions from my birth or from my original circumstances. I think evolution is an interesting science. I guess I am interested more about the situation that I'm in and what the opportunities are for others to be aware of their situation. As an artist, I want to make the grandest gesture that I can, and being aware of my situation gives an understanding of what the vastness of my gesture can be.

NR It's interesting that you say the 'grandest gesture', because that's actually the next question that I already had prepared for you – the real issue is, what do you mean by the grandest gesture? What is the grandest gesture in your head? Is it a movable feast? At the moment you seem to be very involved with this kind of relationship between the antique and the present. Is that where the grandest gesture lies, or do you have some vision, some expressionistic gesture? You are not naturally, and most people do not think of you as, an Expressionist artist, but do you think of yourself in that way, because gesture implies a certain kind of Expressionism? What do you mean by the word 'gesture'? It's a beautiful phrase, by the way.

JK It's not just an expressionistic, physical gesture, but a gesture that's revealing something in a psychological way – it's an act.

NR Is it an ambition?

JK Yes, it's an ambition, but I'll go back to antiquity here, to Plato again. I often speak about anxiety, the removal of anxiety and that true acceptance of things. Art is a way of having less anxiety so that you can really see clearly the situation and be open to understanding all the freedom you have in life, and a way to be open emotionally to the possibilities of taking an action.

NR Is it about reaching out to the world?

JK It's about being open to information. It's about being open to your situation – really removing inhibition, removing all the things that keep you from the openness to reality.

NR So where do you feel the frustration? Do you have areas of frustration now?

JK As an individual I always feel a sense of frustration in that I like to have as much clarity as possible. The freedom just to be able to make one revealing gesture is difficult to maintain. When you can, it helps yourself, it helps the essence of what your life is able to be, it helps everybody. It helps every individual to be able to have a bit more vastness in their life. I would like to be responsible for that emotional sense of vastness.

NR I want to come back to the idea of frustration, as it relates to making art. But let's carry on with the vastness of ambition for a moment. Do you see yourself as an observer both of yourself and of the world as an artist? You probably remember my friend Joseph Beuys. He wanted to alter the world. Do you want to alter the world?

JK I would like to have impact in the world. I would like to try to live to my greatest potential, so that biologically I can also reach the greatest potential.

NR Do you think that's the same for everybody?

JK No, because often people don't really want to participate. They want somebody else to assume the responsibility. And I've really always wanted to do it. So through my desire of wanting to participate I have been able to participate.
I think if you really have vision of something and you have a passion for something, you can achieve it.

NR Do you think any individual can achieve what you've achieved, or indeed, in my little sphere, anybody can achieve what I have achieved?

JK I think they can achieve what they have desired to achieve, what they have interest in achieving, what they would like to participate in. I think they can do that.

NR Regardless of what you might call background, or anything like that, such as social status and parents?

JK It depends. First you start off with where you were born, who your parents are. But it's the way you navigate yourself through these things, and how you follow your interests. You know, young artists make so many mistakes. If an artist has an interest in Pop or modern painting, if

overleaf
Hulk (Wheelbarrow), 2004–13
[HULK ELVIS]

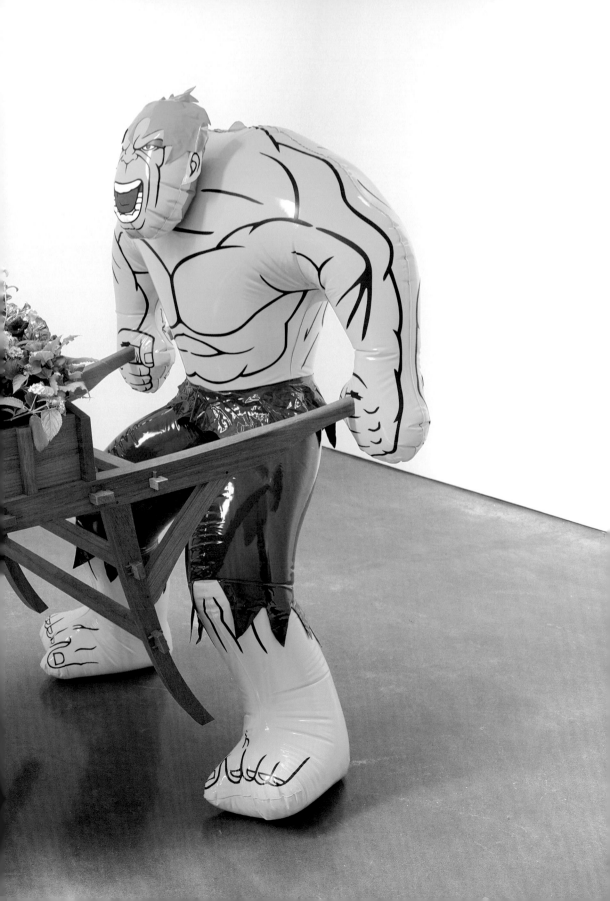

they take their artworks when they are young to somebody who handles Impressionist paintings, that would be a mistake. They should go to people who enjoy Pop painting. If you are interested in painting dogs, you should take your work to a gallerist who shows paintings of dogs. A lot of times people make mistakes; people who paint dogs take their works to Leo Castelli's gallery and think they would respond.

N R Do you feel privileged?

J K I feel very privileged and very grateful for the support that I have. I work very, very hard to try to show what my potential could be, and I don't take for granted the opportunities that I have. I know that the world could look elsewhere, but I like doing what I do, and if the world does look elsewhere, I can continue to do what I do.

N R In a kind of more modest way?

J K I wouldn't have the same amount of …

N R Infrastructure?

J K Yes, it would be a different infrastructure. But I could always follow my interests. That's what I'm doing, following my interests and trying to be true to my interests. Right now, if I have an idea to work in marble, I can just do that, and if I want to work with computers to get to a higher level of detail, I can do that. Maybe I would be more limited in a different situation. I would have to make a model instead of rendering with a computer, to work using a more traditional method. It might not be as detailed as I would like it to be, and maybe my idea would come out more conceptually grounded. It would be a different type of abstraction.

N R Which leads on to the very interesting problem of mediating your own art, of taking action so that the object is actually made. I have spent 10 years organising a show – a single exhibition – but that doesn't mean I haven't got 20 other things going on simultaneously. Sometimes, as I know has been your experience, actually getting the thing ready takes 10 years.

J K Well, some artists are always creating, and every day they have to make a gesture; here's an object, here's an object, here's a gesture. I tend to work more intuitively, so maybe I won't actually come up with a new image or a new object for a month, maybe two months. I think gesture is really important. I see the whole work as a gesture. That's what's being called for. That's physically what your self wants to do.

N R Is there room for accident – beautiful accident – in your working process?

J K Yes, within my creative application. If I'm making a collage on the

computer, I might have an idea to bring one element in with another. But just the way that the element comes into the collage initially – just the way it lands maybe at a different scale, or maybe more to the left when I envisioned it in the centre – those types of things are always open. Where my work gets specific is really after the creative process.

NR In the realisation, as I would call it.

JK Yes, that's it. The first conception is very open, but that chaos isn't involved in the realisation of the piece. I am more open at the beginning. If I'm just walking down the street, I might be able to find something anywhere at any moment that I could somehow …

NR Transform.

JK Yes, make art out of in some way, enrich it or connect it to something else and embed it with more vitality. So I'm consciously always involved in that activity.

NR Do you think anything is capable of being transformed into this weird thing we call art – this bottle on your table, this machine, this little book?

JK Yes, absolutely. I mean, it might need another individual to do it. We are not all capable of finding a connection with something to embed it as art. But I think there would probably be some individual who could give it more interest than it has naturally.

NR So, art is like a kind of still life in that sense?

JK But if you try to create art you can't, Norman. It's just impossible to do. I mean, you have to listen to yourself and follow your interests, to see if you can embed something, or make interest in something. You can always design something, but design is different from art. Art is about an openness to potentials, design is much more about work.

NR Would you ever like to do more portraits? Has it ever occurred to you, say, to do portraits of your patrons and your friends?

JK I've been asked to do it, and it's very difficult for me because I really don't believe in commissions. I think what's beautiful about art is you make what you are thinking about.

NR What's coming out of your head?

JK What moves you, and there's no element controlling it other than your own being and wanting to realise it, and how much desire you have to realise it. I am open to it if people invite me for public sculpture [such as *Diamond (Blue),* 1994–2005] there are certain locations you go to and people say, 'Do you have an idea for here?', and either it happens or it doesn't happen. But if somebody is saying, 'I have a thread factory, and I

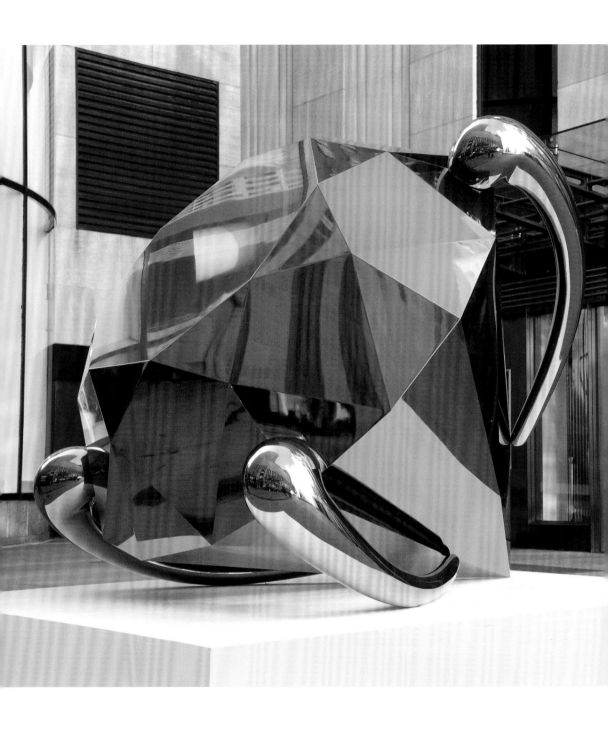

Diamond (Blue), 1994–2005
[CELEBRATION]

would love you to make a sculpture out of thread and you can use a thimble, you can use a spool', I would never get there.

N R Let's think about your group titles. You call one of your series 'Easyfun'. Is there such a thing as difficult fun as well? What you are doing here sometimes seems incredibly difficult.

J K I don't think things being difficult are good. There are certain aspects to create these objects that I am involved with. I give a lot of care to the works, but it's not craft. It really isn't craft. Craft has an excessive amount lost in its own application, in a way, and it's a loss of energy; it's a form of fetishism.

N R Do you think that your many assistants who are working here with you to make these extraordinary things have the same attitude? Do you think you are able to instil that in them? Or are they doing this as a kind of banal craft that you are somehow controlling?

J K I think they learn to care and realise there's an experience we are creating, there's a power that we are creating – that these things become embedded with a visual power and they have the ability to be a platform to communicate.

N R But what they do – I won't say it's craft-like, but it's very, very precise work that they are up to. What you are up to is very precise, and you control these things with incredible predetermination. Your reputation, to me and seemingly to most outsiders, is that of someone who is incredibly concerned with this idea of perfection, the total realisation of something. But you deny this, and still if anything is even slightly off-kilter and not quite right, it is to be rejected.

J K I don't believe in perfection.

N R I know, you have said that to me before.

J K But I believe in trying to maintain a platform for communication. So if I'm dealing with a certain material or a certain look, I want the viewer to be able to get lost in that. So whatever abstraction they are taking in can continue for as long as possible. So if you have surface distortion, all of a sudden they realise that you don't care so much about the continuing of presenting a situation for them to become lost in abstraction, and it shows a lack of respect for the viewer. It's not the object that you don't care about; it's the viewer that you don't care about. But I'm trying to show respect to the viewer so that they understand that I respect them.

N R What do you feel like when you are producing work with your helpers? Is it as though you are in charge, like being the conductor of a great orchestra, with everything flowing through you and producing what is in your head? I see

you as a kind of medium, but do you see it like that? I don't want to put words in your mouth.

JK Well, when you have talked about my studio being as you would imagine the studio of Rubens – I do see the studio in that tradition.

NR Or of Raphael.

JK But it's not a factory. A lot of people think of the Warhol model, and they think of a factory producing products. I understand the power of distribution, but I don't believe in distribution, I really believe in ideas. I believe that if you want to affect the mass, you affect it through ideas. So I produce very few works a year, maybe approximately 10 paintings, and maybe I'll create 10 sculptures, but that's about it. It takes a lot of activity, and a lot of caring is put into these objects, but these objects are a metaphor for people, so through this you are really just showing the viewer that you care about them. You want the abstraction that they experience to carry them as far as it can and to last as long as it can for the viewer. You treat them as an equal. You love them.

NR Would you say your care for materials comes with a theory of materials, similar to colour theory? There is a kind of symbolism inherent in colour. Is there a symbolism inherent in materials like steel and aluminium or bronze and wood, or glass even? You have used all of these materials and others.

JK Absolutely. And you are aware of that symbolism through everyday life, through growing up. I started working with steel, enjoying its ability to be a material for everybody, and still having a sense of luxury, a feeling of needs being met, a feeling of a certain economic security. At the same time there's a sense of cool abstraction.

NR You have used an enormous variety of manufacturing methods.

JK I always think about emotional response, and so I'm thinking about what it would feel like to confront this image or to confront this object, what my physical being would experience. And whether it's a numbing quality, whether it's a heightening quality, and which materials are best suited to creating an exaggerated state that makes people aware of an experience. If the material does not provoke an exaggerated state, it's like a non-experience – just such a casual, everyday experience that people aren't even aware they are having it – and that's not great art.

NR Of course, the most beautiful material of all was your flowers in *Puppy* – living flowers as a kind of material to make sculpture. There's an amazing abstraction there, of something so delicate becoming monumental and timeless.

New Hoover Convertibles, 1984
[THE NEW]

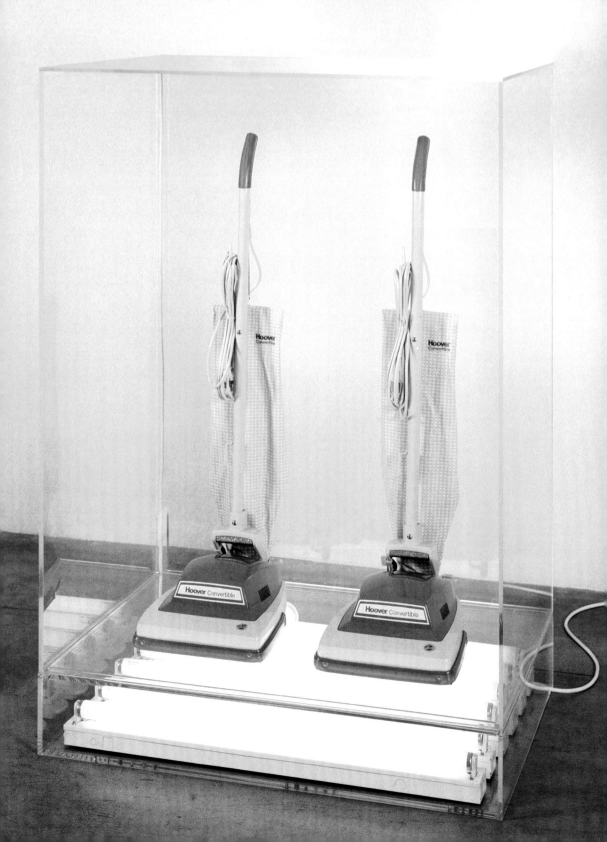

Cracked Egg (Magenta)
[1994–2006],
Museum of Contemporary Art
Chicago, 2008
[CELEBRATION]

JK Water is always also very spiritual. The 'Equilibrium' tanks used water, and I loved that. In its very pure state it's like birth.

NR You worked with scientists on those tanks, and presumably you must work with engineers as well on other sculptures?

JK You know, I do. When you create something you want it to be able to come into realisation, and they are great for that. I started to realise I needed things to be engineered back in the '90s. Prior to that, I was making works myself, so I would just engineer something as I went along. If I was making a doubledecker or a tripledecker Hoover, I would just make it through trial and error. Getting into larger pieces increased the complexity of manipulating those materials. Then I had to start to rely on engineers.

NR You are the architect of your works, and then the engineer has to somehow help you realise them. You have to pay huge attention to the detail, I imagine, to preserve your vision.

JK Everything from the way you polychrome something, ensuring that you're using the correct polychrome chemicals, to how they stand up, the balancing of weights …

NR Precise colour and so on.

JK It becomes more complex with scale. When the scale is smaller, a lot of these investigations are easier to do on your own, but as they grow you have to rely on people who are really expert in different areas. Now, when working in steel, even as the works develop, the processes become more and more refined, and there are always new problems because you are trying to make the work the best you can, to have the fewest imperfections possible. You end up working with steel that has virtually no imperfections, then all of a sudden your welds show up and now you've got this new problem. So you attack that problem, and you have to create all types of grinding systems just to remove the weld. It's really kind of evolving so the manufacture always needs a great store of information, and part of that is engineering. The other part is working with people who are very, very expert in these different materials.

NR You making sure there are no imperfections.

JK You do it through a process of making and viewing, and in both there is a certain kind of contact with the self. Just like if someone is doing some athletic activity, they would feel an understanding and be in contact with their self. It is that sense of being in contact with the self – in a way, giving everything up – and relying, placing trust in this activity that you are involved with.

NR You even lose yourself in the perfection of what you would call the abstraction.

 JK You know, Norman, I don't think I really care about perfection. I really don't.

NR I am very surprised by that.

 JK I don't. I absolutely don't. But what I do care about is the viewer. In my father's furniture store I grew up around objects just displaying themselves – a lamp, a little china dish, a chair. When I came to New York I started to work with ready-mades and this sense of just accepting things, accepting their perfections and their imperfections.

NR Their industrial perfections?

 JK The process is industrial, but of course it is a metaphor for people. I mean, I don't really care about an inflatable flower, I don't really care about the colour pink, the colour green. But as a metaphor for people, for individuals and exchange like the exchange we are having right now, I do care. It's about recalling an excitement about something – that's why certain colours are chosen.

NR I look at those extraordinary colour charts that you have around the studio, which I only half-understand, and the unbelievable, exquisite care that goes almost beyond the colour theory of an artist like Seurat. I don't know whether you admire Seurat very much, but I do and I am sure you do.

 JK Sure, yes.

NR It's fantastic – the attention you pay to detail or seem to. It's a thing that makes you gasp. Because when I see your works, I gasp with astonishment, and that is part of the pleasure I get from them.

 JK Well, I don't really like the idea of craft for craft's sake, because that's like a dog chasing its tail. It's wasted energy. The greatest thing – and Warhol really did this so well – is to get more energy out of something than is put into it, and so, as I said, I really dislike craft.

NR Me too. I hate craft too. But I don't think perfection and craft are identical.

 JK I am responsible for each and every mark in every painting; in every sculpture I take care of every detail. And if I am working with something that pre-exists, it gives me a format and then it just has to be like that. That's the framework, that's the guideline that people who are working with me have to follow, have to work within, so that I can really be responsible for each mark. I have to have direct honesty.

Inflatable Flowers (Short Pink, Tall Yellow), 1979
[INFLATABLES]

Colour charts in the Jeff Koons studio

Georges Seurat
Bathers at Asnières, 1884
National Gallery, London

N R Nonetheless, you are very demanding in terms of the execution of these very complex pieces. They sometimes take 10 years to realise.

J K Maybe it's like focusing a camera: you want to have it correct. It's a system, setting up a system, so that chemically, as a work, as an image, it can produce a result and that result is to engage a viewer with a certain intensity. I think the viewer does get it in some manner. I think that they feel better about themselves, feel more potential, and they realise that this dialogue – maybe they don't fully understand the dialogue – but they realise that it is about them and they feel better about their own potential. I think they feel that sense of self-acceptance.

N R You have this huge apparatus around you at the moment. Do you sometimes almost wish you didn't have it and that you had the ability just to make it all by yourself, literally with your own two hands?

J K The ideas for artworks come from myself, and they come from very simple, open places, which I try to embrace. I try to keep my ideas very simple and open to a very, very pure situation, and I do feel a certain need to direct action to realise those ideas. I want an immediate result, but sometimes I realise, 'OK, this is going to take two and a half years to finish', and then I'll realise that even to accomplish that within that time frame is challenging, because of all the attention that those works need from me. The immediacy is then satisfied by starting a new painting or bringing one new object on to the next step, having it produced. Everything happens in stages. It is a cycle, sometimes more satisfying and other times about delaying.

N R Can I ask, do you ever actually do it yourself? Have you ever actually put the brush or the chisel to a surface? Do you stand with your technical people and show them how to do it? You must want to sometimes.

J K I really believe that the type of systems I have set up mean that I'm doing it myself. This is what's necessary to be able to achieve the scale; it's the only way to be able to do as much as I try to.

N R So your hand, your own hand, is not the essential thing, it's the systems?

J K It's the end result that is the essential thing. If I would do everything …

N R Could you spend a day doing what those kids in this studio are doing? Would you even think about doing that?

J K I could do it, and I would enjoy it.

Jeff Koons painting with his son at
the Kids for Kids Family Carnival,
New York, 2006

overleaf
Jeff Koons's studio,
New York, 2008

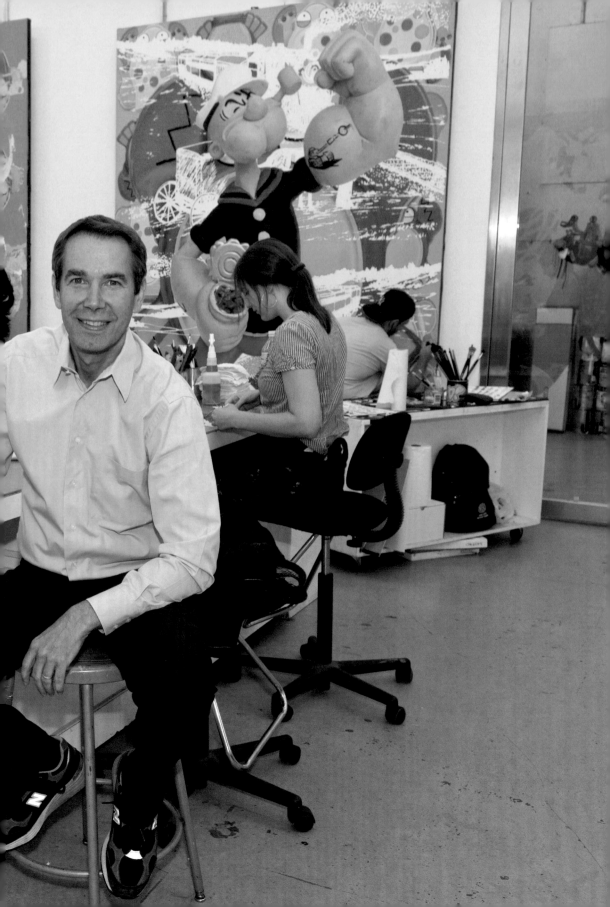

NR You could?

JK And I show them every day what's necessary to be done, where the problems are. I will bring up immediately where colours are OK, where textures are, where there could be a scratch or a flaw. I mean, they couldn't do it if I wasn't giving them guidance. But eventually I would become bored because I want to be doing these other things. I love to have a dialogue between different dimensions, between two-dimensional images and three-dimensional things. I love that interplay when you bring them together, because when you bring two-dimensional and three-dimensional elements together, this other dimension almost like a human space appears.

NR That's very interesting. Do you think there is a fundamental difference between painting and sculpture?

JK No. No fundamental difference.

NR Are they the same?

JK They are in different dimensions, but what you are trying to achieve and how you are trying to move people is the same.

NR Which is the more difficult art form? Is it more difficult to be a painter?

JK I find sculpture sexier.

NR Your paintings are becoming more like sculptures in a way. And you know, sculpture and the form, this idea of dimensionality, is becoming increasingly apparent in your paintings. Would you agree with that? The paintings, as it were, are striving towards the properties of sculpture.

JK I think that the paintings want to move you, they want to move people. I like to be moved, so when I create them, I try to create them so that they move me. I think very precisely about what I want them to be. It's very much about having them be as intense as they can be. I probably create about 10 a year.

NR Paintings?

JK Yes, paintings. They're very, very time-consuming. Sculpture is actually more time-consuming to oversee, and it takes time to bring in resources, but certain aspects of it are freer. Painting is very, very demanding at every moment. Sculpture can fit into systems a little more easily than paintings, because there is more human involvement with paintings.

NR Is there an optimum way in which to see a sculpture, or is it all about moving around it?

JK It's about experiencing it. It's about moving around it. Because it's physical, there's a sense of openness. You are dealing with the presence

of what you would relate to in a human being, whether the possibilities are anthropomorphic or animal, or more static.

NR But usually, when you show work, you mix the two, don't you?

JK I like to mix the two. I would become absolutely bored just making sculpture. And I'd become absolutely bored just making paintings. But if I had to say that one area feels more powerful to me, I'm not sure what I would say.

NR Or empowering.

JK Or empowering. Well, I think I would say sculpture, only because we have physical form and we have a mind, and so physical form may be related to sculpture and the mind to painting. There are more things that the body has to be acutely aware of in this world than the mind, and that gives sculpture a certain intensity. There are more areas of being attuned or aware.

NR You must think of yourself as an artist, rather than a sculptor or a painter, because you do both.

JK Absolutely. I started doing sculpture because when I came to New York I was so tired of subjective art, and until then felt that I'd really been involved in painting work that was very much about the self, about the subjective, about personal iconography.

NR What is your definition of the subjective?

JK It's about the self. It's about the artist. It's not about who's viewing it; it has no relationship outside the particular artist.

NR And is that in itself bad?

JK It's limited. It doesn't experience other levels.

NR Can I ask you a straightforward question? Can Expressionist painting be objective? I'm thinking, for example, of an artist like Baselitz.

JK A certain objective dialogue can be partly subjective. The subjective opens it up, but the dialogue is not about self-experience. It's interested in the external. Somebody who's dealing just with the subjective is still really in a dialogue about their own self-acceptance – everything, the world, viewed from the perspective of yourself, your own interests, your own rights. And the objective is where you and others are considered equal and you can envision their rights as equal to yours, or their interests equal to yours, their pleasures equal to yours. That's a higher state.

NR And what about the setting for sculpture and the setting for painting? Where do you like to see it best? In a museum, in a gallery, in a private house,

or could you imagine a kind of quasi-temple? Would you like to have a
museum of your work one day?

 J K Not really. I would say finished is the way I like to see it. I actually like it that things go out in the world. I enjoy my own work, that's why I do this, but I don't live with my own work, because I try to give my family a distance from it, because they are very, very aware of what I do. I do it all day long. I am surrounded by it, but I don't want its personalities also to project very much in our home, so we live with other artists' work. The idea of the museum would feel like some support, but I would hope most that the work is in a lot of other places. I am really honoured that sometimes I can travel and go to certain locations and see my works together as a group. It's always hard for me, though, to view my work, because I always look at it and I always see the imperfection. I always see the flaws.

N R In the work or in the presentation?

 J K In the work. With the presentation I always accept that everybody has done the best that they can.

N R Really?

 J K Yes. And people have, you know, generally. I like the opportunity to present my own work, but it's difficult because I'm always going to notice more.

N R You don't want to control the way things are shown? Once they exist,
you are happy for them to find their place in the world?

 J K I enjoy the opportunities to determine display. Usually you are given that in a commercial gallery, and you make a show in a gallery and that's where you are in complete control.

N R In complete charge?

 J K Sometimes museums invite you, and you are able again to create a similar type of situation. I can sometimes do this if people are not sensitive. Some curators are not sensitive. Some are very sensitive, and they like to be involved. Others just want to give it to the artist, and you do it, and they are involved in other things, the other parts of making exhibitions come about.

N R How important is context for you in art, the place where things are
actually presented to people?

 J K I think context comes later. It's not the first thing. It's not like you come up with context and think, 'Right, now I'm going to create something for this context'.

Moon (Light Blue) [1995–2000],
Château de Versailles, France, 2008–9
[CELEBRATION]

NR I sometimes say that if you place the most incredible painting
by Cézanne, for example, or by Courbet for that matter, next to a big lorry, or
for that matter a huge automobile, in a room or on the street – if you were to
lean one against the other – there is no question about the piece that would
win. It would be the lorry or the automobile, wouldn't it? Do you agree with
that or not? In that sense the context is so important.

> JK I don't know. Absolutely, there are aspects of art history to consider
> and context is important, but for creating a work, if you are sitting down
> to create a work of art, you don't first create the context, you just create
> the work.

NR Of course.

> JK And the vocabulary that kind of follows a work, and the way the
> work should be presented, those aspects come a little later. But if you are
> looking back at the way something is viewed historically, then sometimes
> context can affect the way you look at something, because it's being
> removed from some of the connecting force that it has.

NR Could you imagine an ideal place for a – I hate the word 'retrospective' –
but for a big Jeff Koons show? You had that amazing show in 2008 at
Versailles. Was that beyond a dream? Was that perfect, or would you rather
have a big, white box in a great city like Paris or London, or here in New York?

> JK You know, Versailles was a great experience, Norman. It was
> fantastic, and it was one that I am very grateful for, but for me that wasn't
> an end-all experience. I look forward to many others. I did the Roof of the
> Met, and that was incredible because it was just the huge open sky
> above these artworks, and that felt like the space went on forever. But I
> look forward to a lot of different opportunities, a lot of different situations.

NR Do you think each artwork becomes different in a different situation?

> JK You know, environment affects things, but the core – what my
> intentions are with the works – doesn't change. But the perception of it
> could change just due to how strong the environment around it is, how
> it's trying to control the situation.

NR The question that occurred to me yesterday – and I was thinking about
it as I went to see various exhibitions in Chelsea, the new paintings of David
Hockney, and the paintings of Mike Kelley, which I thought were extraordinary
in their own way – the question is, how hard is it to be an artist? How hard
have you found it to be an artist? I love art, but I couldn't be an artist, and I'll tell
you why. Because art, even as it exists today, is such a bottomless pit of
incredible things that have been done by humankind that I wouldn't know
what to do next. I would be scared to be an artist.

Coloring Book [1997–2005] and **Sacred Heart (Red/Gold)**
[1994–2007],
Metropolitan Museum of Art, New York, 2008
[CELEBRATION]

JK You know, it's easy, Norman, because it's not that you just have to go out and do something that's different from following your interests. If somebody says, 'I have to create something really new – what will I do, what will I do?', that's really not the process. The process is just to feel secure within yourself. What am I really thinking about? What have I really found interesting in the world? 'Oh, I have been thinking about something hanging from this chain', and OK, you just start following that, and before you know it you are really dealing with a vocabulary that has meaning to you. So there's no difficulty at all.

NR Really? I am very surprised. I am very impressed as well. That almost scares me that you find it so easy and that it's a kind of natural thing for you, not just to do nice things, but really to go to these places where, in my opinion, no artist in human history has been before. And that's really what it's all about – not to make a cliché.

JK Well, Norman, when you are a young artist and, let's say, you have had a dialogue with art and made different paintings and drawings, you are starting to focus on things, and maybe you work on a drawing for 40 hours or you work on a painting for months. When you start to get involved in this activity you start to realise that if you stop – say it's summer break at college and you stop doing something – then to get back into it is a kind of a rough process. You start to make something that's not so good. But you start to make something else and you focus, and then, 'Oh, it's getting a little better', and before you know it you start to feel this chemical charge that things are better – 'Oh, that's right, now it's happening'. You know, it's impossible for it not to happen if you just start focusing on something and following it. Eventually it just starts to flow. It's almost like changing gears in a car – finally you are in fourth gear and you're just moving, you're in touch with it, and it's in that metaphysical area.

NR You know, there are tens of thousands of artists in this city alone. In Paris in about 1880 there was a census which apparently revealed there were something like 70,000 or 80,000 artists – people who described themselves as artists, painters or people working at art, whether they were printmakers, sculptors or whatever. And if you are reasonably cultivated you will remember now, 100 years later, 20 of them, and maybe if you are a dealer you will remember 40 of them, and the rest have been consigned to this horrible kind of garbage can of failed art. Does that not scare you as a thought? But you cannot be written out of the history of art any more.

JK As far as being remembered goes, everything just turns to dust in the end.

Dolphin Taz Trashcan, 2007–11
[POPEYE]

Dogpool (Logs), 2003–8
[POPEYE]

NR Does that concern you?

JK **No.**

NR Where do you see yourself in the history of art, either American art or world art? Are you conscious of your place in art history or do you just let that take care of itself?

JK I let that take care of itself, because I am much more involved in trying to participate now, and I think once you've gone it doesn't really matter. It may affect your children, or it could affect friends or other people, but it doesn't matter to you.

NR Are you aware of how long you have left in life? Do you treat every day like your last day?

JK I try to pinch myself to take advantage of every day. That's not about picking something up and thinking that I'll do this or I'll try that. It's more about coming into contact with intuitive drives, intuitive forces, things that I've been carrying around with me or that I come in contact with that I feel are profound, have meaning and are archetypal. It seems now in my own life the further I've gone, the more reassured, the more stable in feeling, the more secure and engaged I feel.

NR Have you ever been depressed? Have you ever been depressed even as an artist? Have you ever felt you couldn't go on?

JK No. When you are young, as I was saying, and you stop your work for any period of time, you have to start up again. It's kind of a bit like riding a bike. The bike goes 'chug, chug', and something happens, then you feel reconnected – you're not quite reconnected, but you focus on your interests and then 'chug, chug', and OK then it's going. And a day or two later your sensations, how you're directing your physical and intellectual responses, really become coordinated and you're back connecting with the external world, with people, and it's not about people liking what you do, it's about communicating and connecting. And there is something likeable about connecting, it's wonderful. You like doing it, and people like to be connected too.

NR How long does this connection last? Do you think art is striving for a kind of immortality? Do you want your works to be there after you have gone?

JK I think everything goes to dust.

NR I agree with you. Even a beautiful Titian one day will be dust.

JK Absolutely. But art is a belief in a possible kind of continuum, the leapfrogging of life, the belief that life can continue to expand its potentials or that there can be a consciousness that gives it a greater ability to expand. I guess I think of life as performing like some kind of bacteria. It just keeps trying to move.

Everybody is hungry for something that can change their life

COMMUNITY, CONNECTION, COMMERCE AND CELEBRITY

NORMAN ROSENTHAL Is it about happiness in the end, about what makes you happy and content? Is it contentment and happiness you are striving for? Or are you striving for something far bigger?

JEFF KOONS I think connection – you know, connecting as a human being with the world, with life, with myself, my family, my community. It's about connecting through art history.

NR By 'community', do you mean the art community?

JK The art community, but it's vaster than the art community. It's about connecting with people that I work with, with the wider community, with the people that you run into in everyday life.

NR It is interesting to think about Picasso in relation to you. I think he deals with acceptance as you do, but whether he deals with the idea of community, I'm not sure.

JK I feel that like me he's involved with objective art. If you think of Duchamp at the turn of the century as representing objective art, external art, there's something about Picasso too that's involved in objective art. I can't pinpoint it exactly, but it's maybe looking at internal life in an objective, open way – every man, every woman.

NR But everybody now has learned to love Picasso, anybody who is reasonably educated in our terms. But it's not that long ago that most people regarded Picasso as just beyond the pale. You know, 50 years ago it was a very small community that found Picasso acceptable. The works of art, the paintings that are going on around your studio now, do you want them somehow to penetrate the universal cultural context in order to – and I'm trying to find the right expression now, as it's quite a difficult line of thought that I am going down – do you want them to penetrate the universal cultural context or consciousness? Is that the most important thing for you in this world?

JK It is, as individuals are the same around the world – their sense of empowerment is the same, which comes from a sense of affirmation of themselves as individuals, the importance that they have, their role, their potential.

NR Do you see it as a kind of experience of luxury, or an experience of necessity, or an experience of therapy? Where does the experience lie for you?

JK The experience is of possibility. You want to give a sense of empowerment to the viewer. Art empowers you. It continually lets the artist expand their parameters of life experience, what they can become and what art can be. So it's really about empowerment, to broaden your

Pablo Picasso
Large Nude in a Red Armchair,
1929
Musée Picasso, Paris

Raphael
The Sistine Madonna, 1512–13
Gemäldegalerie Alte Meister, Staatliche
Kunstsammlungen, Dresden

parameters and to give that same empowerment to the viewer. Because it's about them. It's not about this artwork or about that artist: it's about what art can be for the viewer.

NR One of the things you have spoken about consistently is an erotic response you want your artworks to elicit. I had first thought of that as being part of the making for you, but I see now it is equally important in the finished object, not as a reference to male or female, but as an erotic charge. Can I just ask you about something else? When we talked about smiling at your art, you said you didn't want people to laugh when they see your things.

JK I don't think so – not laugh.

NR There's nothing wrong with laughter, by the way. It's a very profound activity.

JK I want people to feel good; I want them physically to feel good. I want them to enjoy life experience. I want them to enjoy their life. I want their life to be vaster.

NR There's a great philosophy behind laughter too. Both Nietzsche and the French philosopher Henri Bergson talked hugely about the profundity of laughter.

JK I think it's something that can be taken out of context very, very quickly. I know that I say I want people to feel good about themselves, but I always feel people try to take it out of context. It's not to feel good, simply – it's the opposite, it's to feel more. You want to expand and to feel something even greater than you're feeling now.

NR Like a dynamic?

JK It's about wanting to keep along a path in a direction that's about growth, not just about feeling good.

NR It's not about indulgence. I can read a book, I can hear a piece of music, I can look at a painting, and one of the things I like to do is to smile. Don't you like to smile, as well as having the ecstasy of sex? The ecstasy of sex is one thing, which is a pleasurable thing, but there's also the ecstasy of smiling.

JK Norman, I like to smile, I think that my works have aspects to them which are very, very cheerful, that bring about a smile, but at the same time they have the aspect of tragedy. So they are not just free of this other side. They want really to be balanced, to be full and rounded.

NR Where do you think the tragedy lies? Where is the potential for tragedy in your work – the catharsis, if you like?

Pot Rack, 2000
[EASYFUN]

Lips, 2000
[EASYFUN-ETHEREAL]

overleaf
Triple Elvis, 2009
[POPEYE]

JK I would say the first thing is just in aspects of mortality, and not necessarily one's own mortality, but just mortality.

NR How big is your potential audience, do you think? If you are not just appealing to this rather limited world of the art audience? Do you want, for instance with the *Puppy*, to embrace the world?

JK Norman, as a human being, I would like to communicate. I would like to embrace the world, but I think that I'm just going about trying to make my works, which hopefully connect with people, and that they are open, they want to communicate. But I'm not going out of my way trying to find a vaster audience, other than just trying to make the best work that I can every day and to be open to dialogues with people. I like the intimacy that art still has because, even though you can deal with many viewers, each viewer is still just there by himself.

NR By himself.

JK Absolutely.

NR It's a one-to-one experience. So have you never been jealous of the way in which music or film can simultaneously reach larger groups of people than art seems to be able to?

JK When I was younger, I was interested in music, in the profound effect that it has, and how it comes into our beings through the air. I am interested in this, but I don't sit and listen to music. I can't do that in my environment, and I don't give it a large place in my life. It is really also a misconception about my interest that I would like to reach the largest number of people possible. If I had jealousy, it would be for the power of another artist's art and how intense their connection was with their art at that moment. If I see a really great performance, or if a musician really takes me somewhere that affects me, I could have jealousy for what was just experienced, the ability of the work to communicate. The greatness of something is in its ability to communicate. Everybody is hungry for something that can change their life, that can open their life, can inform them. That's what something really great does. So that's what I'm interested in, and of course the rest comes with that. I'm not interested in the mass, I'm interested in that great piece.

NR You often talk about your art appealing to the middle classes, a kind of American ordinary middle-class life.

JK It's really more about how we respect ourselves and respect others. Class does not limit that.

NR Do you think that class is important for an understanding of art at all?

JK Education is, but not class. I don't think you have to be in the upper class to feel enlightenment. Actually, I think it could be even harder for the upper classes; they don't even have that sense of space to expand to. They already feel that they are at that parameter in some way.

NR Do you ever go and see American violent movies, which I hate? Do you know what I mean – what I call 'heavy-shooting' movies?

JK Well, I've seen them.

NR Do you like them?

JK No, I really don't. I'm not so involved with film.

NR Do you not even go to the cinema from time to time?

JK Well, I have children, so it's a little more difficult. If I do see a film, it's a film that's been directed more towards my children. I don't really have an interest in the narrative. I think the form of narrative that I'm involved with in my own art I find more interesting.

NR Yes, more complex, and more ambiguous as well.

JK Than the narrative of Hollywood films.

NR Most of the world now in a certain way has become – with pluses and minuses – more and more like America. Would you say that's true? Most of the world – I mean there are places like North Korea, which are exceptions – but almost everywhere has somehow – on balance, I think, for good – got the American bug. The American cultural bug. Would you agree with that?

JK Norman, I don't know, I think that things go in swings. I know that it might seem that way. Through television and technology there's been a proliferation of American cultural content, but then there's also a kind of swing away from America over a couple of decades.

NR Everybody wears jeans, everybody eats hamburgers, everybody has incredible machines, and even if they are made in Japan they are somehow American. And it's a great American tradition that in a way everybody is free to get to the top somehow, to get to the top of their profession and the top of themselves and to invent themselves, that America is the great land of opportunity. Do you think that still holds true?

JK I don't think what I am speaking about is just American.

NR So it's not about the acceptance of your particular culture, the culture of America? I think of you trying to give American culture a universal message in the way that when Raphael painted the *Sistine Madonna* [1512–13] he spoke for an era. Have you seen it, by the way? Have you been to Dresden?

Hulk Elvis I, 2007
[HULK ELVIS]

Monkey Train, 2007
[HULK ELVIS]

JK Yes, I have.

NR There is a strange affinity between that fantastic painting, with the little
angels popping up from below, and your paintings, but again that painting is
about a kind of acceptance of a reality of the culture that was then.

JK I think the idea of acceptance is universal. If you are in a different
place, in a different system, you still have yourself to deal with, and you
have your potential to deal with, and you would be able, I guess, to a
certain degree, to fulfil your potential as much as possible.

NR Do you think art is invoking people to fulfil their potential, telling people
to free themselves? Is it trying to make people change, to empower
themselves in the way that you would like them to? That is very political.

JK I think art can do that, but I think art is an interaction with content
that human beings have structured to in some way explain life
experience. And it's not specifically in one kind of political area that I
would like art to have this effect; I hope that the effect would be vast in
different political areas.

NR Political areas – what do you mean by that? Are you interested in the
environment, for example?

JK My issue would be more the sense of people's self-respect and
people finding self-acceptance. It would be just more along the
philosophical line about how people embrace who they are and feel they
have a platform for the future. That's actually quite a big political
question.

NR But if you take the big American political issues of the day, like
Medicare, do those interest you at all?

JK I have a moral interest in the sense of communal well-being, but I
try not to get lost in the specifics.

NR There's no reason why you should get lost in the detail, but are you
interested in these political issues? You sometimes talk about politics, but I've
also heard you say, 'I don't want to get involved in politics'. I remember you at a
dinner in Berlin when somebody was talking about the next president of the
United States, and you didn't want to get involved in that at all, and you were
very specific about it. You remember that occasion, I'm sure, quite well. It was
quite funny. But you were also very serious.

JK If you get involved in a specific issue, you seem to limit yourself in
other areas. I have always enjoyed my vast area, which I think is more at
the core of people being empowered.

Split Rocker (Orange/Red), 1999
[EASYFUN-ETHEREAL]

Popeye, 2003
[POPEYE]

Olive Oyl, 2003
[POPEYE]

NR Of existence.

JK And it's about self-empowerment and trying to give to people, to
the best of my ability, a sense of their potential.

NR What I love about your recent work, particularly, is that with single
images you seem to absorb so much culture of the past – layers and layers of
it – in a very precise way and at the same time it remains as of now and of now
in America, because you are an American, with all that implies. Do you think
that up to now in your art you've reflected a kind of world – sometimes in a
critical way, sometimes in a very positive and optimistic way – the world that
has existed in America for the last 15 years, which has certain characteristics
that we can perhaps define? I would like to know how you see the world of
America over the last 15 years and how you see the America of, say, the
short-term future, in terms of its possibilities, its ideologies and, I suppose,
even its economics? Do you think we are in a new era in America?

JK From all the information that I come across, Norman, of course
America is going through a tremendous change in its relationship with
the external world and its hierarchy within that world. It will probably lose
a tremendous amount of its power and influence in the world in the
future. It has already lost some. This type of information, these things, do
affect people and the environment that they are in. These things do affect
you as an artist, and in the future, if people have the desire to look back
at my work, they will see that I'm living in New York at a certain time
period and that period influences it. But as an artist you want your work
to be much vaster than dealing with these issues. They're not the core
information I think that's interesting for an artist to deal with. Even if
America didn't exist, my work still could exist, or at least certain aspects
of my work could exist – the important aspects of the work – which are
that everybody is equal and people shouldn't be disempowered.

NR Are you interested in the changing ways that your ideas, your concepts,
your vision of the world will be distributed in the future?

JK I think that if you are an artist and you want to be involved in the art
dialogue, there are certain cities that you go to. Today one of them is
New York. If it's not New York 50 years from now, if it's Beijing or if it's
another international location, I am sure that's where artists will be, that's
where artists will be going.

NR It could be in the Middle East.

JK Yes, it could be in the Middle East. Whatever that location is, people
who really want to participate on an international level will go there.

N R By participating, do you mean in a dialogue?

 J K Yes, in a dialogue – to be involved, to be contributing. To be on the front line, really to be there and engaged.

N R Do you like this culture of celebrity in which you are part? Do you like being invisible or do you like being recognised?

 J K I think as an artist you have a fantastic position in the community because you have a lot of anonymity, a lot of privacy – most people do not recognise you. You move about the world very, very freely and you can look at things and not be distracted and at the same time you can participate and, hopefully, have some impact in the cultural environment. If somebody comes up and says, 'I enjoy your work', it's a nice thing to hear. But I would have to say I am probably drawn to and have stayed within the traditional fine arts because I enjoy that anonymity, that freedom.

N R So it's not quite the red carpet syndrome for art – the one you get in the movies, for example, or in music. How did you come to work with Lady Gaga?

 J K The Lady Gaga album cover was really a project where people came to me. It's flattering when other parts of culture show interest in my work. It's wonderful to see that some people appreciate things.

N R They get it.

 J K They get it.

N R They want to participate.

 J K They are happy that you are participating, especially if they can represent that to youth too – kids of 15 years old.

N R Did you really enjoy that work with the music industry?

 J K I actually prefer just to be involved with my own work, making my own art specifically, but at the same time I try to be coordinated and do what's necessary to help the work have a voice and a chance to be seen.

N R Do you mind if we talk a little bit about commerce and art? You said in an earlier conversation that you enjoyed sales when you were younger. What relationship does selling have with morality?

 J K I enjoyed sales because of a sense it gave of self-reliance, but it was more the communication, the interacting with people and the feeling that both people's needs were being met. I was making a sale, placing a product; somebody was excited by the product and was happy to acquire the product.

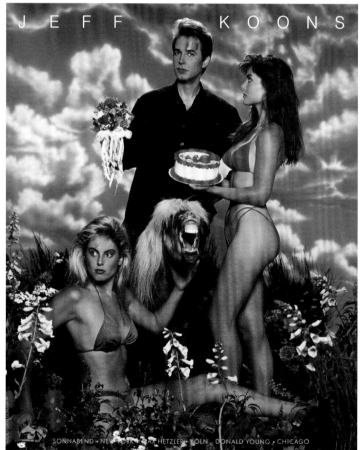

N R What's the difference between selling a pair of shoes and selling a work of art?

J K As far as the transaction goes there's not much difference, if any difference at all.

N R So if some guy chooses a Nike pair of sneakers over an Adidas pair of sneakers, is that the same as choosing a work of art?

J K The reason that he chose the Nikes might have been the construction of them, or maybe he just liked the colour. Maybe he saw the colour and thought, 'Oh, that blue. I would feel more comfortable with that'. So there's a reason for that choice and it's the same with art. People have reasons for their choice. They may see something on a very, very profound level or it could be completely surface.

N R What about the mega prices? Do you think the prices of your artworks are correct, or crazy?

J K I'm making the things that I'm making, doing the things that I'm doing, because that's what I would like to do and that's how I've always lived my life. I'm surprised at all the success and I'm surprised really at how the art world has been able to gain such a wide platform in such a short period of time. But at the same time I understand that within society art is feeding needs that other areas are maybe not fulfilling.

Lady Gaga ARTPOP
album cover art by Jeff Koons, 2013

Art Ad (Art In America), 1988–9
[BANALITY]

Vocabulary is a profound subject

A KOONS LEXICON

NORMAN ROSENTHAL Every great artist invents a vocabulary by which he is, I hope beautifully, recognised. You have invented your own vocabulary, with words which you use a lot and which I would like you to try to define as precisely as you think you can.

JEFF KOONS Vocabulary is important to discuss; it's an interesting subject, a profound subject. I mean, you can discuss anything when you are speaking about making something, about life and even one's activity in art. In that way vocabulary can also be about biology, not just about images.

NR You have specifically invented a whole new critical vocabulary around your art that can be applied to all art in a certain kind of way. You use words like **Acceptance** in a very particular kind of way. When did this kind of language come into your mind? Right at the beginning, even when you were a student, did you see acceptance as an integral function of your art?

JK When I did the body of work 'The New' and called it 'The New', I realised that I was displaying a certain type of narrative, or taking responsibility for presenting the context that I saw the work in, how I saw the work functioning: I wanted to assume that responsibility. I would say that it was around the time of 'The New' that I started to articulate it as being about self-acceptance – the removal of cultural guilt and shame. I wanted to focus on how I saw art functioning as a means of empowerment, how it could empower people and what the dangers were – how I saw art being used to disempower people and to not let them have a secure foundation.

NR I would like to know about another word you use quite a lot: the word **Equilibrium**. What you mean by that word. We have talked about Dionysus and Apollo. Is that what your equilibrium is about? A *balançoire* – a seesaw, going up and down?

JK It's a Utopia, with all forces being equal. I really associate equilibrium with being in the womb. It's like pre-birth, but also it's within time. It's equilibrium with time. Again, your position in time seems to be a past and a future. You're not even in the moment, but somehow you are encircled by the moment.

NR I'm not really very good at Jewish literature, but I read a very beautiful Hasidic story about an image of a child in the womb who knows all the Torah. He has total knowledge inside the womb, but the minute he leaves the womb an angel comes and takes all that knowledge away and he has to start again. Do you find that a truthful idea?

Pancakes, 2001
[EASYFUN-ETHEREAL]

Pam, 2001
[EASYFUN-ETHEREAL]

New! New Too! 1983
[LUXURY AND DEGRADATION]

New Rooomy Toyota Family Camry, 1983
[LUXURY AND DEGRADATION]

I Could Go For Something Gordon's, 1986
[LUXURY AND DEGRADATION]

Encased – Five Rows
(6 Spalding Scottie Pippen Basketballs,
6 Spalding Shaq Attaq Basketballs,
6 Wilson Supershot Basketballs,
6 Wilson Supershot Basketballs,
6 Franklin 6034 Soccerballs),
1983–93
[EQUILIBRIUM]

JK I am a little familiar with that – not that from the Torah – but the idea that everything is known and it's just about bringing it forward. It's known within the self. All knowledge is kind of known.

NR Do you think art can release this knowledge?

JK I think art can perform as a medium to get you to a state where everything can be revealed. It's just down to the self, to open oneself up to the experience, just letting life and knowledge reveal themselves. It's all there, you just have to open yourself up to it. That's what I believe, and I think art can be a medium that does that. That's what I am striving for with my work.

NR Do you think that it is in this suspension within the womb that equilibrium best takes place? Do you try to find an equivalent of it through what you are doing in your art?

JK If I think about the womb, I'm not sure I think about a consciousness of the situation. I think maybe of a consciousness of one's location, a sense of where one is physically located within space, but not of everything being revealed, of systems.

NR It has always struck me as perhaps somewhat peculiar that **Banality** is another big Koons word. It's a kind of very pejorative word. What does it mean?

JK When I made the 'Banality' show, I was looking at different advertising billboards and posters. I remember thinking about Newport cigarette ads: maybe they would show somebody walking down the street with a watermelon on their head, or somebody playing a trumpet, or another individual throwing a beach towel around somebody – just these dislocated situations. And I thought about that and about the things we are exposed to when we are growing up, and how these things can be categorised in a certain way so that we use them against ourselves or other people use them against us. On my grandfather's table beside his chair where he watched television there was a little porcelain ashtray of a woman lying down, and she had her legs up in the air, and when you put a cigarette underneath her legs, the smoke from the cigarette would make her legs go back and forth. It was a type of porcelain that was made in Japan after the war.

NR Yes, there were zillions of them. What you call little tchotchkes.

JK But I was always amazed by that piece. So I enjoyed thinking about that work and accepting it, and that it was beautiful to me and is beautiful in itself. It was an experience that's just like looking at a great

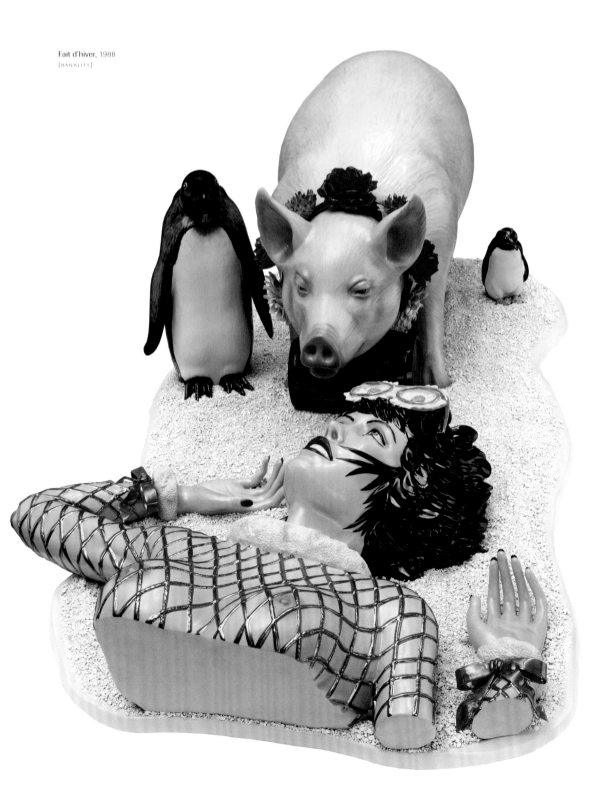

Fait d'hiver, 1988
[BANALITY]

Rubens or a great Fragonard, and that culturally in no way can be taken away. In dealing with banality it was really just trying to tell people to embrace the things that they respond to. That their responses are absolutely biologically perfect, and any kind of critical categorising that somebody could do of an aesthetic experience is meaningless and that nothing could be more profound than your own personal history.

N R **Biology** is another big word in your language. When did that come into your vocabulary? Can you remember?

J K You know, I don't know. I know that my tanks [in 'Equilibrium'] are trying to deal with the more biological side of consumerism.

N R What do you mean by 'biological'?

J K DNA. DNA is our truest history, but there's also a biological narrative that's an archetypal narrative. It's also embedded in biology, in our biology – like instinct and those other areas. So it's about trusting in the intuitive. To an artist intuition and intuitive response are just perfect. It's like a state of grace with the past.

N R Can you define **Intuition**? That's a very complex question that could be the subject of a whole dialogue between you and me for a couple of hours!

J K I think, Norman, if something presents itself to you that you are curious about – if all of a sudden you see a ladder, and you think, 'Oh I should make a work with a ladder' or you have interest in a ladder – that's intuition and you follow that, stay on that and act on it. These things can lead you somewhere, and so you should act on them.

N R What about the relationship between the DNA, as you call it, and the cultural memory? Do you think cultural memory is embedded in our DNA?

J K Yes, I think it's embedded in some way into our biological being. There is information that we carry, and getting involved with the 'Antiquity' series, it has been interesting to read different writings from antiquity, going back to the philosophy books that I read when I was in college. Plato, of course, believed that we've always known everything – it's forgotten at birth, but everything is already completely known and is just there to remember.

N R Memory is a very big, complicated thing, the whole business of the memory of images especially. The other thing you talk a lot about is sociology and the memory of sociology. Is it embedded in society and in teaching? Do you see yourself as a teacher in a kind of way?

J K I see myself as self-taught. I had a desire to inform myself more about the world around me, so up to my limitations I always tried to

educate myself. When I say 'my limitations', as an artist I try to be the artist I can be, and I really want to do it for myself. It's for my own expansion, although I like to share that expansion with others. I feel a sense of transcendence in the heightened, in the wider parameters of the possibilities of my life, and I try to share that in a generous way, not in a commanding way, not in a dictatorial way.

NR **Transcendence** is another word you use quite a lot, which it would be nice to try and define. What do you mean by that? It's as though through art we can become like gods and angels. Do you think we can?

JK I think you can have change. You can have change in your life. You can change your perceptions of things. Even going from my understanding of art when I was young, making or reproducing something, to then thinking art can be involved in a dialogue about sociology – all these different levels of abstraction, ways that art can affect the ways you perceive yourself and the world – that is a form of transcendence. And wanting to participate too, Norman. Maybe when I was younger, I didn't really want to participate so much. To a certain degree I wanted to participate in life, or within my community, but all of a sudden I had an understanding that something could help take you there, could give a sense of momentum.

NR There are different ways of participation, aren't there? I mean, if you think back to countries in the time of the Utopian epoch of socialism, artists like Malevich, for example, or Diego Rivera in Mexico and those amazing murals that he conceived, there was a kind of attempt in both cases – one through abstraction, the other through history – to achieve a sense of participation and reaching out, and making, I suppose, almost a religious art in a certain kind of way. Because in both cases it involved what I might call 'community'. So 'participation' is a very big word in your vocabulary, and I'm trying to get to the bottom of what you really mean by that, because participation means almost holding hands. Participating implies not being alone, and, of course, here in the studio you have all these extraordinary young people, with whom in a certain way you are participating. So, in the outside world, where has participation existed, and where does it lie today?

JK It's being in dialogue, interacting. It's trying to enhance something. It's making these references with other artists, feeling a sense of contributing and adding something. I like the intensity that art brings, to come up with something that's like a good cocktail. It has a power to it.

NR Does it exist in words or thoughts, or does it merely exist in this strange thing that we call the visual language? Because words are important to you, aren't they?

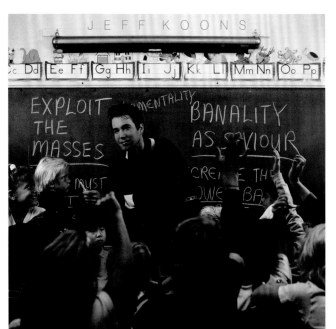

Diego Rivera
Detroit Industry. North Wall, 1932–3
Detroit Institute of Arts, Detroit, Michigan

Jean Honore Fragonard
The Swing, 1767
Wallace Collection, London

Norman Rosenthal as Wittgenstein –
the Teacher in the film *Back to Fucking
Cambridge*, directed by Otto Mühl and
Terese Schulmeister, 1987

Art Ad (Artforum), 1988–9
[BANALITY]

JK I feel things through ideas. I feel enlightenment through ideas.

NR Which you verbalise?

JK Which I verbalise. I am always trying to verbalise my work. I think I have created a verbal dialogue around my work. But the power of art for me is usually a visual power. The strongest thing usually comes from an interaction of things and seeing them visually. I like something that deals with all the senses and deals with different abstract areas of thought and language and everything at the same time, with the visual sense, and the sense of touch.

NR There's a sense of touch, and there's a sense of sound too. And are there things that are not visually beautiful? Are there things that you find ugly, that are unpleasant and you don't want either to look at or depict or relate to?

JK Absolutely.

NR Can you perhaps give some instances of such things?

JK You know, the Austrian works, the violent performance works, where they slaughtered cattle and blood would be everywhere – the Viennese Actionists.

NR Yes, I once took part in one of those performances at a party. Did you know that? There was a film made called *Back to Fucking Cambridge* [1987], and I played Ludwig Wittgenstein. It was a kind of funny event. It's a famous film throughout Germany.

JK You know, if I knew more about some of those works, I would probably be more open. I do accept all work, and I don't like to make judgements, but it's something that I just don't prefer.

NR You don't like to make judgements?

JK I really don't.

NR There are zillions of artworks out there, even just walking around funny old Chelsea a couple of blocks down from here. I don't know if you ever do that. Do you ever walk the galleries?

JK I do, I do.

NR You must see things sometimes when you go into a gallery that make you say, 'Wow!' Or do you ever go into a gallery and say, 'This stuff doesn't need to exist'? I do that.

JK I like to go into a gallery and say, 'Wow!'

NR Of course you do. We all do and are moved by something.

JK But if you really look at anything, you can find some value in it, something of interest. If I look at some of my paintings where I make

gestures in silver in them, it comes from just looking at these very commercial prints that were in a little hotel in Germany – a bed and breakfast. If you looked at them, you might think, 'What ghastly looking images!'

NR But in your case it's about managing a transformation, I think.

JK Everything has something to offer, and if you look at something at some level there's something there that you can find of benefit. I really try to take life like a glass filled with water and put a sponge in there and try to get something out of everything. And acceptance does that. So to try not to make judgements, to look at something and try to find something of interest there, only gives more possibility.

NR To find the positive in everything?

JK The positive – even trying to recognise the negative in something – I prefer the positive, but you can always find something.

NR I would love to achieve this state, which almost sounds like a kind of nirvana, that you have achieved. Are you getting close to a kind of nirvana, do you think? I'm not even exactly sure what 'nirvana' means.

JK It's a perfectly heavenly state or something like that, and I have a long distance to go, but I do believe that if one can accept everything, it can lead you pretty close to this nirvana. If it doesn't get you there completely, it gets you pretty close.

NR This gets into another whole world, a world of morality. I mean, is everything OK? If a man murders his wife, is that OK?

JK I don't think it has to be even associated with morality. It's just to do with accepting things. Even though I know if you look at morality, you could say, 'That's a moral act'.

NR I have a friend, a great friend, or a good friend – a great friend is a big word – who murdered his wife. He did a crazy thing. He was the director of a huge company and a very cultivated man, and he sponsored my first exhibition, which was bringing Joseph Beuys to London. He somehow smothered his wife with a cushion, and for whatever reason he chose not to have a lawyer. He thought he was such a bright guy and he could defend himself in court. In fact, the jury found him guilty, and he was sent to jail and locked up for 15 years. I visited him in jail for a couple of years. He was a very intelligent man. He loved art, he loved culture, he loved music, loved the visual arts, but he was unbelievably accepting of the situation he found himself in. He would look around when I went to see him in jail – I went a couple of times – and he'd look at all the people, and they looked no different from anyone else,

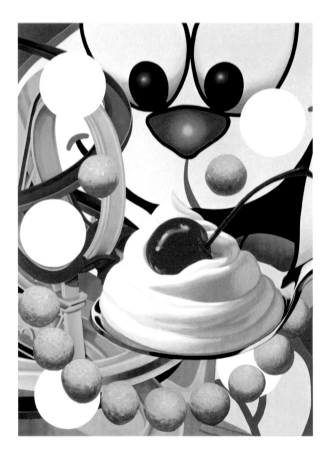

Loopy, 1999
[EASYFUN]

Couple (Dots), 2008
[HULK ELVIS]

and he said, 'This is the life, this is somehow the throw of the dice that has happened to me'. And he was very happy about it, and he made his life in jail into something very creative. He actually set up a company that would help prisoners when they left jail to set up their own businesses. He would help people get out of jail – he got himself a law degree and studied and read books – and I would send him art exhibition catalogues and so on. He was completely accepting of his situation and not in any way bitter, and he made out of what sounds like the most ghastly, unimaginable experience, something very positive. Now, isn't that rather wonderful? I mean, we are talking about acceptance, which is another of your big words. Acceptance is a big thing, isn't it – acceptance of your world, of the world you find yourself in, however horrendous it might be on the surface? It's about relative values too, isn't it?

> JK It seems he did make the best of it, but it's not that his actions have to be accepted. I think actions can be different from objects, and it comes down to people. So it's one thing for the acceptance of the individual, acceptance of the complexity of a situation or even acceptance of things that can happen, but it doesn't mean that you have to accept certain actions, and I don't think you have to accept murder.

NR I am not saying that one should accept murder, no.

> JK I know you aren't, but I'm trying to think about it in a philosophical way.

NR **Sexuality** is another very important concept for you. The Western man and, in fact, the world in general – partly through the dominance of the three monotheistic religions – has come to find the acceptance of sex rather difficult, to put it mildly?

> JK Absolutely. That's why I think sexuality is heightened in the work, because, like energy, I think that metaphysically sex is the true narrative; it's biological.
> It's a narrative that you can trust in. Sex leads you into this realm of the truest narrative, as well as self-acceptance, absolutely – the acceptance of one's body, the acceptance of one's past. There are certain physical marks that maybe you have, but there's also a mental landscape, and sexuality is really at the core.

NR Do you suspect in ancient times – Classical antiquity, for instance – that things were much simpler in that respect? In a way that seems to be the message of your very latest work.

> JK Norman, I always think that enlightenment, the sense of a consciousness, of the self, the possibilities of the self, the expansion that one can have towards a higher perspective – like to climb on top of a

mountain to get a greater view – is individual. There are certain aspects in certain civilisations, but I think it's always up to each individual's grasp of life and their own potential, and their attempt to try to live to their potential. I don't think that things were simpler then. I think that every life form is presented with that kind of challenge to make the most of it, and hopefully they can get a perspective of what situation they are really in.

N R What about **Debasement**? What does debasement mean, in your language?

J K To bring down. Culture debases people by making them feel insecure about themselves. There is no correct way, there is no correct aesthetic, there is no correct path, but when somebody gains a sense of authority they can exercise that authority recklessly, and people can become very insecure about their own potential. And culture can do that, if it's directed towards people to make them feel as though there is a correct path, that there is only one way of looking at something, and that if you don't follow that path, or if you don't know about that path, you have no foundation.

N R That's kind of fascist. Everyone forced to have the same culture.

J K Everybody has their own independent culture, and that culture is as valid as any other culture. One person's culture could be considered more refined, but that doesn't make it more valid or rich. It just makes it different; within one perspective it is being viewed as refined, but it's not.

N R But do you like the fact that there's a McDonald's on every street corner of the world now, as a representation of a kind of global culture, to me, at its worst?

J K No, and if an individual doesn't use their ability for transcendence, use their ability to have as much life opening, life experience, as possible then you could look at a culture and maybe say that it wasn't as vast. But it has to do with what people do with their environment.

N R I'm not asking you to attack McDonald's specifically.

J K I'm not.

N R What I'm trying to ask you is whether McDonald's – what I call the 'McDonaldisation' of the world – is that a bad thing? Is that form of the homogenisation of the world draining people of their own empowerment, their sense of empowerment? Do you think that?

J K I think the more variation that people have around them, the more it gives them a perspective on something.

N R Choice.

JK Yes, choice. But still people have to deal with the situation they find themselves in, and just because people grow up in those situations doesn't mean that their cultural experience is less than that of somebody who grew up in a different situation. It's just what it is, and they can use that cultural experience to make something as vast of themselves as possible.

NR Are you happy that you've grown up in late 20th- and early 21st-century America, or would you rather have grown up in the jungle, for example? Which people have the richer experience? The American of the late 20th- and early 21st century, or the jungle dweller, who still exists in obscure parts of the world?

JK Sorry, Norman, I want to go back to what I said. Information comes from specific experiences that people have, and somebody could really end up having a great experience from an experience that to other people would not even be considered beneficial or even not that interesting.

NR Something creative, you mean?

JK That's right, creative. Being able to make a different connection. I'm opposed to judgements. There are class judgements and through these class judgements come cultural judgements, and these are things that limit people. It limits them because they don't have a sense of self-respect. They feel inadequate instead of embracing what their history has been and using that as a foundation.

NR You mentioned before a 'state of grace'. Is the word **Grace** still an important word for you?

JK It's very Christian – a house can't stand that's divided. It really deals with foundations, philosophical foundations that can come not only from Christianity, but can come from other philosophies.

NR And cultural backgrounds too – from positive cultural backgrounds. I don't think these things are just the prerogative of Christianity.

JK Even though there are certain backgrounds that could be looked at as being more ideal, it's important that the background of an individual is embraced for what it is and that every individual looks at it as perfect, because it can't be any different from what it is and what it has embraced. From that moment forward, it's up to them to take advantage of what their potential is, what their interest is, if they have interest in altering the form of cultural interaction they have. But it's about that consciousness that their history is perfect.

Saint John the Baptist, 1988
[BANALITY]

1955
Jeffrey Lynn Koons is born to Henry and Gloria Koons in York, Pennsylvania. His father was a furniture dealer and interior decorator, and his mother's family, through her father, had a background in business and politics. He was their second child, three years younger than his sister Karen.

1960
Jeff Koons receives his first artistic training in the form of drawing lessons. A kindergarten photo taken of him sitting at a table holding a box of crayons is later used by Koons in *The New Jeff Koons* (1980) (page 11).

1963
Henry Koons displays his son's copies of old masters paintings in his furniture store.

1972
Jeff Koons studies at the Maryland Institute College of Art, Baltimore, producing paintings influenced by his dreams and Surrealist art.

1973
He calls Salvador Dalí at the St Regis Hotel where Dalí is staying and arranges a meeting in New York with the Spanish artist, whom he greatly admires.

1975
Studies at the School of the Art Institute of Chicago, and becomes friends with artist Ed Paschke, one of his teachers.

1976
Moves from Chicago to New York, living in a Lower Manhattan apartment.

1977
Begins a job at the Museum of Modern Art (MoMA). Often wearing flamboyant, flower-adorned outfits that he custom-made, he recruits new members and sponsors at the Membership Desk. He starts work on his first inflatable flower works.

1979
The artist starts his series later titled 'Pre-New', in which household objects are fixed to fluorescent lights. He begins to include vacuum cleaners in his sculptures. He departs MoMA for a job on Wall Street to finance his new work.

1980
The New Museum of Contemporary Art presents Jeff Koons's first exhibition, 'The New', in its window. The show features the artist's arrangements of vacuum cleaners from the series of the same name.

1982
Koons leaves New York to live with his parents in Sarasota for six months to fund his next series.

1983
Works as a commodities broker to raise funds for the production of his ambitious series, 'Equilibrium'. Koons consults with Nobel Prize laureate for quantum electrodynamics Dr Richard P Feynman on the basketball tanks.

1985
Jeff Koons's first solo gallery exhibition, 'Equilibrium', is presented at the International With Monument Gallery in New York's East Village. The series includes the 'Equilibrium' basketball tanks along with Nike posters and bronze objects such as snorkels and casts of inflatables like *Lifeboat*.

1986
International With Monument exhibits his second solo gallery exhibition, 'Luxury and Degradation', which targets the advertising industry and focuses on class and social mobility. *Rabbit* (page 133) is unveiled as part of a group exhibition of Neo-Geo artists at Ileana Sonnabend's prestigious New York gallery in SoHo.

1987
One Ball Total Equilibrium Tank (1985) is included in the Whitney Biennial at New York's Whitney Museum of American Art. For a square in Münster, Germany, the artist produces *Kiepenkerl* (page 134), a stainless-steel replica of one of the city's monuments.

1988
Three major galleries simultaneously show Koons's new series 'Banality': Max Hetzler in Cologne, Ileana Sonnabend in New York and Donald Young in Chicago. Koons places ads starring himself in four art magazines to announce the shows.

1989
Koons arranges to meet Ilona Staller, aka La Cicciolina, after seeing her photos in magazines. He organises a photo shoot with her, from which he creates a billboard titled *Made in Heaven*, which is installed on Broadway as part of an exhibition at the Whitney Museum.

1990
At the Venice Biennale, the artist presents a sculpture and the first paintings from 'Made in Heaven' with him and Staller.

1991
The 'Made in Heaven' series is shown to critical opprobrium at Ileana Sonnabend, New York, and Max Hetzler, Cologne. Jeff Koons marries Ilona Staller.

1992

While living in Munich, the artist produces a gigantic West Highland Terrier dog sculpture from living flowers, *Puppy* (pages 148–9), to sit in front of Arolsen Castle in Hesse, Germany.

1993

Conceives of the 'Celebration' series that is inspired by the the wonderment of childhood he experiences with his young son and the notions of the cycles of life. He separates from Staller and a custody battle ensues. They divorce in 1994.

1999

As 'Celebration' continues to be beset with production difficulties, the artist starts the 'Easyfun' series, comprising mainly colourful paintings juxtaposing diverse images and wall-mounted sculpture. The works are exhibited at the Sonnabend Gallery in New York.

2000

A version of *Puppy* is shown at the Rockefeller Center in New York. *Split-Rocker*, the artist's second large-scale floral sculpture, is installed at the Papal Palace in Avignon. 'Easyfun-Ethereal' is shown at the Deutsche Guggenheim Berlin.

2001

Michael Jackson and Bubbles (1988) (page 141), from 'Banality', sets a record auction price for Jeff Koons of $5.6 million. He receives the decoration Chevalier de la Légion d'Honneur from France.

2002

Jeff Koons is the subject of major shows at venues such as the Guggenheim Museum, New York; Kunsthaus Bielefeld, Germany; Musée d'art Contemporain, Nîmes; and Chosun Ilbo Art Museum, Seoul. Koons marries Justine Wheeler.

2003

'Popeye', a series of sculptures and paintings begun in 2002 and inspired by the eponymous cartoon character and further exploration of the Duchampian readymade, is presented at Sonnabend, New York.

2005

The artist starts a new series of sculptures and paintings, 'Hulk Elvis', which features the Incredible Hulk comic book character. In his 50th year, Jeff Koons is nominated to the American Academy of Arts and Sciences.

2006

Balloon Flower (Red) (1994–9) is unveiled at 7 World Trade Center. Americans for the Arts presents Koons with the Artistic Achievement Award.

2007

The artist is promoted from Chevalier to Officier de la Legion d'honneur by Jaques Chirac. 'Re-Object: Marcel Duchamp, Damien Hirst, Jeff Koons, Gerhard Merz' opens at the Kunsthaus Bregenz as the first exhibition of a two-part series. Gagosian Gallery exhibits a 'Popeye' sculpture on Davies Street and an exhibition of 'Hulk Elvis' paintings on Britannia Street, both in London, over the summer. The Koons Family International Law and Policy Institute is developed to combat global issues of child abduction and exploitation.

2008

The artist presents at four major institutions: the Museum of Contemporary Art, Chicago; Metropolitan Museum of Art, New York; Neue Nationalgalerie, Berlin; and Château de Versailles, France. He receives an Honorary Doctorate from the School of the Art Institute of Chicago, and the Wollaston Award from the Royal Academy of Arts. National Galleries of Scotland and Tate are endowed with the Artist Rooms, where Koons is represented with 17 works.

2009

Starts the 'Antiquity' series, which explores the artist's longstanding interest in humanity and art history. His 'Popeye' series is presented at the Serpentine Gallery, London. He curates the 'Ed Paschke' exhibition at Gagosian Gallery in New York.

2010

Cracked Egg (Blue) (1994–2006) is shown at Waddesdon Manor, England. Jeff Koons is made an Honorary Member of the Royal Academy of Arts, London. The Jeff Koons 17th BMW Art Car races at Le Mans.

2012

His monumental multicoloured mirrored tulip sculpture, *Tulips* (1995–2004) (page 88), is sold for a personal auction record of $33.7 million. His international exhibitions include those at the Schirn Kunsthalle and Liebieghaus Skulpturensammlung in Frankfurt, the Almine Rech Gallery in Brussels and the Beyeler Foundation, Basel. The State Department's Medal of Arts is awarded to Koons by Secretary of State Hillary Rodham Clinton, Art in Embassies.

2013

Summer exhibitions include simultaneous shows in New York with new paintings and sculpture at the Gagosian Gallery, and 'Gazing Balls' exhibited at the David Zwirner Gallery. The November sale of the iconic 'Celebration' sculpture *Balloon Dog (Orange)* (1994–2000) (see overleaf) at Christie's for $58.4 million creates a new world auction record for a living artist. The artist designs the cover art for Lady Gaga's ARTPOP album.

2014

A major retrospective that covers the artist's entire 35-year career is staged at the Whitney Museum of American Art in New York, before travelling to the Centre Pompidou in Paris and Guggenheim Museum Bilbao.

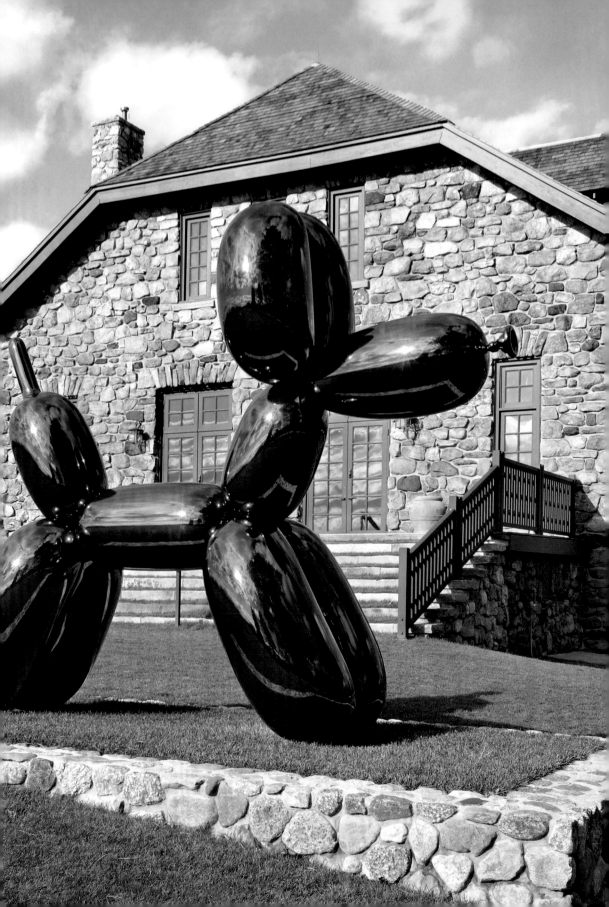

INDEX

A

Acrobat 117, **120**
Ad Art (Art) 30
Americanisation 255, 283
Andre, Carl 81
Antiquity 1 (Dots) **20**
Antiquity 2 164, **167**
Antiquity 4 212
Antiquity (Daughters of Leucippus) 40–1
Antiquity (Farnese Bull) 178, **179**
Antiquity (Satyr) 213
Antiquity series 20–1, 40–1, 164, 167, 177–8,
 179, 186–7, **194–5**, 211, **212–13**, 218,
 245, **276–7**
Antiquity (Uli) **276–7**
Apollonius of Tralles 180
Aqualung 26, 99, 114
Aqui Bacardi 119
Art Ad (Artforum) **278**
Art Ad (Art In America) **264**
Auto 35

B

Back to Fucking Cambridge **278**, 279
Bagel 183
Ballet Couple 190, **195**
Balloon Dog (Blue) **152–3**
Balloon Flower (Yellow) **157**
Balloon Rabbit 182
Balloon Rabbit (Violet) 66, **67**
Balloon Rabbit (Yellow) **185**
Balloon Swan 52
Balloon Swan (Blue) **53**
Balloon Swan (Magenta) **29**
Balloon Venus 193
Balloon Venus (Magenta) **21**
Balzac **192**, 193
Banality series 30, 94, 113, 135–40, **137–9**,
 141, 214, **215**, **264**, 272–4, **273**, 278, 287
basketball tanks *see* tanks
Bear and Policeman **139**
Beckley, Bill 89

Bernini, Gian Lorenzo **144**, 148, **188**, 189
BMW Art Car 34, **35**
Board Room 118
Bob Hope 125, 128, **130**, 201
Boone, Mary 105
Bouguereau, William Adolphe **188**
Bourgeois Bust – Jeff and Ilona **16**
Building Blocks 158

C

Campus, Peter 83
Cannonballs (Hulk) **196**, 201, 202
Canova, Antonio **188**, 189
Carpenter, James 83, 89
Casa dei Vettii 134
Castelli, Leo 62, 81, 110
Caterpillar Ladder 169, **171**
Celebration series 12, 31, **88**, 151–9, **152–3**,
 157–8, **160–1**, 214, **216–17**, 224, **228**,
 238, 241
Chainlink 78
Chicago Imagists 66, 69
Coloring Book 12, **241**
Couple (Dots) **281**
Couple (Dots) Landscape 202
Courbet, Gustave 114, **144**, 148, 174, 202, 240
Cracked Egg (Magenta) **228**

D

Dada 62, 76
Dalí, Salvador **17**, 55–6, **57–8**, 59–60, 69, 114,
 181
Deitch, Jeffrey 156
de Kooning, Willem **175**, 176
Diamond (Blue) 223, **224**
Dictator **198–9**, 201–2
Doctor's Delight 128, **130**
Dogpool (Logs) 242
Dolphin Taz Trashcan 242

Donkey 19, **216–17**
Duchamp, Marcel 24, 69, 79, 140, 248
Dutch Couple 168
The Dynasty on 34th Street 118

E

Easyfun-Ethereal series **22–3**, 35, 183, 250,
 259, 269
Easyfun series 19, 164, **165**, **166–7**, 225, 250,
 281
Elephant 95
Elephants 22
The Empire State of Scotch, Dewar's 119
Encased – Five Rows 271
Equilibrium series 15, 26, **36**, 37, **96**, 98, 110,
 114–17, **115**, 118, 191, 229, 268, 271,
 272, 274

F

'The Fab Four' 125
Fait d'hiver 273
Farnese Bull 112, 178, **179**, 180, 206
Feynman, Dr Richard P. 116
Fisherman Golfer 121, **124**
Flavin, Dan 81, 90, **92**, 94
The Flaying of Marsyas 37, **38**, 39
Fragonard, Jean Honore 148, **278**

G

Gaga, Lady 263, **264**
Gainsborough, Thomas **54**, 55
Gazing Ball (Ariadne) **70–1**
Gazing Ball (Esquiline Venus) **70–1**
Gazing Ball (Farnese Hercules) **70–1**
Gazing Ball series **70–1**, **72–3**

Geisha **150**, 151
Gibson, John 89
Girl with Dolphin and Monkey 164, **166**, 169
Girl with Dolphin and Monkey Triple Popeye
 (Seascape) 170, **172–3**, 174, 176
Gorky, Arshile 65
Green, Dr 116

H

Hair 165
Halsman, Philippe 56
Halstead, Whitney 66, 68, 89
Hanging Heart (Red / Gold) **31**
Hartigan, Grace 62
Harunobu, Suzuki 149
Hennessy, The Civilized Way to Lay Down the
 Law 119
Hoover Celebrity III 90, **91**
Hoovers 90, 102–7
 see also The New
Hulk Elvis I **256**
Hulk Elvis Monkey Train Swish (Blue) **61**
Hulk Elvis series **32, 61, 150,** 151, **168, 172–3,**
 196, **198–200**, 201–2, **203,** 220–1, **256–7,**
 281
Hulk (Wheelbarrow) **220–1**
Hybrid series **29, 53, 67, 185**

I

I Could Go For Something Gordon's **270**
Inflatable Flower and Bunny (Tall White, Pink
 Bunny) **77,** 79
Inflatable Flowers (Short Pink, Tall Yellow) **231**
Inflatable Flower (Tall Yellow) 79
Inflatables series 76–81, **77, 85,** 87, 94, **95, 231**
Irwin, Robert 81
I Told You Once, I Told You Twice 81, **82**

J

The Jim Beam – J.B. Turner Train 121, **126–7**
Jones, Alan 113
Judd, Donald 81
Jung, Carl 62

K

Kiepenkerl 128, 131, **134,** 136, 211
König, Kasper 128
Koons, Jeff
 childhood 10, **11,** 47, 50–2, 72, 121
 children 121, 155, 156, 159, 205, **232**
 divorce 155, 159
 family 42–73, **46,** 80
 photo in apartment 85
 price of work 265
 student work 62, **63,** 65
 studio 226, 230, **231, 234–5**
 vocabulary 266–87

L

Landscape (Cherry Tree) **32**
Landscape (Waterfall) II 202, **203**
Lawrence, Thomas **54,** 55
Liberty Bell **200,** 201–2
Lichtenstein, Roy 89, 112, 148, 151, 174
Lifeboat 114, **115**
Lips 206, **250**
Lobster 97, 99
Loopy **281**
Louis XIV 125, 128, **129,** 201
Lundberg, Bill 83, 89
Luxury and Degradation series 117, **119,** 121,
 124, **126–7, 270**
Lysippos 180

M

Made in Heaven series **16,** 52, 145–8, **146–7,**
 155, 211, **284–5**
Magritte, René 56, 181
Malevich, Kazimir 275
Manet, Édouard 27, **28,** 50, 114, 148, 186, **188,**
 189
Masaccio **144,** 145, 148
Massys, Quentin 17
Metallic Venus **245**
Michael Jackson and Bubbles **141,** 145
Michelangelo 114, **141,** 145, 190
Miller, Lee **206–7**
minimalism 79, 81, 89, 94
Modernism 90
Mol, Gretchen 164, 170
Mondrian, Piet 90
Monkey Train **257**
Moon (Light Blue) **238**
Morris, Robert 81
Moses **15**
Mozart, Wolfgang Amadeus 211

N

Nefertiti 182, **184**
The New 60, 114, **227,** 268
New Hoover Convertible, New Shelton Wet/Dry
 10 Gallon Doubledecker **104**
New Hoover Convertibles **227**
New Hoover Deluxe Rug Shampooer **92**
New Hoover Deluxe Shampoo Polishers **103**
New Hoover Deluxe Shampoo Polishers New
 Hoover Quik-Broom, New Shelton
 Wet/Dry 5 Gallon New Shelton Wet/Dry
 10 Gallon Tripledecker **107**
New! New Too! **270**
New Rooomy Toyota Family Camry **270**
The New series 92, 93, **100–1,** 102–7, **103–4,**
 107
New Shelton Wet/Dry Tripledecker **104**
Nike 117
Nutt, Jim **64,** 66

O

Oldenburg, Dick 86
Olive Oyl 261
Oppenheim, Dennis 89
Outsider Art 66

P

Page, Bettie 164, 170
Pam 269
Pancakes 269
Paschke, Ed 24, **25**, 27, 66, 68–9, 72, 84
Picabia, Francis **180**, 181
Picasso, Pablo 65, 89, 90, 148, 174, **175**, 211, 248, **249**
Pictures Generation 89
Pink Ballerina 190, **194**
Plato 33, 106, 218
Play-Doh 156, **158**
Popeye 260
Popeye series 78, 79, 117, **120**, 169–70, **171**, 176, **242**, 252–3, **260–1**
Porter, Fairfield 62, **64**
Pot Rack **250**
Praxiteles **180**, 189, 190, 197
Pre-New series 76, **91**, **92**, 93–4, 102
Prison (Venus) 23
Puppy 47, **48–9**, 189, 205, 211, 254

R

Rabbit 128, **133**, 135
Rabbit – Macy's Thanksgiving Day Balloon 121, **122–3**, 125
Raphael **249**, 255
Rauschenberg, Robert 89, 112
Ribera, Jusepe de **98**, 99
Rivera, Diego 275, **278**

Rockwell, Norman 55
Rodin, Auguste **192**, 193
Rubens, Peter Paul **54**, 226
Rubin, Bill 86

S

Sacred Heart (Red/Gold) **241**
Saint John the Baptist **287**
Scarpitta, Sal 62
Seurat, Georges **231**
Shelter **160–1**
'shiver effect' 37
Sleeping Ariadne **141**, 145
Smithson, Robert 81, **82**
Snorkel (Shotgun) **191**
Snorkel Vest **96**, 99
Solomon, Holly **87**, 89
Sonnabend, Antonio 110, 112, 113
Sonnabend, Ileana 81, 110–13, **111**, 125
Sonnabend, Michael 112
Split Rocker **142–3**
Split Rocker (Orange/Red) **259**
Stacked **138**, 214
Statuary series 125, 128, **129–30**, **133**, 201, 211
Stormin' Norman **118**
String of Puppies 214, **215**
Surrealism 13, 55–6, 62, 66, 76

T

tanks 37, 79, 83, 99, 114, 116–17, 229
see also Equilibrium series
Teapot **92**, 93–4
Titian 37, **38**, 39, 66, 170, **175**, 186
Train (model for public sculpture) **204**, 205–6
Travel Bar **124**
Triple Elvis **252–3**

Tulips 86, **88**, 152–3
Tutankhamun's funerary mask 17
Two Ball Total Equilibrium Tank (Spalding Dr. J Silver Series) **36**, 37
Two Kids 128, **130**

U

Ushering in Banality **137**

V

Varnedoe, Kurt 86
The Venus Felix 17
Venus of Willendorf 99, 128, **132**
Versailles show **240**
video 83
Viennese Actionists **279**
Violet – Ice (Kama Sutra) **284–5**

W

Warhol, Andy 89, **111**, 112, 202
Weinberg, Daniel 105
Wesley, John **149**, 151
Woman with Head **63**, 65

Y

Yoakum, Joseph **64**, 66

PHOTOGRAPHIC CREDITS

Sir Norman Rosenthal, former Exhibitions
Secretary at the Royal Academy of Arts, London,
is an independent art historian and curator.

First published in
the United Kingdom in 2014 by
Thames & Hudson Ltd,
181A High Holborn,
London WC1V 7QX

www.thamesandhudson.com

First published in 2014 in hardcover
in the United States of America by
Thames & Hudson Inc.,
500 Fifth Avenue,
New York, New York 10110

www.thamesandhudsonusa.com

British Library Cataloguing-in-
Publication Data
A catalogue record for this book
is available from the British Library

Library of Congress Catalog Card
Number 2013950853

ISBN 978-0-500-09382-5

Printed and bound in China

This book was designed
and produced by
Iqon Editions Ltd,
Sheridan House,
112–116a Western Road,
Hove BN3 1DD

Publisher: David Breuer

Design and typography:
Isambard Thomas

Content Editor: Sam Phillips

Copy Editor and picture research:
Caroline Ellerby

Editor: Matthew Taylor

Interview transcriptions: Ann Winton

Index: Caroline Eley

Grateful acknowledgement is given
to the following for support, advice
and essential encouragement:
Inigo Philbrick; Daniel Wolf; Francesca
Vinter; and Gary McCraw, Lauran
Rothstein and Amy Silver from
Jeff Koons's Studio.

Jeff Koons and Norman Rosenthal
have supported this project
throughout and their wisdom,
dedication, patience and supreme
professionalism is acknowledged
with thanks.

Timeline text makes use of
and acknowledges with thanks
information included in monographs
and exhibition catalogues published
by Taschen, Kunsthaus Bregenz
and Fondation Beyeler.